The CAPE COD CANAL

The

CAPE COD
CANAL

BREAKING THROUGH THE BARED AND BENDED ARM

J. NORTH CONWAY

Charleston — London

THE
History
PRESS

Published by The History Press
Charleston, SC 29403
www.historypress.net

First published 2008
Second printing 2009

Manufactured in the United States

ISBN 978.1.59629.374.8

Library of Congress Cataloging-in-Publication Data

Conway, J. North (Jack North)
The Cape Cod Canal : breaking through the bared and bended arm / J. North Conway.
p. cm.
Includes bibliographical references.
ISBN 978-1-59629-374-8
1. Cape Cod Canal (Mass.)--History. 2. Canals--Massachusetts--Design and construction--History. I. Title.
HE396.C3C66 2008
386'.46--dc22
 2008001935

Notice: The information in this book is true and complete to the best of our knowledge. It is offered without guarantee on the part of the author or The History Press. The author and The History Press disclaim all liability in connection with the use of this book.

Contents

Acknowledgements

The author would like to thank the following people, organizations and institutions for their help in researching this book: Lucy Loomis of the Sturgis Library in Barnstable; Barbara L. Gill, archivist for the Town of Sandwich Archives; Anne Connolly Saganic of the West Falmouth Library; Ranger Samantha Mirabella, the United States Army Corps of Engineers; Snow Library; Truro Public Library; Wellfleet Public Library; West Dennis Public Library; Whelden Memorial Library; Woods Hole Public Library; Historical Society of Old Yarmouth; Osterville Public Library; the Cotuit Library; the Hyannis Public Library; Dennis Public Library; Eastham Public Library; Falmouth Public Library; Mashpee Public Library; Wilkens Library; Cape Cod Community College; the Jonathan Bourne Historical Center; Bourne Historical Society; Cape Cod Maritime Museum; Centerville Historical Museum; Falmouth Historical Society & Museums on the Green; Osterville Historical Society and Museum; U.S. Life-Saving Service Heritage Association; Nantucket Life-Saving Museum; Wellfleet Historical Society; U.S. Coast Guard; Historian's Office, Woods Hole Historical Museum; Massachusetts Historical Society; Provincetown Library; Wareham Free Library; the Bristol Community College Learning Resource Center; the University of Massachusetts Library; and my son, Nate Conway.

Introduction

There are not many things in this life that one can claim with some certainty—"this much I know is true"—and mean it. As a writer, it has always been a quest of mine to find such things, to find the truth in this world, even if it is only a small truth. That would suffice. I have learned this much, however: sometimes it takes longer than anticipated to find the truth. Nevertheless, it is a worthwhile task to uncover those things that allow one to say, "This much I know is true."

We hit the beach early in the old days, always early in the morning before the sun was too high. And we would stay at the beach most of the morning, with a break for lunch and some sightseeing, and then we'd go back and hit the beach again until the afternoon wore on and the chill set in. Then, we would pack up everything, tossing sandy wet towels, toys, blankets, books and anything else we had brought into the car, and head home from the Cape, making sure to stop to buy an ice cream that melted and dripped all over the place. By the time we arrived back home, my two boys would be asleep in the backseat of the car, still warm and brown and sandy and, most of all, happy.

When my son was little and I was unemployed—being unemployed for periods of time is a fact of life for most writers—I used to take him to Onset Beach in Wareham, Massachusetts, not far from the Buzzards Bay side of the Cape Cod Canal. Onset was a good beach for kids, small and protected from the surf. I would bring my eight-year-old son and his nine-year-old cousin there early in the day, we'd lay out a blanket and they would hit the water, playing there in a protected beach area that was no more than three feet deep and surrounded by bright orange netting that served as a barrier. The kids, and there were loads of them at the beach, would be splashing and running and throwing sand and building sand castles, doing what kids usually do at the beach. And they were watched over, not only by us, the parents, but by two on-duty lifeguards sitting high above the kids in whitewashed wooden lookout chairs, young and bronze and fit, wearing bright orange lifeguard trunks with whistles dangling around their necks. Together we watched over the small beach and the children playing there.

My son Nate and my nephew Andy, whom we had more or less adopted during the summer, would splash around for hours, engaged in their games of sand castle building and pretend shipwrecks, growing tanner and tanner in the salty water and bright glowing sun. My wife always made sure that I took loads of sunscreen with me on these excursions and I dutifully would call my two boys in at intervals during the day and smear the white lotion all over them. Nate would complain and Andy would complain, but the sunscreen ritual went on most of the day.

I would sit on a blanket, using towels to prop up my head, and read or write, or simply sit and watch the boys and the sea and the sand and the sun, rubbing sunscreen all over myself at intervals.

When it was noon or so I'd gather my boys up, dry them off and we would head up the sandy embankment onto the sidewalk where we would scout for places to eat lunch. There would be no indoor restaurants for us because we were sandy and wet, wearing flip-flops and soggy sneakers, naked except for our bathing suits or cut-off khaki trousers, which was my usual attire then, with battered old straw hats to shade our faces. I adorned the two boys with plastic sunglasses, ones they bought with emblems of their favorite television cartoon characters emblazoned on them—Mickey Mouse and Casper the Friendly Ghost. The lenses were always scratched and covered with sand and sunscreen oil. I wore my old prescription aviator glasses, whose lenses were also scratched beyond belief, so much so that I could only wear them if I knew I would be walking in a straight, unobstructed line; otherwise, they hung around my neck from a shoestring I had tied to the ends. We were a motley, sun-drenched, water-logged crew and I don't think any restaurant would have allowed us inside anyway. There was always an outside hot dog stand or a place where we could buy pizza by the slice and sodas. We would fill up on whatever caught our scratched lens–covered eyes as long as it was outdoors. And there would be a small stand where, for dessert, we could buy a cone of ice cream or sticky blue cotton candy.

We would find a place to sit on a public lawn or up along the curbing. We weren't alone. Onset would be crawling with little kids and their parents looking for lunch. We would stroll out onto the town pier in Onset to see the boats, and sometimes we'd see the big Cape Cod cruise ship sail by with people waving from the deck. The cruise usually took sightseers through the Cape Cod Canal from Buzzards Bay to Cape Cod Bay on the other side. And the boys would ask to take the cruise, but it wasn't something I could afford, nor did I feel comfortable taking the two small boys out on a canal cruise.

"Someday," I would tell them when they asked when I would take them on a cruise through the Cape Cod Canal. I never did.

On these Onset Beach excursions during late July and August, we would always drive up through Bourne to catch a glimpse of the Bourne Bridge and then drive farther on to where we could see, from one of the highest points along the highway, the length and breadth of the Cape Cod Canal. And the boys, sitting in the backseat, would squeal and point if there happened to be a sailboat or a tug or any other vessel navigating through the canal. And we'd catch a glimpse of the Sagamore Bridge, turn around and head for

home, checking out the magnificent view of the Cape Cod Canal once more, always keeping our eyes out for an ice cream shop.

Back then, when walking around town without a shirt was all right to do, dressed in old khaki cutoffs, holding hands with my two water-logged and tanned little boys, leading them around the sun-drenched little cape village of Onset like little ducklings, I had no answer for my son when he asked me one day, "Who built the canal, Daddy?" I told him I did, but of course he didn't believe me. "I don't know," I admitted, and he shrugged his little bronze shoulders and went back to playing with his cousin Andy.

Good question, I thought. Who did build the Cape Cod Canal? Like everything ever associated with the Cape Cod Canal, it would be years and years before I could answer my son's question. But now I know. My boys are now men—husbands and fathers with young children of their own. And they both go to the Cape. My son lives in Wareham, and he and Andy and their children remain close friends. They still go swimming sometimes at Onset Beach.

I am no longer allowed to walk bare-chested in public places. I seldom go out in the sun. I hardly ever go to the beach. And hot dogs and cotton candy are no longer nutritional staples in my diet. Still, I can safely say this much with certainty to my two boys, Nate and Andrew, and to my grandchildren, should they ever ask, "Who built the Cape Cod Canal?" This much I know is true: August Belmont Jr. built the Cape Cod Canal. This book tells you how and why he did. I hope you like it.

PART ONE

The Loom of Time

A Brief History of Cape Cod, Its People and Its Heritage

It seemed as if this were the Loom of Time, and I myself were a shuttle
mechanically weaving and weaving away at the Fates.
—*Herman Melville,* Moby Dick

The Most Dangerous Sailing Route in the World

The brig St. John, *from Galway, Ireland, laden with emigrants, was wrecked on Sunday morning, it was now Tuesday morning, and the sea was still breaking violently on the rocks…The bodies which had been recovered, twenty-seven or eight in all, had been collected there…I witnessed no signs of grief, but there was a sober despatch* [sic] *of business which was affecting.*

—*Henry David Thoreau,* Cape Cod

It is surprising that the Cape Cod Canal was built at all. The idea of building such a canal to circumvent the dangerous sailing route around the Cape had been proposed, and it languished on the drawing board for nearly three hundred years. When August Belmont Jr. undertook the building of the Cape Cod Canal between the years 1909 and 1914, the canal was a solution to the centuries-old challenge to safe passage around Cape Cod. If indeed there was *one* driving force behind the digging of the Cape Cod Canal, it was the loss of ships and their crews, passengers and cargo that had been caused by the treacherous currents and dangerous shoals that lay in wait off the Cape Cod coast. Since the earliest settlers landed on Cape Cod to make their homes and colonize this portion of the New World, the sailing route around Cape Cod had been a nightmare for mariners and their vessels. Thousands of ships were sunk trying to navigate this deadly passage, taking with them hundreds of lives and tons of precious cargo. The question is not "Why was the Cape Cod Canal ultimately built?" but "Why had it taken so long?" From the earliest of historical times, dating as far back as the 1600s, everyone from mariners to politicians agreed that the building of a canal though Cape Cod would save lives and protect precious cargo. And yet, for nearly three hundred years, despite all the best intentions, the inertia of Massachusetts politicians kept the canal in a perpetual state of bureaucratic limbo.

In 1697, a Massachusetts General Court resolution called for the digging of a canal. The resolution read, "For the preservation of men and estates, and very profitable and useful to the publick [*sic*] if a passage be cut through the land at Sandwich from Barnstable Bay." But nothing was done.

One charter for the building of the canal after another was filed with the Massachusetts state legislature and one charter after another was awarded. Still, not a single shovelful of Cape Cod soil was dug. All in all, it is surprising that the canal was dug at all. But it was, and the longtime dream of traversing Cape Cod, out of the reach of the dangerous tides and currents, was undertaken not by any Massachusetts citizen but by a New Yorker—August Belmont Jr. His reasons for doing what no one else had done were many, but one important reason was to save lives and cargo from the watery depths off Cape Cod.

The First Recorded Shipwreck

The first recorded shipwreck off the Cape Cod coast was the sinking of the thirty-six-ton *Sparrowhawk*, sailing from England to the Virginia Colony in 1626. The small, two-masted vessel had twenty-five passengers on board in addition to the crew. Many were sick with scurvy, and their supplies had just about run out after a treacherous six weeks at sea.

The forty-foot, two-masted vessel was blown far off course, sailing into the outer reaches of the Cape Cod coast off Chatham. Trying to land the ship in order to search for food and water, the *Sparrowhawk*'s captain set a dangerous course heading in closer to shore and ran the ship aground. Luckily for the passengers and crew, the friendly Native Americans had gathered on the beach and were watching as the ship tried to make its way into shore. They brought food and water to the stranded passengers and crew still on board the listing vessel, and they offered to take crew members up the coast to Plymouth to get help from Plymouth Bay colonists. The Plymouth colonists sailed down the coast to help rescue and right the stranded ship. Passengers were taken off the ship and fed, while the crew, with the help of men from Plymouth, helped repair the vessel. Once repaired, the *Sparrowhawk* set sail south for its original destination, Virginia. Sadly, the vessel did not get very far. Caught in one of the many storms that rose up off the Cape Cod coast, the tiny ship sank off the coast of Nauset. The passengers and crew managed to save themselves and they returned to Plymouth to spend the winter. Finally, after nearly a year, the passengers and crew sailed south for Virginia on another ship.

The wreck of the *Sparrowhawk* was set on fire by the Native Americans. The vestiges of the ship, its oaken timbers and keel, were buried in sand, hidden for nearly two hundred years by the Cape Cod elements. In 1863, the remains of the tiny ship were discovered. The frame of the ship had been protected beneath the sands, and when its frame was finally exposed it remained intact.

When the remains of the vessel were identified as those of the *Sparrowhawk*, the very first recorded shipwreck off the Cape Cod coast, the ship became a matter of great curiosity. The well-preserved frame of the ship was taken on tour and displayed in Boston. The remains of the *Sparrowhawk* were finally housed safely in Plymouth, where they are on display today.

Although the *Sparrowhawk* was the first recorded shipwreck off the Cape Cod coast, it by no means would be the last. From the mid-1600s to the late 1800s, it is estimated that there were three thousand known shipwrecks in these treacherous waters.

The First Plans to Build a Canal

During the late 1700s, 120 ships per day were rounding Cape Cod along its treacherous shoals and currents. Many of New England's worst recorded shipwrecks happened off the dangerous coastline of Cape Cod. During the early 1800s, in a mere ten-year period (1843–1853), more than 100 ships were lost trying to sail around Cape Cod, with more than a hundred lives lost at sea and approximately $1.8 million in property sunk to the ocean's depths.

The public pleas and plans to save lives and ships by building a canal began as early as the Revolutionary War. In 1776, none other than General George Washington proposed that a canal be dug through Cape Cod as a military defense and trade route. In May of that year, the Massachusetts General Court, then acting as the colonial legislature, passed a resolution to study the feasibility of building a canal:

> *Whereas, it is represented to this court that a navigable canal may without much difficulty be cut through the isthmus which separates Buzzards Bay and Barnstable Bay, whereby the Hazardous Navigation round Cape Cod, both on account of the shoals and enemy, may be prevented, and a safe communication between this colony and the southern colonies be so far secured,*
>
> *Resolved That James Bowdoin and William Sever, Esqrs., with such as the Hon. House shall join, or the major part of them, be a committee to repair to the town of Sandwich, and view the premises, and report whether the cutting of a canal as aforesaid be practical or not.*

An engineer named Thomas Machin was appointed to survey the Sandwich area and make recommendations on the digging of a canal. Machin, however, was called back to active duty by General George Washington, but parts of his survey were presented to the general court. Machin's was the first recorded survey on record regarding the building of a canal through Cape Cod, and although it was practically universally agreed that the building of a canal would substantially eliminate the number of ships lost at sea, reduce shipping insurance, increase the speed of the journey, eliminate delays due to storms and reduce the loss of life and property, the actual digging of the proposed waterway floundered until the early 1900s. In August 1776 James Bowdoin, on behalf of the committee designated to study the idea, reported back to the general court:

> *If there be sufficient depth of water on that part of Buzzards Bay, your Committee are of the opinion that cutting a navigable canal across the said isthmus, is very practicable, and would be of great security to the navigation to and from the southern United States, not only against the enemy, but by affording the means of avoiding the dangers of the shoals, in passing around Cape Cod.*

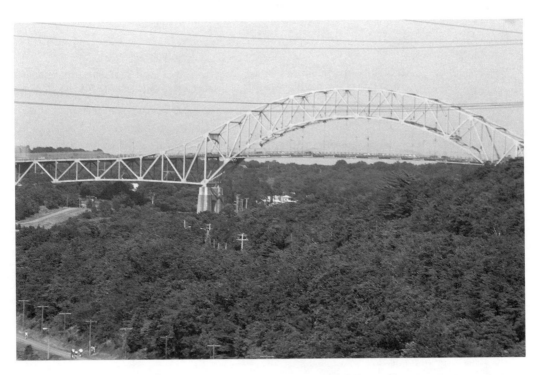

The Bourne Bridge today is one of two bridges connecting travelers from the mainland to Cape Cod. *Courtesy of Nate Conway.*

Despite this, Bowdoin went on to recommend that the entire idea of building a Cape Cod Canal be forwarded to the Continental Congress for deliberation.

In an unsigned letter to the editors of a 1791 edition of the *Massachusetts Magazine*, a monthly review of literature, history and politics, the unknown author voiced the continued and obvious concern about the necessity to build a canal through Cape Cod:

> *It has been in contemplation to cut a Canal (through the northerly part of the town of Sandwich) across the Cape so as to save the circumnavigation of it, and the dangerous passage over the shoals of Nantucket. Could this scheme be executed, it would be vast saving to the commerce and lives of the inhabitants of the United States, as well as foreigners….Not a year revolves without the loss of many vessels and lives passing the shoals and Cape, which might be prevented by the execution of this plan…If this scheme in practicality is an object worth the attention, not merely of one, but all the United States. The motives of humanity and interest are wholly in its favor…Whether it will ever be accomplished time must reveal.*

It took another century before it was accomplished.

The Sinking of the *General Arnold*

The sinking of the *General Arnold* off the coast of Cape Cod in 1778 was one of the worst maritime disasters in that area. More people died in this single shipwreck than in the first horrible winter suffered by the Pilgrims in 1620.

There is no way to account for the number of lives lost before the canal was ultimately built, and yet, not even a tragedy like the sinking of the *General Arnold* in Plymouth Harbor could propel the people of Massachusetts to action in 1778.

The *General Arnold* was sailing from Boston Harbor on Christmas Eve 1778, bound for the West Indies, when a snowstorm hit. The ship had barely made it to Cape Cod. The captain of the vessel, James Magee, headed for Plymouth instead of trying to fight the storm around the point of the Cape. Magee managed to find the outer reaches of Plymouth Harbor in the blinding snowstorm, and he anchored his ship less than a mile from the Gurnet Lighthouse. By midnight the storm had turned into a full-blown gale and the ship was listing in the pounding waves that washed over its decks.

Magee prepared his ship for the worst. He brought most of the ship's twenty cannons below deck, lowered the topmasts and secured his sails. Extra cables were tied to the anchor to secure the vessel and every other precaution imaginable was taken to secure the ship from danger. But it did little good against the fury of the gale.

At the height of the storm, the anchor broke free and the ship began to toss and spin its way dangerously toward the shoals around Plymouth Harbor. With his crew readied on deck, Captain Magee waited for his ship to hit bottom. With a loud, thunderous crash the *General Arnold* smashed into the ocean floor.

Magee ordered his crew to cut away the masts in the hopes of saving the ship. His men scrambled down the hatchway to get axes and saws, but instead of returning with their tools the crew broke into the liquor barrels down below and began drinking. By the time Magee managed to round them up again, most of them were drunk. On deck, the waves crashed over the sides and the ship sank deeper into the sandy bottom.

Magee managed to roust his crew on deck and finally the masts were cut away. The crew settled below deck hoping to ride out the storm through the night, but it wasn't to be. The *General Arnold* took a massive beating. The gale was at its full peak, battering the ship and crew severely. First slowly, and then with a sudden torrent, water poured in through the beams and seams of the ship. The crew, 105 men and boys, raced from below to the top quarter deck for safety. There was not enough room for all of them, so many had to lie on top of each other. A sail was stretched over the crew to protect them from the storm as the ship sank deeper.

By sunrise, the storm still had not let up and it appeared to be picking up even more intensity. The snow was falling in blinding sheets and the icy waves crashed over the deck. Several of the crew, unable to move beneath the weight of the sail that covered them and the bodies of their fellow crew members on top of them, suffocated where they lay.

Captain Magee knew the end was near and he tried as well as he could to prepare his crew. He issued out portions of the rum from below deck and ordered the men

to pour some of the alcohol into their boots to keep their feet from freezing. During the remainder of the day the crew fought heroically to save their lives and ship from the fury of the raging, icy sea. The water on the main deck had risen to nearly a foot deep. If the sea rose further the ship would go down. But, as the last rays of daylight disappeared, the tide turned. The receding waters gave the crew renewed hope. It was not the sea that now threatened them, but it was the bitter cold wind that froze them in their soaking clothes. Although they struggled to keep awake, keep warm and stay alive through the long, cold night, by the next morning nearly thirty men had died, either frozen to death, suffocated or been swept off the sinking vessel.

At dawn's first light, with the storm slowly ending and the waters receding, Magee ordered a rescue boat over the side. Three volunteers rowed away from the *General Arnold* in search of help, but they never returned. It was reported from survivors of the wreck that the three rowed out as far as they could before hitting solid ice about a half mile away. They climbed out of the small boat and took off on foot across the frozen harbor. They were never seen again.

In the hopes of attracting help from the Plymouth mainland, Magee ordered the crew to build fires on deck and to hoist distress flags on every available mast or rigging. It did not matter. The residents of Plymouth had been watching the plight of the *General Arnold* for hours and had frantically tried to reach the wreck by boat. The boats were unable to break through the heavy ice floes and returned to shore. They, like the crew of the ship, could do nothing but wait for the end to come.

That night was the beginning of the end for the ship and its crew. The temperatures fell to below zero and the frigid wind picked up fury. The icy wind and cold swept over the ship, and during the night more than half of Magee's remaining crew died.

The survivors worked desperately to save themselves. They stacked the dead bodies of their comrades in a circle around them to make a human barrier against the wind and cold. They huddled in a circle together with their legs draped over one another, each man shaking his frozen legs as best he could to keep the circulation going. Magee issued the last of the rum. Some drank; some poured it over their hands and into their boots. The alcohol would help stave off the cold. Through the night, the remaining crew kept one another awake. Drifting off to sleep meant certain death.

By morning, the deck of the *General Arnold* was scattered with the dead and dying members of the crew. Some lay dead in the exact positions where they fell. Others were frozen to death standing or sitting, their hands cupped, their legs stretched out. Magee and the remaining survivors continued to fight to stay alive through the long, cold day. By noontime, their prayers were at last answered. Although originally thwarted in their rescue attempts from shore, men from Plymouth had not given up hope of saving the crew. During the night and day they had inched their way out through the ice floes and were now within sight of the wreck. Using small boats and sleds they made their way to the ship.

What awaited the rescuers on board the *General Arnold* was a sight of gruesome terror. Victims were scattered along the deck, huddled and sprawled, some dead, some living and some barely alive. There had been a dozen Cape Cod men on board the ship. One

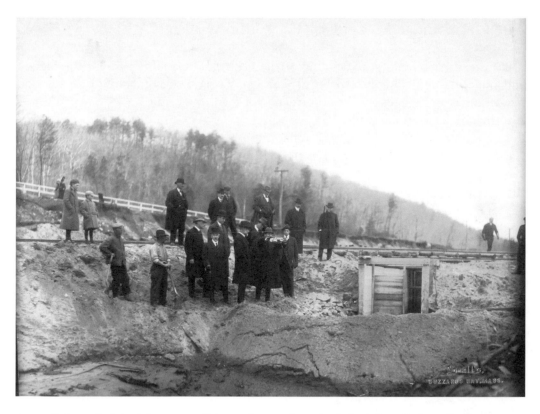

August Belmont Jr. joined the waters of the two bays to show that indeed Cape Cod was finally an island. *Courtesy of the Town of Sandwich Archives.*

of them, Barnabas Downs of Barnstable, was lying on the deck, frozen, barely alive and unable to move. As he heard the Plymouth rescuers climb onto the deck, he was not able to cry out and was fearful that he would be left behind for dead. Luckily, one of the rescuers saw Downs roll his eyes as he lay on the deck, and he was saved. Others were not so lucky. Only 33 of the *General Arnold*'s crew of 105 survived, and 9 of them died shortly after being brought ashore.

Captain Magee was the last to be rescued, choosing to stay on board the wreck until all his surviving crew had been taken off. Magee was still able to walk, and he attributed this to the rum he had poured into his boots to keep his feet from freezing. Sadly, others, who had chosen instead to drink their rum, died.

Magee was one of only fifteen survivors who fully recovered from the ordeal. Most of the others were crippled in some way. Barnabas Downs, the only Cape Codder to survive, never regained the use of his feet and he spent the rest of his life walking on his knees. A mass funeral for the dead was held at the Plymouth courthouse, and a mass grave for the seventy dead brought ashore was dug in the Plymouth town cemetery.

It was not until 1862 that a monument was erected to the seventy who died on board the *General Arnold* in one of the worst shipwrecks in Plymouth Harbor's history.

THE GEOLOGICAL MAKEUP OF CAPE COD

The history surrounding the building of the Cape Cod Canal is perhaps the biggest and longest-lasting example of political inertia in Massachusetts state history. Cape Cod today is an island because of the construction of the Cape Cod Canal—one of the *only* man-made islands in the world.

It is estimated that more than a million tourists from all over the world visit the Cape Cod Canal each summer, but there is a good chance that not many of them ever notice the white quartz monument once located at the end of the Sagamore Bridge and now moved to a sightseeing location along the banks of the canal in one of the many Army Corps of Engineers park-and-view sites. The monument is dedicated to New York financier August Perry Belmont Jr., the man responsible for building the Cape Cod Canal.

Beginning in 1909, and using two hundred Italian laborers from Boston, Belmont's company, the Boston, Cape Cod and New York Construction Company, began work on the canal. Five years later, on July 29, 1914, the Cape Cod Canal was officially opened.

At a cost of more than $11 million, approximately 14 million cubic yards of sand, stone, clay and boulders were excavated. At its grand opening, the canal measured 13 miles long, 25 feet deep and 100–250 feet wide—the widest artificial waterway in the country. Since its completion, the canal has served as a commercial shipping route, a military defense system and, ultimately, as one of New England's most popular tourist attractions.

To understand the history of the building of the canal, one must understand the geological makeup of the region. By knowing the sum and substance of the landmass of the Cape, one may better understand the enormity of undertaking the building of the Cape Cod Canal.

Thoreau wrote:

> Cape Cod is the bared and bended arm of Massachusetts; the shoulder is at Buzzards Bay; the elbow, or crazy bone, at Cape Mallebarre; the wrist at Truro; the sandy fist Provincetown,—behind which the state stands on her guard, with her back to the Green Mountains, and her feet planted on the floor of the ocean, like an athlete protecting her Bay,—boxing with northeast storms, and, ever, and anon, heaving up her Atlantic adversary from the lap of the earth,—ready to thrust forward her other fist, which keeps guard the while upon her breast at Cape Ann.

The Cape is a long and narrow hook-like peninsula jutting out into the Atlantic Ocean off the southeastern coast of Massachusetts. The Cape peninsula is approximately sixty-five miles long and is, at its widest point, nineteen miles wide. It is a watery stretch of land, riddled with nearly five hundred ponds and lakes of various sizes and shapes. One-third of Cape Cod is, in fact, made up of ponds.

Cape Cod is approximately eighteen thousand years old in geologic time. It evolved from the melting glacier that was once New England as it slid slowly from its

northernmost points into the sea. The geologic history of Cape Cod mostly entails the progress and departure of the continental glacier known as Laurentide. This happened approximately twenty-five thousand years ago. This glacier advanced to its outermost point of what are now the islands of Nantucket and Martha's Vineyard and then slowly began to melt away. As it began to melt away, the glacier left behind rock fragments called "drift." This material settled over the bedrock. Unstratified drift, known as "glacial till," is made up of a mixture of earth particles ranging in size from the smallest particle of dirt to good-sized boulders. The glacier melt also left behind what is known as stratified drift, made up of sand, gravel and clay. Much of Cape Cod is made up of this soil content, called "outwash plains," which formed when the glacier melted, turned into streams and receded, leaving behind its deposits.

These outwash deposits formed an extremely asymmetrical and obtrusive landscape called "kame and kettle" terrain. Kame is a knoll or small hill composed of outwash deposits. When the glacier melted, the outwash settled to form a higher landmass. When outwash settled around or over the glacier points and then melted away, the deposits settled to form a hole, or kettle. These kame and kettle, high and low landmass deposits, form what is now Cape Cod. Huge boulders, another byproduct of the glacial ice age, are all across the Cape Cod landscape.

One of the most celebrated of these glacial boulders is Doane Rock in Eastham. It is the largest exposed glacial boulder on Cape Cod. It protrudes above the otherwise level ground surface of the Eastham plain. In 1644, Deacon John Doane became one of the first settlers of Eastham. He was a prominent member of the Pilgrim Church. During its early settlement, the land in Eastham was rich and fertile, but because the soil was exhausted through farming and land clearing, it led to an otherwise barren landscape where Doane Rock now stands.

Henry David Thoreau wrote in *Cape Cod*:

> *It is remarkable that the Pilgrims (or their reporter) describe this part of the Cape, not only as well wooded, but as having a deep and excellent soil, and hardly mention the word sand. Now what strikes the voyager is the barrenness and desolation of the land…We did not see enough black earth in Provincetown to fill a flower-pot.*

According to a geologic history of Cape Cod by Robert N. Oldale of the U.S. Geologic Survey, Woods Hole Field Center, Massachusetts:

> *Before the landscape was well covered with vegetation, winds blowing across the barren glacial deposits, including material from the exposed bottoms of drained glacial lakes, picked up sand, silt, and clay and deposited this material as a thin almost continuous blanket on the drift surface. Stones lying on the drift surface were cut, faceted, and polished by sand blasting. These stones, called ventifacts, have been moved into the windblown layer by frost action. They are distinctively shaped and some have been mistaken for tools of Indian origin.*

According to Oldale, this windblown material makes up most of Cape Cod soil. The abundance of this sandy soil and its shift gave rise, literally, to the great sand dunes on Cape Cod. Exquisite examples of these dunes are seen in Provincetown, Truro and on Sandy Neck Beach in Barnstable. Robust onshore winds also carry sand inland where it is deposited and creates dunes. Some sand dunes reach heights of fifty to one hundred feet. These dunes also suffer from the onslaught of the coastal winds. Where the sandy hills are unprotected by any form of vegetation, they continually change in size and shape. Many geologists and others, among them Oldale, insist that erosion on Cape Cod by sea currents and wind will eventually lead to the depletion of the Cape Cod landmass.

Oldale notes:

> *The cliffed ocean side of lower Cape Cod loses about 5 acres a year to marine erosion. New land constructed from this eroded material averages about 1 acre a year. Thus for each acre lost, less than half an acre is gained. Estimates for other parts of the Cape may vary greatly from this figure.*

To the east of Cape Cod lies the Atlantic Ocean. To the south, Nantucket Sound. Cape Cod Bay lies nestled within the flexed arm, while the canal runs in a northeast line through what once was a part of southeastern Massachusetts. From its beginnings, where the Bourne and Sagamore Bridges connect the mainland to the rest of Cape Cod, the bare and bended arm remains one long stretch of exquisite beaches with sandy dunes, scrub pines and pounding surf.

THE EARLY SETTLEMENTS OF CAPE COD

Cape Cod Bay is formed by the Cape's mainland seacoast to the north. Buzzards Bay is to the west of the Cape Cod shoreline. To the south is Nantucket Sound where the larger islands of Nantucket and Martha's Vineyard are located. The Elizabeth Islands, a chain of small islands, extend southwest from the southern coast of Cape Cod. Located there is the town of Gosnold, with a population of eighty-six, making it the least populous town in Massachusetts. These islands were discovered in 1602 by the English explorer Bartholomew Gosnold. The town was first settled in 1641 and was officially incorporated in 1864.

Cape Cod is made up of three distinct sections. The "Upper Cape" is the section of Cape Cod closest to the mainland and includes the towns of Bourne, Falmouth, Mashpee and Sandwich. Bourne was first settled in 1640 and was officially incorporated in 1884. The Cape Cod Canal bisects the community with both the Bourne and the Sagamore Bridges and the lift railroad bridge.

Falmouth was first settled in 1660. Early residents were farmers, and many of them served in the militia and defended the town from British attacks during the Revolution and the War of 1812. Its residents prospered from coastal trading and whaling.

Falmouth is the home of the renowned Woods Hole Oceanographic Institution, a private, nonprofit research facility dedicated to the study of marine science. It is the largest independent oceanographic institution in the world. Also of some note: Katharine Lee Bates, the author of the lyrics to "America the Beautiful," was born and lived in Falmouth.

Mashpee was first settled in 1660. It has four of the largest freshwater ponds on Cape Cod.

Sandwich was settled in 1637 and is the oldest town on Cape Cod. Located on both sides of the Cape Cod Canal, the majority of its population and landmass is on the southerly side of the canal. Sandwich Village, a world-renowned tourist destination, is located there.

While part of the city of Barnstable can be considered to be located on the Upper Cape, it is more commonly thought to be in the "Mid-Cape" area. The Mid-Cape includes the towns of Barnstable, Dennis and Yarmouth. Barnstable, formed in 1685, is the county seat. It is located on the bicep of the Cape Cod arm, bordered by Cape Cod Bay on the north, Nantucket Sound on the south, Sandwich and Mashpee on the west and Yarmouth on the east. It includes seven villages: Barnstable, Centerville, Cotuit, Hyannis, Marstons Mills, Osterville and West Barnstable.

Dennis was first settled in 1639 and incorporated in 1793. The town is named in memory of the Reverend Josiah Dennis, who served as pastor of the town's principal

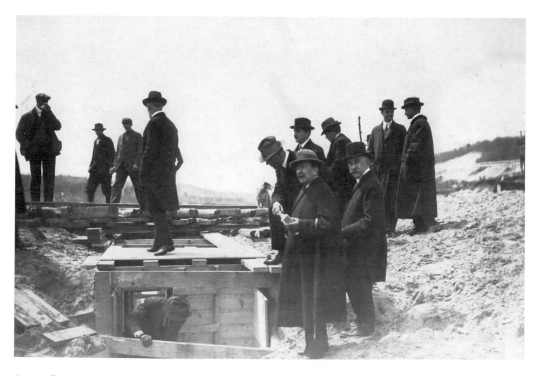

August Belmont Jr. ceremoniously joined the waters of the Cape Cod and Buzzards Bay prior to the grand opening of the canal. *Courtesy of the Town of Sandwich Archives.*

church for thirty-seven years. It is estimated that the ponds in Dennis cover an area of over 450 acres.

Yarmouth was first settled in 1639. One of the more interesting historical facts of the Mid-Cape region is that Kalmus Beach, in Hyannis, received its name from Herbert Kalmus and his wife Natalie. This husband-and-wife team was the creator of "Technicolor," a three-strip color film process invented in the 1930s by their company, Technicolor Corporation. Kalmus and his wife bequeathed this beach land to the Town of Barnstable on the condition that it never be developed. It is considered one of the earliest efforts of open-space preservation in the country.

The "Lower Cape" is the narrower portion of Cape Cod, bending to the north. This area includes the towns of Brewster, Chatham, Eastham, Harwich, Orleans, Provincetown, Truro and Wellfleet.

Brewster was first settled in 1656. Established in 1803, the town encompasses approximately twenty-three square miles, including over 325 acres of beach and marshlands, with twenty-four ponds larger than 10 acres in size.

Chatham was incorporated in 1712. In the 1690s, seventeen families lived in Chatham, and that number slowly grew to fifty families in the early 1700s. It was first established as Constablewick in 1696 and the settlement belonged first to Yarmouth and then to

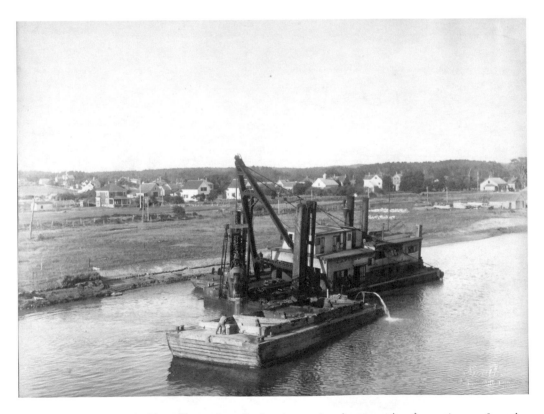

Barges and dredges worked in endless unison digging the canal and transporting the earth away from the site. *Courtesy of the Town of Sandwich Archives.*

Eastham. Chatham's early prospects were not promising. The first hundred years of recorded history reveal a struggle to establish an economy and a stable population on the Cape.

Eastham was first settled in 1644. It was originally home to the Nauset Indians, but in 1644, Plymouth Colony sent a seven-man delegation to scout Eastham for a new site for the center of government. Although no decision to move was made, the seven members of the delegation brought their families and established a new town. In 1651, Eastham was incorporated by this group of Pilgrims.

Harwich was first settled in 1670. It is widely known for its cranberry bogs and also has the largest lake on the Cape, called Long Pond. The pond serves as a private airport for planes with the ability to land on water.

Orleans was first settled in 1693. It became incorporated in 1797 after seeking independence since 1717. Saltworks were located on the bay there. The Nauset Indians were native to the area. The present Nauset Heights area was the farming site of the Native Americans. The Nausets taught the settlers about shell fishing, which became a major economic source for the area.

Truro was first settled in 1700 and was officially incorporated in 1709. The town lost its chance at a place in the country's history when one of the Pilgrims from the *Mayflower* decided not to stay in the rolling hills and moors that might have reminded him of home and instead followed Captain Myles Standish to the area across the bay that became Plymouth Bay Colony. Farming was the basic way of life for the settlers of Truro, but shore whaling soon became a big part of its economy. Deep-water whaling offered new economic opportunities, and for a while Pamet River Harbor became a center for whaling. In October 1841 a great storm virtually wiped out the Truro fishing fleet, sinking seven of the eight boats in the fleet and killing fifty-seven whalers, both men and boys.

Wellfleet was incorporated in 1763. It was first discovered in 1606 when French explorer Samuel de Champlain explored and named it "Port aux Huîtres" (Oyster Port). It originally developed as part of neighboring Eastham, achieving town status after nearly thirty years of petitioning. Despite Wellfleet's obvious oyster riches, it was mainly a whaling town in the years before the American Revolution. During the Revolution, Wellfleet's harbor was blockaded, forcing the residents to take up commercial fishing.

Provincetown was incorporated in 1727, but it had been a safe harbor for ships for nearly a century. Samuel de Champlain visited Provincetown as early as 1605, and in 1620 the Pilgrims signed the Mayflower Compact in Provincetown Harbor. The Pilgrims decided to settle across the bay in Plymouth. Provincetown was eventually settled as a fishing village in 1700. Provincetown grew rapidly as the fishing and whaling center of Cape Cod. By the early decades of the twentieth century, the town had acquired an international reputation for its artistic and literary output. To this day, Provincetown continues to be a working site for many artists, and galleries can be found throughout the town.

REAL CAPE COD CHOWDER

For seafood lovers, Cape Cod remains the home of clam chowder. True Cape Cod chowder is made solely from clams, clam juice, potatoes, onions, milk and butter. Not a bit of flour or cream is added. There are three tests you can conduct to determine whether you are eating authentic Cape Cod chowder. If you place your spoon in the middle of the bowl and the spoon stands on its own, you can be sure it is not Cape Cod chowder. Flour has been added to give it density. If the potatoes in the chowder are uniformly diced, this too is a dead giveaway that you are not eating authentic Cape Cod chowder. The potatoes in authentic Cape Cod chowder come in every sort of size and shape. Lastly, should you ever find a tomato in your chowder it is definitely not authentic Cape Cod chowder. Only New York clam chowder has tomatoes in it.

Gosnold Discovers Cape Cod

Captain John Sears, of Suet, was the first person in this country who obtained pure marine salt by solar evaporation alone; though it had long been made in a similar way on the coast of France, and elsewhere. This was in the year 1776, at which time, on account of the war, salt was scarce and dear...Quite recently there were about two millions of dollars invested in this business here. But now the Cape is unable to compete with the importers of salt and the manufacturers of it at the West.

—Henry David Thoreau, Cape Cod

It was English adventurer Captain John Smith, most noted for founding the first colony in Jamestown, who gave New England its name. In 1614, Smith set his sights on what he called "Virginia." This included all the land stretching up the Atlantic Coast from Jamestown to Canada. Although Smith told investors he was in search of gold, he was, in fact, seeking to establish ties to the Native American tribes for trading in furs, for farming and for timber. He left England with two ships, the *Frances* and the *Queen Anne*, armed with fishing equipment, and made a brief six-month journey to New England.

Landing in parts of Maine, Boston Harbor, Plymouth and Cape Cod, Smith found a bountiful treasure in fish, fish oil and furs that he brought back with him to England. Smith had sailed from Nova Scotia to Rhode Island, and he sketched the first precise map of New England. This, too, he brought back to England.

Smith intended to return to New England and establish the first colony there where his settlers would fish, hunt for fur and cut timber. He planned to establish a working relationship with the Native American tribes he had encountered. In 1615, he again set sail for New England, but he never came close. Both ships he commanded were ravaged by storms, and he never again returned to New England.

Still, his opinions of New England and especially the Cape Cod coast remained intact. Captain John Smith was more forward thinking than most. He envisioned his New England colony being much more than a foothold in the New World. Although he

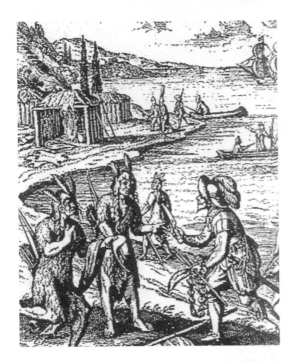

Bartholomew Gosnold developed good
relationships with the Cape Cod Indians.

understood the potential in the fishing industry that Cape Cod and all of New England
offered, he knew that fish wasn't the only vital commodity available to the settlers.

Smith had observed the Native Americans trek north and west into the Great Lakes
region to hunt for fur, beaver and otters. He was also aware that the sandy Cape
Cod soil would support many crops. The Native Americans grew deep fields of corn.
Farming, he imagined, would be another rich and plentiful resource. The timber on
the Cape also captured Smith's industrious imagination. He envisioned using it to build
forts and homes and as a source of energy for the iron forges.

But Smith's view of the New World was not so readily adopted by the English royalty
and investors who financed his voyages to America. They sought gold, and Smith long
argued that gold was not what New England offered. His investors did not want to hear
about his plans for growing crops or harvesting timber. They did not wish to develop
friendly relationships with the Native Americans. His benefactors wanted gold and nothing
less would do. His royal investors subsequently abandoned Smith, leaving him stranded in
England.

According to Smith, the region was "the Paradise of all those parts: for here are
many isles all planted with corn; groves, mulberries, savage gardens, and good harbors:
the Coast is for the most part high clayey sandy cliffs." Smith's book, *A Description of
New England*, published in London in 1616, was the first time the name New England
was used in association with the region. In the publication, Smith took great pains to
set about describing Cape Cod:

> *Cape Cod is the next paradise itself: Which is only a headland of high hills of sand,
> overgrown with shrubby pines, hurts and such trash; but an excellent harbor for all*

weathers…I found thirty fathom water aboard the shore and string current: which makes me think there is a channel about this shoal; where is the best and greatest fish to be had, winter and summer, in all that country.

GOSNOLD'S DISCOVERY

Bartholomew Gosnold, known as "the Columbus of New England," is credited with being the first Englishman to set foot on Cape Cod. Others speculate that he may have been the first Englishman to establish the first permanent settlement in the New World in Jamestown, Virginia, in 1608. Gosnold is credited with not only discovering and naming Cape Cod, but also with the discovery and naming of Martha's Vineyard and the Elizabeth Islands.

In March 1602 Bartholomew Gosnold sailed from Falmouth, England, in a small ship named the *Concord*. Gosnold's expedition intended to establish a trading post in America. He took with him a small crew of eight sailors and twelve explorers, along with twenty other men who agreed to remain at the trading post that was to be built and stocked before the ship returned to England. Approximately fifty days later, the *Concord* made landfall on the southern coast of what is now Maine. Gosnold then sailed south until he reached a peninsula at the mouth of a large bay teeming with codfish. A record of Gosnold's expedition was kept by Gabriel Archer, a lawyer, who accompanied him. Archer's account of the discovery of Cape Cod was published in 1625 in *The Relation of Captain Gosnold's Voyage.*

> *The fifteenth day we had again sight of the land, which made ahead, being as we thought an island, by reason of a large sound that appeared westward between it and the main, for coming to the west end thereof, we did perceive a large opening, we called it Shoal Hope. Near this cape we came to fathom anchor in fifteen fathoms, where we took great store of codfish, for which we altered the name, and called it Cape Cod. Here we saw sculls of herring, mackerel, and other small fish, in great abundance. This is a low sandy shoal, but without danger, also we came to anchor again in sixteen fathoms, fair by the land in the latitude of 42 degrees.*

Gosnold anchored off Cape Cod near Provincetown. His men at first called it Shoal Hope, but it was later renamed by Gosnold as Cape Cod because of the massive schools of codfish found there. For the next three weeks, Gosnold and his men explored inland as far as Wellfleet. Gosnold built a fort and traded with the Native Americans. Gabriel Archer recorded glimmering accounts of the Cape's abundant natural resources. Gosnold and his men regularly bartered and ate with the Native Americans. The relations were friendly and peaceful and the Native Americans were helpful in showing Gosnold and his men where to find food and other resources. Archer wrote:

This cape is well near a mile broad, and lieth north-east by east. The captain went here a shore and found the ground to be full of pease, strawberries, whortleberries, &c., as then unripe, the sand also by the shore somewhat deep, the firewood there by us taken in was of cypress, birch, witch-hazel and beech. A young Indian came here to the captain, armed with his bow and arrows, and had certain plates of copper hanging at his ears; he showed a willingness to help us in our occasions.

After exploring the Cape, Gosnold sailed around the ocean side where he discovered an island. Gosnold and a few of his men went ashore where, according to Archer's journal,

we found it to be 4 English miles in compasse, without house or inhabitant, saving a little old house made of boughes, covered with barke, an old piece of [fish weir] *of the Indians to catch fish, and one or two places where they had made fires.*

The island was covered with the wild fruit of raspberries, gooseberries and huckleberries. Gosnold named it "Martha's Vineyard" in honor of his daughter. Archer wrote:

From this opening the main lieth south-west, which coasting along we saw a disinhabited island, which so afterward appeared unto us: we bore with it, and named it Martha's Vineyard; from Shoal Hope it is eight leagues in circuit, the island is five miles, and hath 41 degrees and one quarter of latitude. The place most pleasant; for the two-and-twentieth, we went ashore, and found it full of wood, vines, gooseberry bushes, whortleberries, raspberries, eglantines, &c. Here we had cranes, stearnes, shoulers, geese, and divers other beards which there at that time upon the cliffs being sandy with some rocky stones, did breed and had young. In this place we saw deer: here we rode in eight fathoms near the shore which we took great store of cod,—as before at Cape Cod, but much better.

A few days later, Gosnold and his men explored another nearby island. They named this island "Elizabeth Island" in honor of the queen. Today it is called Cuttyhunk. During their three-week stay on Elizabeth Island, Gosnold and his men stored a quantity of sassafras, cedar and furs to bring back to England to pay for the cost of the voyage. When it came time for Gosnold to sail home to England, the men who agreed to stay behind at the trading post had a change of mind and returned to England with Gosnold and the rest of the crew.

Part of Gosnold's goal was to gather sassafras, which was a highly prized commodity in England because it was erroneously thought to have curative powers for syphilis. The New World then abounded with the so-called sassafras wonder drug. It did not cure syphilis as many thought, but its roots and leaves were good for cooking and in making a drink later named "root beer."

Although Gosnold failed in his objective of establishing a trading post in the New World, he succeeded in discovering Cape Cod, Martha's Vineyard and the Elizabeth Islands, and through the publication of the journals of Archer and Brereton, the exploits

of his expedition further fueled the English desire to colonize the New World. Thirteen years later the Pilgrims, sailing on the *Mayflower* in the hopes of establishing religious freedom and surviving on fishing and farming, landed in Provincetown Harbor off the coast of Gosnold's Cape Cod.

Bartholomew Gosnold's Cape Cod discovery was his first New World expedition, but it was not his last. In 1608 he sailed as second in command on the expedition to establish the first permanent English settlement in Jamestown, Virginia. He was named vice admiral of the Jamestown expedition and was one of the six members of the original governing council that helped design James Fort. Second in command to the famous Captain John Smith, he was responsible for trying to maintain order and industry among the Jamestown colonists. He died of malaria three months after landing in Jamestown, where he was ceremoniously buried.

Edward Wingfield, the first president of the Jamestown Colony, expressed grief over Gosnold's death, remembering him as "the worthy and religious gentleman, Captain Bartholomew Gosnold, upon whose life stood a great part of the good success and fortune of our government and colony."

ENCOUNTERS WITH THE CAPE COD INDIANS

Gosnold encountered the Nauset Indians when he first landed on Cape Cod. According to Archer, the encounters with the Cape Cod Indians were peaceful and friendly. Based on the reception the Native Americans gave Gosnold and his men, and on the fact that some of the Nausets spoke Christian words, Archer projected that they were not the first "white" men to have encountered the tribe. Archer surmised in his journal, which was not published until 1625, that the Native Americans had previously encountered European explorers, although Gosnold and his explorers were surely the first Englishmen to set foot on the sandy soil of the Cape.

> *After signs of peace, and a long speech by one of them made, they came boldly aboard us, being all naked, saving about their shoulders certain loose deer skins, and near their wastes seal skins tied fast...They spoke divers Christian words, and seemed to understand much more than we...These people are in color swart[hy], their hair long, uptied with a knot... They paint their bodies, which are strong and well-proportioned. These much desired our longer stay.*

Gosnold described both the Cape and the Native Americans in a letter he wrote to his father in September 1602:

> *We cannot gather, by anything we could observe in the people, or by any trial we had thereof ourselves, but that it is as healthful a climate as any can be. The inhabitants there, as I wrote before, being of tall stature, comely proportion, strong, active, and some of good years, and as it should seem very healthful, are sufficient proof of the healthfulness of the place.*

John Brereton, a clergyman who accompanied Gosnold and Archer on the Cape Cod expedition, and who also kept a journal of the event, described the Cape Cod Indians:

> *These people, as they are exceeding courteous, gentle of disposition and well-conditioned, excelling all others that we have seen; so for shape of body and lovely favour, I think they excell all the people of America; of stature much higher than we; of complexion or colour much like a dark Olive; their eybrowes and haire blacke, which they wear long, tied up behind in knots, whereon they pricke feathers of fowles in a fashion of a crownet* [coronet].

The journals of Archer and Brereton and the letters of Gosnold show a new world (Cape Cod), fertile in resources of animals, birds, plants and timber, and populated by attractive people who lived in peace and harmony with the natural order of their native world.

The poet Benjamin Drew preserved Gosnold's discovery in verse:

> *Old Neptune heard the promise made,*
> *Down dove the water-god—*
> *He droveth meaner fish away*
> *And hooked the mammoth god.*
> *Quick Gosnold hauled. Cape…Cape…*
> *Cape Cod!*
> *Cape Cod! the crew cried louder;*
> *Here, steward! take the fish along*
> *And give the boys a chowder!*

"Before we owned the land, the land owned us," New England poet Robert Frost wrote. There could not be more truth in this statement as it relates to Cape Cod. Long before English explorer Bartholomew Gosnold is credited with discovering Cape Cod in 1602, this "bared and bended arm" belonged to the Native Americans.

The Native American population in the early 1600s, prior to the English and European exploration and settlement of the New World, was approximately one million. The principal Massachusetts tribes included the Wampanoag, Narragansett, Massachuset, Nauset and the Saconnet.

The Nauset Indians, formerly an Algonquian tribe, populated much of Cape Cod, although they were under the rule of the Wampanoag sachem, both Massasoit and later King Philip. The Nausets were probably the first of the Massachusetts tribes to make contact with English and European explorers since Cape Cod was a frequent destination for travelers. When Bartholomew Gosnold landed on the island of Martha's Vineyard in 1602, he reportedly traded easily with the Native Americans there. Other explorers, notably the French explorer Samuel de Champlain, who led expeditions to Cape Cod in 1605 and 1606, described his encounters with the Cape Cod Indians as violent. His own reports told of bloodshed where both French explorers and Cape Cod Indians were killed.

Still later, when the Pilgrims landed in Provincetown Harbor, where the Mayflower Compact was created and signed, and before they decided to leave and ultimately settle in Plymouth, the Pilgrims explored the Cape in an effort to determine whether to settle there. The Pilgrims sent out three separate expeditions to explore the region and nearly had a confrontation with Cape Cod Indians. The near battle with the Native Americans was recorded by the Pilgrims as "the First Encounter." Despite these incidents, the Nausets remained peace loving.

THE NAUSET INDIANS OF CAPE COD

In the 1600s, the Nauset population on Cape Cod numbered approximately fifteen hundred. This was before the outbreak of the 1617 smallpox epidemic. By 1621 there were about five hundred Nauset Indians on Cape Cod. The Nausets did not join King Philip's Indian war confederacy in 1675—they were joined by the remnants of other New England tribes that were displaced at the end of King Philip's War or by increased English settlement. Another epidemic in 1710 diminished the tribe to approximately three hundred. Census reports show that there are currently a thousand members of the tribe left on Cape Cod.

By the time of the outbreak of King Philip's War in 1675, and because of their early and frequent contact with English and European settlers, many of the Nausets were Christianized. Beginning as early as 1640, the missionary John Elliot succeeded in converting most of the Nauset tribe to Christianity. Colonists were disposed to suspect all natives, whether Christian or not. The Nauset Indians were already secluded on Cape Cod. The colonists did not relocate the tribe after King Philip's War ended in 1676. The tribe's village was Nauset, near present-day Eastham. Although they sustained themselves primarily through fishing, they were also farmers, growing both corn and beans that they traded with the settlers.

The Nausets' first encounters with the earliest English explorers were harsh. The most treacherous was an encounter with the English Captain Thomas Hunt in 1614. Hunt captured twenty-seven Native Americans, including seven Nausets, and sold them as slaves in Spain. Slavery was the least of the atrocities committed by Hunt. Members of Hunt's crew were sick with smallpox and they infected the native tribes during their raids along the New England coast. The epidemic Hunt inflicted on the tribes spread like wildfire through the Native American population, killing nearly 75 percent of the tribes in New England from 1614 through 1617.

Another early incident might have dissuaded the Nausets from their otherwise peaceful nature toward the early settlers. When the Pilgrims anchored off Cape Cod in November 1620 before sailing to Plymouth and settling there, they sent a landing party ashore to search for food. The Pilgrims on board the *Mayflower* were running out of supplies after their journey. On shore, the Pilgrims' landing party reportedly came upon a Nauset burial site—victims of the smallpox epidemics. As was the Nauset burial custom, they had left ears of corn beside the graves. The landing expedition gathered the corn and began digging around for more. When the Nausets discovered

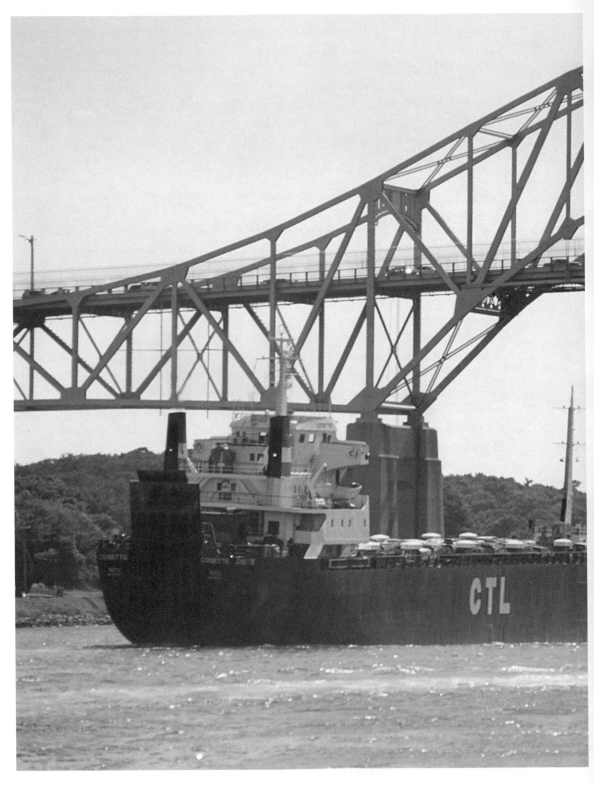

Huge oil tankers use the canal as a safe and reliable transportation route. *Courtesy of Nate Conway.*

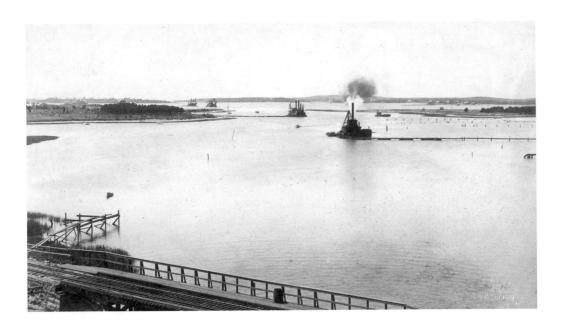

The huge railroad bridge allowed passengers to cross the canal by train. *Courtesy of the Town of Sandwich Archives.*

the desecration in progress, they attacked and sent the Pilgrims fleeing for the safety of the *Mayflower*. This was the Pilgrims' "First Encounter."

Although this early encounter made the Pilgrims wary of the Nauset tribe, the Wampanoag chief or sachem, Massasoit, helped smooth over the relationship between the settlers and the tribe. One incident, set in motion by a lost boy, helped seal the good relations between the Nausets and the settlers. In 1621, a young boy wandered off into the woods from Plymouth. He was found by a Nauset hunting party and taken to Truro, where the Nauset sachem Aspinet was. When the settlers learned that Aspinet had the lost boy, they arranged a meeting to get the boy back. Although the relationship between the settlers and the Nausets was still tense, the Pilgrims offered their apologies for taking the corn found at the burial site and the Nausets apologized for attacking them. Aspinet returned the boy, and following the incident, a strong friendship developed between the Pilgrims and the Nausets. During the Pilgrims' first hard and devastating winter at Plymouth, it was Aspinet, the Nauset Indian sachem, and Massasoit, the Wampanoag sachem, who brought food to the Plymouth colonists and saved many of them from certain starvation.

THE WAMPANOAGS

The Wampanoags' land stretched from Narragansett Bay in Rhode Island into most of Bristol County, Massachusetts. The most famous of the Wampanoag chiefs were Massasoit, who made a treaty of friendship with the early New England colonists, and

his second son, Metacom, who is known historically as King Philip. Massasoit, who is credited with helping the Pilgrims survive their first winter in Plymouth by bringing them food and furs and teaching them how to plant corn and about the many uses of codfish, faithfully observed the peace treaty he had made with the colonists. Following Massasoit's death in 1662, Metacom became chief or sachem of the Wampanoag tribe. For nearly ten years King Philip was accused of plotting against the colonists. Defiant, King Philip refused to acknowledge himself as a subject of the English king and he became the leading voice in the long struggle against English colonization of Native American land. Philip plotted against the colonists, made preparations for war, organized a confederacy of Native American tribes against the settlers and finally declared war against the English settlements. The Native Americans of Cape Cod and Martha's Vineyard generally remained faithful to the whites; the latter persistently refused to comply with Philip's solicitations to join him in the contest.

King Philip's War began in 1675 and lasted approximately two years, ending in the death of Philip and many of the chiefs of other Native American tribes. Out of the ninety settlements, fifty-two were attacked by Philip's warriors and twelve were completely destroyed. Despite inflicting great losses on the English settlers, the war was more disastrous to the Native Americans. The Wampanoag and Narragansett were practically exterminated, and many of the surviving Native Americans fled to other inland tribes. Native American villages were destroyed and many of the surviving Wampanoags and Narragansetts were sold into slavery. During the war, most of the Native Americans on Cape Cod, including the Nausets, remained faithful to the colonists, refusing to join in Philip's war confederacy.

It was not this war alone that diminished the power and population of the Massachusetts Indian tribes. In 1616, nearly sixty years before the outbreak of King Philip's War, a smallpox epidemic among the New England tribes nearly wiped out the Native American population from Maine to Rhode Island. By the time the Plymouth Bay Colony was settled in 1620, the Wampanoag were reported to have approximately thirty villages throughout the region and were stronger in number than before the epidemic nearly depopulated the tribes.

THE PILGRIMS

Almost twenty years after Gosnold's discovery of Cape Cod, the Pilgrims, sailing from Amsterdam, Holland, on board the *Mayflower*, dropped anchor in Cape Cod waters. The Pilgrims sighted Cape Cod in early November 1620 after sixty-six days at sea. Unable to navigate the treacherous shoals and sandbars along what is now the Chatham shore, they anchored safely in Provincetown Harbor. Following is an extract from the *Pilgrims' Journal*, 1620:

> *On the fifteenth day, we waighed Anchor, to go to the place we had discovered, and comming within two leagues of the Land, we could not fetch the Harbour, but were*

faine to put roome againe towards Cape Cod, our course lying West; and the winde was at North west, but it pleased God that the next day being Saturday the 16. day, the winde came faire, and wee put to Sea againe, and came safely into a safe Harbour; and within halfe an houre the winde changed, so as if we had beene letted but a little, we had gone backe to Cape Cod. This Harbour is a Bay greater than Cape Cod, compassed with a goodly Land, and in the Bay, 2. fine Ilands uninhabited, wherein are nothing but wood, Oakes, Pines, Wal-nut, Beech, Sasifras, Vines, and other trees which wee know not; This Bay is a most hopefull place, innumerable store of fowle, and excellent good, and cannot but bee of fish in their seasons: Skote, Cod, Turbot, and Herring, wee have tasted of; abundance of Musles the greatest & best that ever we saw; Crabs and Lobsters, in their time infinite. It is in fashion like a Cikle or Fish-hooke.

The Pilgrims were "Separatists." They wanted to be completely separate from the official Church of England. One of their beliefs was that they should be allowed to select their own church leaders and ministers. King Henry VIII started the independent Church of England known as the Anglican or Episcopal Church. Many people in England did not adhere to the teachings of this new church and desired the Anglican Church to be more like the old Catholic Church. Others wanted it to rely more on Bible teachings. Two major religious opposition groups formed: the Puritans, who wished to make the Church of England more pure and simple, and the Separatists or Pilgrims, who wanted nothing to do with the Church of England. When King James came to the throne of England, the Pilgrims thought they might finally be able to ask for permission to set up their own church, but their request was denied. It was at this point that the Pilgrims decided to leave England and move to Holland, where freedom of religion was accepted. But there were still problems. Pilgrim children wanted to speak Dutch instead of English and many of their English customs were being absorbed by the Dutch culture. After several years of living in Holland, leaders, notably William Bradford, made plans to sail for America where they could have religious freedom and maintain their English identity. The *Mayflower* left for America on September 6, 1620, and arrived in the New World, off the Cape Cod coastline, in November of that same year.

The original contract that the Pilgrims signed with the London Company in England called for them to put ashore much farther south than Cape Cod. Faced with no formal binding form of government to guide them, the forty-one male members of the *Mayflower* drew up and signed a far-reaching covenant that they would use to govern themselves and future settlements in the New World. The Mayflower Compact, the first and fundamental premise upon which all American government is based, was conceived on Cape Cod. That premise was, and remains, that the will of the majority will prevail:

We...do...covenant and combine ourselves together into a civil body politic, for our better ordering and preservation...and by virtue hereof, do enact, constitute and frame such just

*and equal laws, ordinances, acts, constitutions and offices, from time to time, as shall
be thought most meet and convenient for the general good of the colony, unto which we
promise all due submission and obedience.*

With the Mayflower Compact newly signed, Captain Miles Standish and an exploring party of sixteen men went ashore onto Cape Cod. Their first look at the Cape was uneventful. They found no signs of Native American inhabitants. The wilderness before them was dotted with scrub pines, sandy beaches and little else. On a second exploration, a small boat was put into the Cape waters and Standish and his crew explored the coast. They put ashore in what is now Eastham and camped there. On their approach to the shore, they saw a band of Native Americans cutting wood. Seeing Standish and the others, the Native Americans fled without incident.

The Pilgrims built a small fort on shore, secured the area and posted guards and lookouts. From their barricade they saw the smoke of Native American fires several miles away. The next morning Standish and his men explored farther inland and came upon an Indian burial site. The Native Americans had left ears of corn, berries and other foodstuffs as part of their burial custom. Standish and his men gathered up the food and dug through the burial site looking for more. They left with the corn and other food and returned to the *Mayflower*. That night hideous cries and war whoops were heard.

The Pilgrim sentries fired several shots that quelled the noise that night, but in the morning the same cries were heard again. Pilgrim guards barely had time to alert the rest of the men and women before a wave of arrows came flying out of the woods at them. The Pilgrims fired their muskets into the woods. Again the Native Americans fled, all except one who the Pilgrims surmised was the leader of the tribe. He hid behind a tree and fired three arrows at the barricaded Pilgrims. The Pilgrims fired back three times with the musket balls, hitting the tree where the chief was hiding. After this exchange the chief fled as well. There were no casualties on either side.

As brief and uneventful as the skirmish was, the Pilgrims recorded the event as "the First Encounter." There is a plaque erected at First Encounter Beach located at the end of Samoset Road in Eastham commemorating the Pilgrims' encounter with the Native Americans.

If it had not been for a blinding snowstorm that swept off the Cape Cod coast that November in 1620, American history might have been rewritten. After exploring Cape Cod for five weeks in November and December, the Pilgrims pulled up anchor in Provincetown Harbor and set sail in search of a safe harbor farther south. The *Mayflower* was hit by a blinding snowstorm that kept the Pilgrims from reaching the safety and beauty of Barnstable Harbor. Instead, they sailed through the storm and beyond Cape Cod, landing in Plymouth Harbor where the first permanent settlement in New England was established. The Plymouth Bay Colony experienced notably more peaceful relations with the Wampanoag Indians under the leadership of the sachem Massasoit. Massasoit taught the Pilgrims how to grow corn, the uses of herring and the delight of cranberries. It was Massasoit who helped keep the Pilgrims from starving to death during the colony's first year in Plymouth.

KING CRANBERRY

One of the most far-reaching gifts Cape Cod Indians gave to settlers was the cranberry. Today, the Cape Cod and Plymouth cranberry is king during the holiday seasons of Thanksgiving and Christmas. Most of the cranberries and cranberry products used throughout the country during these holidays come from Cape Cod and Plymouth, Massachusetts. The earliest use of cranberries by Cape Cod Indians was in pemmican, which was a sun-baked concoction made from deer meat and cranberries used by the Wampanoag Indians as a staple on long hunting trips. It was easy to carry, didn't spoil quickly and was a rich source of energy. Pemmican is still sold today in health food stores and is used by campers, hikers and long-distance bicyclists.

The legend of the cranberry goes back to the earliest Cape Cod history. The legend is that the Reverend Richard Bourne (Bourne, Massachusetts, was named after him) and a Wampanoag Indian medicine man named Cometommeba became embroiled in an argument about who had the most power, the reverend's God or the medicine man's Indian Spirits. In order to resolve the dispute, the Reverend Bourne and Cometommeba were placed in a pit of quicksand from which they could not escape.

During a two-week ordeal, each prayed to his god. The Reverend Bourne's prayers were answered when a snow-white dove flew to him, bringing him nourishment in the form of a plump, crimson berry—a cranberry. The medicine man conceded the spiritual duel.

Although the cranberry grew wild all over Cape Cod and was used by both Native Americans and settlers, it was not until the early 1800s that a Cape Cod farmer named Henry Hall began cultivating cranberries for commercial use. Hall discovered that by mixing beach sand into the soil the cranberry plants would flourish. Soon, farmers all over Cape Cod were growing the crimson berry.

> *There's nothing to me in foreign lands,*
> *Like the stuff that grows in Cape Cod sands;*
> *There's nothing in sailing foreign seas,*
> *Equal to getting down on your knees,*
> *And pulling the prizen ivy out.*
> *I guess I know what I was about,*
> *When I put down my chart and glass*
> *And took to growing cranberry sass.*
> *—Cranberry Picker's Chant, 1811*

Neptune Rushing

The white breakers were rushing to the shore; the foam ran up the sand, and then ran back as far as we could see (and we imagined how much farther along the Atlantic coast, before and behind us), as regularly, to compare great things with small, as the master of a choir beats time with his white wand; and ever and anon a higher wave caused us hastily to deviate from our path, and we looked back on our tracks filled with water and foam…The breakers looked like droves of a thousand wild horses of Neptune rushing to the shore, with their white manes streaming far behind.

—Henry David Thoreau, Cape Cod

In 1630, Massachusetts Governor William Bradford wrote, "Avoid the compassing of Cape Cod and those dangerous shoals, and so make any voyage to the southward in much shorter time and with far less danger." Ironically, one of the earliest proposals to build a canal through Cape Cod came from the Plymouth Bay Colony's leading military officer, Miles Standish. Standish made numerous trips down the coast to Cape Cod from Plymouth, where he learned from the Native Americans where he could portage (carry overland) his boats across the outermost shoulder of Cape Cod in order to avoid the dangerous shoals and tides. Standish suggested to his fellow Plymouth Bay colonists that a canal might be dug through the stretch of land connecting Cape Cod and Buzzards Bays as a means of avoiding the treacherous waters around the Cape and to reduce the amount of time and labor it took to transverse the peninsula. Standish's idea was given careful consideration, since trading with the Rhode Island Narragansett Indians, and later the Dutch colonists in New Amsterdam, was very profitable for the Plymouth Bay colonists. Although Plymouth Bay never built the proposed canal, they did establish a small trading post in 1627 in Manomet, along the shores of the Monument River in Buzzards Bay. The trading post was named Aptuxcet and the sole purpose of those assigned to the trading post was to navigate goods out along Narragansett Bay in Rhode Island and Long Island Sound.

The Pilgrims carried their goods and supplies by foot and in wagons along twenty miles of rough and hazardous terrain. The trip, despite the trading post, was slow and

arduous. Another route was tried. The Pilgrims discovered that it was faster to sail down from Plymouth to the Scusset River on Cape Cod. Sailing inland for about a mile, they were then able to portage four or five miles to the Monument River.

The founding of the Aptuxcet trading post, along with the founding of the town of Sandwich, forced settlers to scrutinize more carefully the need for a canal through Cape Cod. Desires to dig a canal came not only from traders to the north, but from Cape Cod landowners as well. Samuel Sewall, who lived in Sandwich, wrote in his diary in 1676: "Mr. Smith rode with me and showed me the place which some had thought to cut, for to make a passage from the south sea to the north."

THE TOWN OF SANDWICH

With the Pilgrims firmly established in Plymouth, the colonization of Cape Cod began, however slowly. The first permanent settlements on Cape Cod were not established until nearly twenty years after the landing of the Pilgrims in Provincetown Harbor.

Barnstable, Sandwich and Yarmouth were established first. In 1637, a land grant was made to Edmund Freeman and nine associates from Saugus, Massachusetts. Freeman was fifty years old when he and his fellow associates settled the town of Sandwich. They settled the town with the aim of "worshipping God and to make money." Freeman and his associates dedicated themselves to the "liberty to view a place to sit down."

A little more than a year after Freeman and the others settled the small town, a church was founded there. The Reverend William Leverish was the church's first pastor.

Sandwich, Cape Cod's first community, is rife with lore and legends. Among them is the tale of the famous German bell that rang over the village for many decades. Captain Peter Adolph, a German sea captain sailing from New York, shipwrecked off the coast of Sandwich in the early colonial period. His entire crew was lost at sea. The citizens of Sandwich recovered the bodies, and Adolph and his crew were given decent burials. Adolph's widow, to show her gratitude, sent the town of Sandwich a huge church bell. The bell was cast in Munich, Germany, and inscribed with the Latin phrase *Si Deus Pro Nobis, Quis contra Nos?* ("If God Be For Us, Who Can be Against Us?"). The bell hung for many years in the town hall spire and was ultimately sold to the town of Barnstable, where it went on display at the Barnstable County Courthouse.

Sandwich also distinguished itself as being the first Cape Cod community to protest slavery in 1773. The citizens of the town registered their protest with the government and demanded legislation forbidding the use of slaves. The Sandwich citizens also proposed that the children of slaves already living in the colonies were to be made free when they reached the age of twenty-one.

Edmund Freeman, the founder of Sandwich, was known as a restless soul. Freeman would travel the Cape on horseback with his wife Elizabeth riding along with him on a pillion, a cushion attached to the back of the horse's saddle. When Elizabeth died,

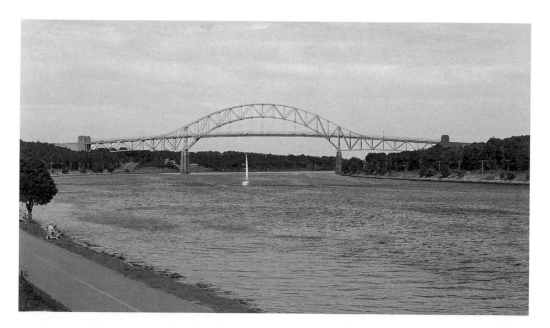

Today the Bourne Bridge is a Cape Cod landmark. *Courtesy of Nate Conway.*

just prior to their sixtieth wedding anniversary, Freeman marked her grave with a stone carving shaped like a pillion. He had erected next to it another stone, in the shape of a saddle, where he intended to be buried. The stone pillion and saddle have marked their graves in Sandwich ever since.

THE SANDWICH GLASSWORKS

One cannot write a history of Cape Cod without writing about the Sandwich glassworks. Deming Jarves, who was a glassmaker in Boston, traveled to Sandwich in 1824 for the purpose of doing some fishing and hunting. Jarves had inherited his father's glassmaking business after his father's death. He had envisioned ways to revolutionize the glass manufacturing industry and decided that Sandwich might be the perfect place to start because of the vast amounts of sand on the beaches and dunes of Cape Cod. Sand was, after all, a major component of the glassmaking business. A year after his fishing and hunting expedition to Sandwich, he opened the Boston and Sandwich Glass Works in Sandwich. Ironically, what he initially thought would be a major benefit to his factory—the sand—was not as favorable as he had hoped. It turned out that Cape Cod sand included too much iron and was not the right type of sand needed to make glass.

But Jarves wasn't about to be deterred. He imported the right kind of sand from other states and began his business. It was an immediate success. He managed to triple his profits in a matter of four short years. By 1850, the Sandwich Glass

Company had nearly five hundred employees and gave a shot in the arm to the Cape Cod region. It included four large furnaces producing more than a hundred thousand pounds of glass products weekly. It wasn't just the people who worked at the glass factory who benefited from the economic boon—other peripheral industries grew up alongside the glassmaking industry. Lumberyards (wood was needed to fire the glass ovens), home building (to house the workers) and transportation businesses (in order to export the glass off the Cape) all expanded alongside the glassworks. Jarves was doing more than $.5 million worth of business a year. But it was not just the business or its economic aspects that became important to Cape Cod. The Boston and Sandwich Glass Works became an innovator of glass manufacturing, and those innovations became known worldwide.

The Boston and Sandwich Glass Works produced the first pressed and laced glass. In addition, because of Jarves's use of standard molds and automation, the company began manufacturing glassware goods that were inexpensive. Customers of average means could now afford a variety of everyday glass products like drinking glasses, bowls, plates and lamps.

Along with revolutionizing the use of glass products in everyday life, the company also manufactured some of the most superb glass pieces in the world, often creating works of art through the use of colored glass. Within twenty-five years, Sandwich became the most successful town on Cape Cod because of the glassworks.

In 1854, Jarves opened a second glass manufacturing company called the Cape Cod Glass Works. The elderly Jarves hoped his son would inherit the family business after his death, but when his son John died prematurely, Deming Jarves lost interest in the companies. He died in 1869 leaving the glass companies without leadership.

The Boston and Sandwich Glass Works continued successfully manufacturing glass until approximately 1884, when then town of Sandwich was divided up into other communities. Bourne, Buzzards Bay, Cataumet, Pocasset, Sagamore and Monument Beach, all villages within Sandwich, were incorporated into other towns, cutting the Sandwich tax base nearly in half. Along with the loss of its tax base, Sandwich suffered when various companies, once located in the town, became suddenly situated in another community because of the divisions. But perhaps more than anything else, the Boston and Sandwich Glass Works found itself in competition with Midwestern glassmakers who were able to produce less costly glass. Their overhead was half the cost of the Sandwich company's overhead because they relied on natural gas to fuel their operations, as opposed to wood, which the Sandwich company had to ship to Cape Cod because the previously existing forests on the Cape had all been cut down. Unlike other glassmaking enterprises that decided to move westward to take advantage of the low-cost fuel, the Sandwich operation did not. Finally, a wage dispute at the Sandwich operation, leading to a strike in 1888, ground operations to a dead stop. The fires had gone out in the "Town of Glass." The furnaces at the Boston and Cape Cod Glass Works were never started again. Massive unemployment followed, leading to an economic depression. There were several unsuccessful attempts at reviving the business, but the glory days of the Sandwich glassworks were over.

During the course of the company's more than half century of operation, the Boston and Sandwich Glass Works manufactured more than $25 million worth of glass products that were shipped all over the world. The famous Sandwich glass is now often on display at museums and antique stores throughout the country, and the Sandwich Glass Museum, another of Cape Cod's most visited sites, keeps the history of the famous glassworks alive.

THE CAPE COD REBELS

Cape Codders by nature have always been depicted as strong-willed, independent and practical, all good New England traits. Cape Cod practicality was displayed by Sandwich rebel John Nye, who in a fit of political fervor ran away to Boston and joined in with other "wild Indians" in the famous Boston Tea Party in December 1773. Although Nye's revolutionary actions were laudable, his Cape Cod practicality shone through when, according to legend, instead of actually tossing the English tea overboard into Boston Harbor, Nye tucked packets of the tea into his pockets and returned home to Sandwich with them as a gift for his ailing mother.

Cape Cod has always been a hotbed of revolutionary fervor and patriotic zeal. Among Revolutionary War heroes and heroines, the Otis family of Barnstable was the most energetic. Mercy Otis Warren helped drive one British governor out of the colonies, drove America's second president from office and helped ensure every American's individual civil rights by advancing the Bill of Rights. Born in Barnstable in 1728, she was a poet, dramatist, Patriot and historian during the country's Revolutionary War period. She has been called "the First Lady of the American Revolution" and "the most remarkable woman who lived during the revolutionary period."

She wrote scathing and oftentimes bawdy commentaries, not only about the British, but also about Americans she felt had betrayed the ideals of the American Revolution, most notably the country's second president, John Adams. She and her brother James, another Revolutionary Patriot of note, grew up on a large and prosperous farm on Cape Cod. Her father served as a judge. In 1754, she married James Warren and they moved to Plymouth. As the conflict with the British became more intense, Mercy became more active in attacking the English roué of the colonies and advocating for independence. She wrote and published the poem "The Squabble of the Sea Nymphs," celebrating the Boston Tea Party, and her play *The Adulateur* was published anonymously in the Boston newspaper the *Massachusetts Spy*. The play portrayed the British-appointed governor of Massachusetts, Thomas Hutchinson, as an ardent foe of those who longed for liberty and independence. Within a year she published the play *The Defeat*, which depicted Hutchinson as a turncoat who would shift his loyalties from the British to the Patriots to further his own ambitions. Shortly after the publication of the play, Hutchinson was dismissed as governor and sent home to England.

In 1775 she published the play *The Group*, in which she accurately predicted that then-governor General Thomas Gage would attack the town of Concord, Massachusetts,

where much of the rebel supplies were being stored. In 1776, she wrote *The Blockheads*, in which she depicted General Gage as a cowardly tyrant. She continued to write following America's independence, focusing her attention on the governance of the new country. She accused John Adams, the country's second president (1797–1801), of betraying the principles of the American Revolution and charged him with being guilty of little talent and great political ambition. Adams advocated a strong central government, strong enough to squelch any subsequent rebellions in America. Anti-Federalists like Otis wanted to protect the individual civil liberties of the colonists. She actively and publicly opposed the signing of the Constitution because she felt it did not provide any substantial guarantees of individual rights for American citizens. In her article "Observations on the New Constitution and on the Federal and State Conventions," she described her objections to the signing of the Constitution. The publication of this article contributed, in large part, to the passage of the first ten amendments to the Constitution known as the Bill of Rights. She continued to write until she died in 1814 at the age of eighty-six.

Her brother James was a lawyer for the British government when he took up the cause of the rebels. In protest of the British law allowing customs agents to arbitrarily enter any home or business to search for and seize illegal contraband, mostly goods not taxed by the government, James Otis resigned his post and became an outspoken Revolutionary leader. James was adamantly opposed to the British rule governing search and seizure, and he argued his cause before the Massachusetts Supreme Court. It was during this case that James Otis coined the now famous historical cry: "Taxation without representation is tyranny." His words soon became the rallying cry of the American Revolution. In 1769 he was attacked and bludgeoned by a British customs officer and never fully recovered. He was forced to spend his remaining days on his family's Barnstable farm. He died in 1783 on Cape Cod from the injuries inflicted on him fourteen years before.

THE UNOFFICIAL NATIONAL ANTHEM

Katharine Lee Bates was born on Cape Cod in Falmouth in 1859. She wrote what is considered the country's unofficial national anthem, "America the Beautiful." In the summer of 1893 she wrote the original version of the poem. Although it is not the country's official national anthem, the poem remains for many Americans the most compelling national song in praise of this country's vast environmental and natural resources. "America the Beautiful" was in competition with Francis Scott Key's "The Star Spangled Banner" as the country's national anthem until 1931, when the issue was resolved by Congress when it voted to make "The Star Spangled Banner" the official anthem.

Although written in 1893, the poem was set aside by Bates for two years as she became more deeply absorbed in her teaching at Wellesley College. It was not until the Fourth of July 1895 that the poem first appeared in print in the pages of the

Congregationalist. It attracted immediate attention all over the country along with requests to place the words to music. In 1904, she rewrote the poem in order to make it as simple and direct as possible. This new version was published first in the November 19, 1904 edition of the *Boston Evening Transcript.* Both the newspaper and Bates received a flood of letters equally praising and ridiculing the verses. The poem continued to be published in hymnals and anthologies of patriotic verse throughout the country.

Over the course of the years, "America the Beautiful" found its way into countless periodicals, and although Bates was generous in giving her permission to reprint the poem, she was often distressed by misprinted versions and deliberate alterations to her original text. She never accepted any payment for the use of the poem, other than the original fees she received from its first publication in the *Congregationalist,* but after copyrighting it, the one stipulation she demanded was that only the authorized version of the poem was to be used.

The poem inspired many composers, and more than sixty original musical compositions have been written for it, not to mention the great number of existing songs it has been associated with. The melody it is most associated with to this day is "Materna," written by Samuel Augustus Ward in 1895. "Materna" was first published in "The Parish Choir" in Boston in 1888 as the musical setting for the hymn "O' Mother Dear Jerusalem." American author Thomas Bailey Aldrich, author of the popular collection of stories *Marjorie Daw,* was the first person to suggest that Bates's

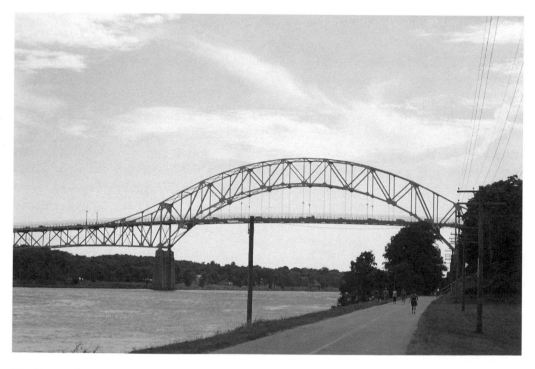

The Bourne Bridge, pictured here, was built in 1935 along with the Sagamore Bridge. *Courtesy of Nate Conway.*

poem was inspiring enough to become the country's anthem. It is not exactly known how or why the poem was combined with Ward's "Materna." Despite the hundreds of musical scores the poem has been set to, the combination of the poem with Ward's music has been the most successful, and it is the only melody and verse combination that has survived throughout the years.

In 1926, the Assembly of the National Federation of Music Clubs held a contest to find an appropriate melody for Bates's well-loved poem. More than nine hundred musical settings were submitted to the judges, but none were found to be appropriate. Although Bates approved of the contest, she expressed no opinion about any of the melodies that her poem was set to.

"That the hymn has gained such a hold as it has upon our American people, is clearly due to the fact that Americans are at heart idealists, with a fundamental faith in human brotherhood," Bates said of the poem's lasting popularity.

Although "The Star Spangled Banner" is the country's national anthem, "America the Beautiful" has long been one of the country's best-known and best-loved songs.

Following her retirement from Wellesley College in 1925, Bates was made professor emeritus. She died on March 28, 1929, and her ashes were buried at the family plot in Falmouth. Before her death she asked that her own inscription be added to the family gravestone: "I will sing unto the Lord a new song."

LEGISLATIVE INEPTITUDE

A hotbed of American Revolutionary zeal and patriotism as depicted by Mercy Otis Warren and Katherine Lee Bates, Cape Cod also became a source of much legislative ineptitude. According to one Harvard University historian: "If ever a strip of land was a parade-ground for surveyors first and a battle-ground for legislative vituperation afterwards, it was the route of the Cape Cod Canal."

In 1697, the Massachusetts General Court passed a resolution aimed at appointing a committee to investigate the possibility of digging a canal though Cape Cod. It was the first of many intentions that were never followed up. The Massachusetts General Court ordered that John Otis of Barnstable, Captain William Bassett and Thomas Smith of Sandwich study the feasibility of digging a canal and report back to the legislative body. The survey was never conducted, or if it was, no report was ever filed with the Massachusetts General Court.

> *It is thought by many to be very necessary for the preservation of men and estates, and very profitable and useful to the publick, if a passage be cut through the land at Sandwich from Barnstable Bay, so called into Monument Bay, for vessels to pass to and from the western part of this country. Ordered that Mr. John Otis of Barnstable, Capt. William Bassett and Mr. Thomas Smith of Sandwich, be and hereby are appointed to view the place and make report to this court, at their next session, what they judge to*

be the General Conveniences and Inconveniences that may accrue thereby, and what the charge of the same will be, and probability of effecting thereof.
—from a Massachusetts General Court resolution, 1697

The idea of building the Cape Cod Canal floundered for many years, although some interest remained. In 1736, Thomas Prince wrote in *Annals*: "The place through which there been a canal talked of for forty years which would be a vast advantage to all the country by saving the long and dangerous passage around the Cape and through the shoals adjoining."

The outbreak of the American Revolution sparked a renewed interest in the prospect of digging a canal through Cape Cod. At the outbreak of the war (1774) the British naval force controlled the Cape Cod coast as well as the entire East Coast. The British fleet was free to sink American ships and capture crews. Suddenly, the military importance of Cape Cod came into vogue. But not even the threat of a naval disaster at the hands of the British was enough to compel anyone to begin digging the canal. What the American Revolutionary War did produce was the first substantial and still-surviving survey of the Cape Cod Canal.

Thomas Machin, an engineer who served under General Artemus Ward in the Continental army, was sent to determine the feasibility of digging a canal through the Cape. Artemus Ward served as the governor of Massachusetts from 1774 to 1775. He later served in Congress (1791–1795). Ward was second in command of the Continental army under General George Washington. If anyone knew the potential of digging the canal it was Ward, and he sent his best engineer to study the idea. Machin surveyed a possible route and wrote a full report recommending that a canal be dug. It is the first Cape Cod Canal survey on record. Although Machin reported favorably on the prospect of digging a canal through Cape Cod, he noted the difference in the height and time of the tides at each end of the proposed canal. This might cause some problems, and Machin noted that the building of a lock would be necessary. His calculations showed that the highest point of land between Buzzards Bay and Barnstable Harbor was approximately thirty-four feet above the low-water mark at Buzzards Bay. Although a canal could be dug with no locks, it would be an expensive proposition. Machin proposed that a canal approximately seven and a half miles long with a depth of fourteen feet could be dug with locks at both ends to control the tides and two bridges to accommodate pedestrian traffic. He estimated that it would be necessary to remove one million cubic yards of earth in order to accomplish the task. He estimated the cost of undertaking the project would be approximately £32,000. Machin advised that digging the canal would be beneficial from a military stance, allowing the American navy to be protected from the open seas and British war ships, and it would eliminate the dangers of sailing through the treacherous shoals surrounding the Cape. Machin filed his report with the General Court meeting in Boston, and it was recommended that the report be sent directly to the Continental Congress that was meeting in Philadelphia. However, Machin was ordered back to his military command in New York. His report remained in Boston and was never acted upon by the Continental Congress.

August Belmont Jr. (second from the left) handpicked the board of directors for the Cape Cod Canal project. Here he is flanked by unidentified members of his board. *Courtesy of the Town of Sandwich Archives.*

THE RENEWED SURGE OF INTEREST

After the Revolutionary War there was a surge of renewed interest in digging a canal through Cape Cod. It was brought about by the boom in shipping trade following the end of the war. Increased shipping also brought with it an increase in the number of ships and sailors lost at sea trying to navigate the dangerous Cape Cod coast. The Massachusetts General Court authorized yet another study. In 1791 the court authorized James Winthrop, an honored Harvard University mathematician, to conduct a survey of Cape Cod and to make his recommendations on the feasibility of digging a canal. Winthrop only took twelve days to make his survey and write a report. The report never included any recommendations.

Unsatisfied with Winthrop's work, the Massachusetts General Court hired John Hills from Philadelphia to undertake a survey. Hills worked for several months and returned with a report that suggested that a canal, twenty-four feet wide and fifteen feet deep with three sets of locks, should be built. Hills proposed that the canal be dug along a route heading out of the Monument River into Buzzards Bay. He estimated the cost of the project at $350,000. Still not satisfied, the General Court ordered *another* survey,

this time to determine the potential use of a canal. The results of this survey showed that at least one-half of all the ships currently engaged in the shipping trade would continue to sail around Cape Cod rather than use a canal. Given the extraordinary results, combined with the hefty costs involved, the Massachusetts General Court tabled the idea.

Although the General Court did not think it was feasible to dig a canal, it did give authorization to anyone who wished to undertake the project to charge tolls to cover costs. It was one of the first attempts at privatization of the canal project.

In 1798, James Sullivan became the first person to take advantage of the authorization. Sullivan and others petitioned the court to set up a private corporation for the sole purpose of digging the Cape Cod Canal. The General Court approved the petition, with the stipulation that Sullivan's group finance all the necessary surveys prior to granting incorporation to the group.

Three years later, Thomas Batcheller approached a Sandwich town meeting with his request to dig a canal. Batcheller's proposal was endorsed at the town meeting and the people of Sandwich became enthralled with the expected economic benefits that a canal would provide. According to Batcheller, the canal would increase property value on Cape Cod, provide enormous employment opportunities and bring a boom in trade and industry to the region. Enthusiasm led to disappointment when neither Sullivan nor Batcheller ever began work on their canal proposals.

In 1803 the Massachusetts General Court again agreed to study the canal proposal. This time the results of the survey included several potential routes. Among them were:

A canal across Cape Cod from the South Sea to the north;
A canal from Narragansett Bay in Rhode Island through the city of Taunton, using the Taunton River;
A canal connecting the Cape Cod coast to the western part of Massachusetts using the Nashua River;
and a canal connecting Boston to Worcester using the Charles and Neponset Rivers.

Despite this extensive study, no canal ever materialized, but in 1808, Secretary of the Treasury Albert Gallatin authorized a federal survey to determine ways to improve transportation across the country. His study did not recommend the digging of a canal through Cape Cod. Gallatin's study recommended digging a canal that would connect Boston Harbor to Narragansett Bay, via a route from Weymouth down the forty-four-mile Taunton River. This proposed canal would be approximately twenty-six miles long and cost an estimated $1.2 million. Again, nothing ever came of this study.

In 1811, Thomas Batcheller once again resumed his efforts to dig a canal. He managed to get permission from various Cape Cod landowners to dig a canal through their property in Sandwich. He petitioned the Massachusetts General Court for a charter to form a company to dig the canal and the petition was granted. Batcheller wrote in his diary:

I called in person on all land owners along the proposed waterway, and gaining permission to cut through their land, petitioned the Legislature for a charter.

But it was too little, too late. The following year, the War of 1812 with England erupted and Batcheller's proposal fell by the wayside.

THE PERRYS OF CAPE COD

The War of 1812 began in June, when President James Madison declared war on England. It was the result of a long period of strained relations with the English.

The English naval fleet anchored in Provincetown Harbor. From there it was able to roam the coastline freely, seizing and sinking American ships. Ultimately, American naval forces prevailed. It was during the War of 1812 that Captain Oliver Hazard Perry defeated the British in a decisive naval battle on Lake Erie. It was Perry who, after accepting the surrender of the British following the Battle of Lake Erie, uttered the historical quote, "We have met the enemy and they are ours." Oliver Hazard Perry was a relative by marriage of August Belmont Jr.

Oliver Hazard Perry was the older brother of Matthew Calbraith Perry, who is credited with opening up Japan to U.S. trade in 1854. Matthew Perry was August Belmont Jr.'s grandfather. August Belmont Sr. married Caroline Slidell Perry, the daughter of Matthew Perry.

The Perry brothers had illustrious naval careers. During the famous Battle of Lake Erie, Oliver Hazard Perry was commanding the flagship *Lawrence*. In the early stages of the battle, Perry and his crew took most of the enemy's fire. The *Lawrence* was severely damaged and more than 80 percent of Perry's crew was killed or wounded. Trying to clutch victory from what appeared to be certain defeat at the hands of the British naval force, Perry, carrying a flag emblazoned with Captain Lawrence's dying words, "Don't Give Up The Ship," transferred his crew to the mildly damaged vessel *Niagara*. The British had also suffered major casualties at the hands of the *Lawrence*. Renewed cannon fire from the *Niagara* under the command of Perry forced the British to surrender a mere fifteen minutes after Perry took command of the ship. Immediately following this decisive victory at the Battle of Lake Erie, in his report to General William Henry Harrison, Perry wrote the now famous words: "We have met the enemy and they are ours." Perry was the first naval commander in American history to defeat an entire British squadron and successfully bring back every ship to his base as a prize of war. At the age of twenty-eight Perry was hailed as a national hero.

In 1853, Commodore Matthew Perry was sent on a mission by President Millard Fillmore to establish trade with Japan—a country that had been isolated from the outside world since the seventeenth century. He sailed a squadron of four ships into Tokyo Bay and presented officials of the Japanese emperor with a proposed commercial and friendship treaty. The emperor rejected the offer and Perry withdrew his vessels from the harbor. He returned to Japan in February 1854 with seven vessels, including

sixteen hundred sailors and marines. After a brief standoff with the Japanese, Perry went ashore to engage in peace and trade talks. He negotiated a trade agreement with the Japanese and signed the Treaty of Kanagawa on behalf of the United States. The treaty established what was hailed as a permanent friendship between the two countries. The agreement guaranteed that the Japanese would save shipwrecked Americans and provide fuel for American ships and also opened trade between Japan and the United States. The signing of the treaty symbolized the end of Japan's isolation.

THORNDIKE'S PETITION

August Belmont Sr., who began his career as a representative of the Rothschild family's banking house in Frankfort, Germany, and then immigrated to New York in 1837, married Caroline Perry, daughter of Commodore Matthew Perry, in 1849. Their second child was August Belmont Jr., born in 1853. Part of August Belmont Jr.'s reason for involving himself in the digging of the Cape Cod Canal was due to his deep affection for his maternal grandfather, Commodore Matthew Perry, who lived on Cape Cod.

During the War of 1812, with the English fleet poised off Provincetown, American sea traffic ground to a standstill. Few American ships attempted to sail around Cape Cod during the war for fear of being captured by the British. Traders resumed their long and arduous voyage of sailing up the Scusset and Manomet (Monument) Rivers and portaging their loads. In 1818, four years after the signing of the Peace of Ghent, which brought the War of 1812 to a close, Israel Thorndike took up the cause of building a canal through Cape Cod. Thorndike petitioned the Sandwich town fathers for the purpose of digging a canal and his petition was approved. The renewed interest in the canal was prompted by an increase in the Cape Cod fishing industry. Fishing was quickly becoming the area's number one export. It was also prompted by the great success met by the Erie Canal.

Construction on the Erie began in 1817 and would ultimately connect Buffalo, New York, on Lake Erie with Albany, New York, along the Hudson River. It was completed in 1825. The Erie Canal was dug with the support of Governor Dewitt Clinton and would ultimately accommodate trade and transportation between New York and the Great Lakes region and the Atlantic Coast. After Israel Thorndike's petition was granted, he began the Massachusetts Bay Canal Corporation. Thorndike's corporation was allowed to sell ten thousand shares of stock at fifty dollars per share to raise the necessary capital for digging the canal. If the money it raised was not enough to cover the costs, the corporation was given permission to sell as many additional shares as were necessary. The Massachusetts Bay Canal Corporation's proposed canal was designed to accommodate ships along a route between Buzzards Bay to Barnstable Harbor. In order to accomplish this, the corporation was allowed to take land along the route up to 825 feet wide. It did provide for jury trials for landowners who disputed any damage awards. The corporation was also held to the task of building a bridge over the canal

that had to be maintained for free. The entire project was to be completed within six years and no taxes would be assessed until the privately owned canal could show a profit from its use.

A civil engineer was hired to conduct a survey of the area. The engineer picked the Back River Harbor as the potential starting point of the canal. It would head west into the Manomet (Monument) River and then east into the harbor. According to the survey, a fifty-foot-wide, sixteen-foot-deep canal with two locks at either end would cost approximately $750,000. Following the completion of the survey, no work was ever begun on the proposed canal. Raising money proved difficult. Although Thorndike's initial petition expired after six years, he was given an extension until 1830. But even with the extension, not a single shovel of Cape Cod soil was dug.

RAIL SERVICE COMES TO CAPE COD

The railroad first came to Cape Cod in 1848, running from Boston to Sandwich. A depot in the town was built by the Sandwich Glass Company. It was an ornate little place. The first Boston to Cape Cod train left the city at 9:00 a.m. and reached the town of Sandwich at 1:00 p.m. The fourteen-car train was decorated with flags and banners and the huge locomotive engine was christened "The Noble Cape Codder."

It was met that bright spring day in May 1848 by an anxious and happy crowd of some eight hundred Cape residents. On board this first train to Sandwich were a number of Boston dignitaries, including the mayor of Boston, Josiah Quincy. A luncheon was held as part of the celebration, and at 4:00 p.m. the train chugged out of Sandwich on its way back to Boston. Modern rail service had finally reached the Cape.

Six years later, in 1854, there was a similar celebration in Hyannis when the rail service was extended to that Cape town. Hyannis also built a depot in the center of the town, and it remains a fixture in the town to this day.

It took until 1873 for the railroad to finally reach Provincetown, the farthest destination on Cape Cod. Rail service had reached nearby Wellfleet three years before, but the short fourteen-mile railroad connection from Wellfleet to Provincetown completed the expansion of the rail system onto Cape Cod.

CHAPTER FOUR

Go Fish

I saw two men fishing for Bass hereabouts. Their bait was a bullfrog, or several small frogs in a bunch, for want of squid. They followed a retiring wave and whirling their lines round and round their heads with increasing rapidity, threw them as far as they could into the sea; then retreating, sat down, flat on the sand, and waited for a bite...And they knew by experience that it would be a Striped Bass, or perhaps a Cod, for these fishes play along near the shore.

—*Henry David Thoreau*, Cape Cod

The importance of the Cape Cod Canal to the fishing industry was enormous. When the Puritans petitioned King James to come to the New World, his response was to ask what profit they might show from their adventure. The simplest answer was fishing. The king reportedly replied that fishing was an honest trade. "Twas the apostle's own calling," he reportedly said.

The waters around Cape Cod were abundant with fish. The Native Americans fished Cape Cod Bay with the crudest of equipment—bones and twine and sharpened stones used for spears. Despite the Native Americans' success, the Pilgrims had little luck. They were more inclined toward trading than fishing, and they established trade routes and trading posts. It was fur not fish that interested the earliest colonists. Still, it was fishing that would far exceed fur trading as the region's dominant industry. The huge wooden codfish that hangs in the Massachusetts State House in Boston symbolizes the importance of the fishing industry to the state and the region.

By the time of the American Revolution, the fishing industry provided more than half the income used in payments to England for goods and materials. The exporting of New England fish extended to Spain, Portugal and France, as well as to other New World colonies. The fishing industry was so vital to the region that, at the close of the American Revolutionary War, Massachusetts political leaders refused to negotiate a peace treaty with England unless all the previous fishing rights were secured. In the Treaty of 1783, which brought about the end of the Revolutionary War, these fishing rights were acquired.

From the time of the earliest settlements and through the period leading up to the Civil War, the Cape Cod economy was dependent on the fishing industry. Nearly all Cape Cod men served the sea either as fishermen or mariners. Even boys, as young as nine years old, took to the sea. It was only women, the old and the sick who stayed behind to cultivate the land. From the fishing fleets evolved the whaling and merchant marine industries. The dangers and risks of the seafaring life were constant. A storm at sea or the dangerous shoals surrounding the Cape often spelled disaster and tragedy for Cape Codders. The toll forced many Cape inhabitants to move farther inland to keep husbands and sons from the dangers of the sea. The entire Cape Cod coast was a choice target for winter storms and gales. One of the worst storms happened in 1841, costing the Cape Cod fishing fleet nearly fifty ships. The town of Truro lost fifty-seven men in the 1841 storm and the town of Dennis lost twenty-six. But this was only one of many storms that hit the Cape Cod coast bringing death and destruction with it.

Fishing trips took Cape Codders out to sea for months at a time. A voyage out to the fish-rich Grand Banks could take up to six months. Some voyages were even longer. The prowess of Cape Cod fishermen was known all around the world. Often a man's fishing abilities merited his social standing in the community—the better the fisherman, the higher his social standing. Edwin Valentine Mitchell wrote in *It's an Old Cape Cod Custom*:

> *The logbooks of New England whale ships, which recorded in minute detail the voyages of the ship usually closed with the solemn words So Ends, which was the abbreviated version of, So ends another day by the Grace of God.*

An entire support industry developed around the Cape Cod fishing industry. There were shipbuilders and outfitters and people engaged in the curing of fish. Another hard but necessary business was procuring bait for the fishing fleets. This was often undertaken by the poorest Cape Codders who had no other choice but to dig clams for bait. Clam diggers were paid less than three dollars a barrel for digging, opening and salting the clams. It took almost twenty bushels to fill just one barrel. Today, clam chowder and clam rolls are a staple on any Cape Cod restaurant's menu.

THE WHALING INDUSTRY

The whaling industry evolved from the Cape Cod fishing industry. It began in Truro and Wellfleet long before whaling became the major industry of places like New Bedford, Nantucket or Martha's Vineyard. It was Yarmouth fisherman Ichabod Paddock who taught the Nantucket fishermen how to kill whales from small boats. And another Cape Codder, Captain Jesse Holbrook from Truro, became the leading instructor of a whaling school in New Bedford. Holbrook was credited with harpooning more than fifty whales. For the most part, whaling in Truro was done from small boats sent from shore once a whale had been sighted. Lookouts were set up all along the Truro coast

and when a whale was sighted, the lookouts would signal the sighting. Boats from shore would then row out after the giant whale. The famous "Thar she blows" cry originated from these lookouts on land.

For years, Massachusetts Bay had been a favorite hunting ground for whales. Whales came there in great schools because the fish there were plentiful and because, for the most part, they could swim undisturbed. The wide arc of Cape Cod was another favorite location for whales since the fish there were also abundant. Whale oil was a precious commodity. It was used for lamp oil. The average yield of oil from any good-sized whale was approximately twenty barrels of lamp oil. When the whale population disappeared from the Massachusetts and Cape Cod Bays, the practice of chasing whales from shore in open boats was abandoned. Cape Codders then took to the open sea to catch them.

The richest portion of any whale hunt was the precious ambergris, which was a substance found in sperm whales and used in manufacturing perfume. Ambergris was worth far more than whale oil. One Provincetown ship, the *Montezuma*, cut into a sperm whale and discovered a piece of ambergris estimated to weigh more than one hundred pounds. It was worth more than $25,000. While the precious substance was being hoisted on board the ship, it fell into the sea and sank, to the dismay of the crew of the *Montezuma*.

Although the whaling industry off Cape Cod and other New England ports was prosperous, it was primarily the owners of the whaling ships and their captains who reaped huge fortunes. More often than not, those engaged in the long and arduous whaling voyages returned home owing money to the shipowners. Before setting sail, whalers had to be outfitted for the long journey. Outfitting included clothes, food and other necessities. These were charged to the whaler by the ship's owner. The families that stayed behind lived a meager existence and they, too, had to obtain credit at stores for food and clothing while their husbands and fathers were out at sea. By the time the voyage was over, many whalers found themselves in deeper debt than before they had set sail. Their shares from the voyage often did not cover their expenses and they became indebted to the shipowners. Whalers, faced with this plight, were often forced to go back to sea or to debtors' prison. The cycle of obtaining food, clothing and necessities on credit was an endless one.

The huge Portuguese population now inhabiting Provincetown, Massachusetts, is a result of the whaling industry. Cape Cod whale ships often recruited crews from the Portuguese Azores and Cape Verde Islands. When their voyages were over, the Portuguese whalers often settled in Provincetown.

The whaling industry was fraught with danger. There are countless recorded incidents where whaling ships never returned from their expeditions. Losses were not just from encounters with whales, many of whom would stove (crash) into the sides of ships in their fury, but also from the dangerous seas and storms.

The greatest tale of the whaling industry and its inherent dangers was written by New England author Herman Melville in his book *Moby Dick*. Although the classic tale of the *Pequod* and Captain Ahab's obsessive quest for the great white whale begins in

the whaling port of New Bedford, Massachusetts, Melville was married to a Cape Cod woman and one of the major characters in the book, Stubb, the ship's second mate, was a Cape Cod man. Melville wrote in *Moby Dick*:

> *He was a native of Cape Cod and hence, according to local usage was called a Cape-Cod-man. A happy-go-lucky; neither craven nor valiant; taking perils as they came with an indifferent air; and while engaged in the most imminent crisis of the chase, toiling away, calm and collected as a journeyman.*

Along with the whale oil used for lamps and the ambergris for making perfume, whale bone was also a high-priced commodity. Horsewhips and corsets were made from whale bone. The great New England whaling industry came to an abrupt end in 1857 when oil under the ground was discovered in Pennsylvania. The need for whale oil for lamps or heating was no longer necessary. There was plenty of oil right underground and it was less dangerous to get. Because of the discovery, whaling became a thing of the past.

"An Old Cape Cod Song"

Cape Cod girls
They have no combs.
They comb their hair
With codfish bones.
Cape Cod boys
They have no sleds.
They slide down dunes
On codfish heads.
Cape Cod cats
They have no tails.
They lost them all in sou'east gales.

SUPERSTITIONS

Cape Codders who made their living from the sea were a superstitious lot. One of the most common beliefs was that any ship that set sail on a Friday would encounter an unlucky voyage. They also rarely put to sea on a Sunday since it was the Lord's Day. Those who were out at sea on Sunday were expected to observe religious ceremonies.

Whistling on board ships and hammering a nail on a Sunday while at sea were believed to bring about sudden gales.

A single bird landing on board a ship was viewed as a bad omen and many ships would head back into port if such an ominous incident occurred. If any odd thing happened during the launching of a new ship it was viewed as a bad omen. Many

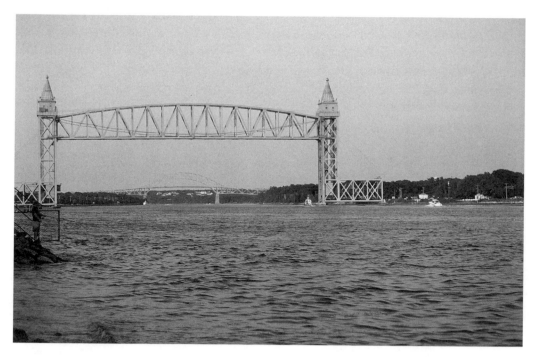

The Cape Cod railroad bridge is still in operation today. *Courtesy of Nate Conway.*

times crews refused to sail on ships that were rumored to have had bad launchings. If word got out about a particularly bad launching, owners even had a hard time selling the ship.

The most common superstition was that rats always deserted a doomed ship. This was somewhat founded in truth since rats do not like to get their feet wet and will abandon a ship when a leak occurs in the hold of a ship.

Horseshoes on board ships were considered good luck as long as they were nailed in a position with their points facing up. Cats were viewed as bad luck since they were the pets of choice for witches. Still, despite these and many other superstitions, Cape Codders led the way in the whaling industry that flourished in New England.

MORE STUDIES

The United States Life-Saving Service, in a report issued in 1875, called the waters surrounding Cape Cod "the graveyard of the Atlantic."

In 1824, United States Senator James Lloyd of Massachusetts successfully introduced into Congress a resolution asking the president to conduct a survey of Cape Cod in order to determine if it would be feasible to dig a canal large enough to accommodate the passage of warships between Buzzards and Barnstable Bays. Because of Senator Lloyd's resolution, a board known as the Board of Internal Improvements was created.

This board reported that the best canal route possible would be one connecting Boston Harbor to Narragansett Bay using the Taunton River as its main travel route. Also in 1824, the Army Corps of Engineers conducted a study of Cape Cod. One of the corps' most distinguished engineers, Major P.H. Perrault, conducted a survey that recommended the digging of a canal through the Back River on the west side of Cape Cod, with two outlets emptying into the harbor on the east side. No one ever acted on the recommendations of either the Board of Internal Improvements or the Army Corps of Engineers.

Three years later, in 1827, another survey was conducted. This survey took three years to complete. It recommended that a canal be dug with an entrance at the Back River on the west side of Cape Cod. It proposed that the canal be sixty feet wide and eight feet deep. On the eastern side of the Cape, the survey proposed that an entrance be dug one mile north of the Scusset River and connect with the western canal. Both ends of the canal would have locks because of the tidal differences. The survey estimated that the cost of digging such a canal would be approximately $700,000. This survey was also relegated to obscurity.

Finally, in 1830, Massachusetts Governor Levi Lincoln, in his inaugural message to the Massachusetts legislature, ordered an end to the redundant surveys. The surveys, he said, "leave nothing further to be desired." Governor Lincoln suggested that, if a Cape Cod Canal was ever to be built, it should be the responsibility of the federal government to build it. With President Andrew Jackson occupying the White House, Lincoln's suggestion was never acted upon. President Jackson was vehemently opposed to using any federal tax dollars on state improvements.

In 1860, toward the end of the whaling industry on Cape Cod and just prior to the beginning of the Civil War, Massachusetts Governor Nathaniel Banks recommended to the Massachusetts state legislature that steps be taken to preserve all the many past surveys and documents concerning the digging of a canal through Cape Cod. His recommendation led to the forming of a legislative committee, the Joint Recess Committee, which produced a report indicating that the flow of traffic around Cape Cod on a daily basis had grown to approximately 120 ships per day. According to the report, the size of these vessels had also grown substantially. The committee determined that, based on the amount of shipping traffic going around Cape Cod, a canal would be of tremendous commercial value to the region, the state and the country. Engineers were hired along with other experts, and over a two-year period, 1860–1862, they gathered information on possible routes the canal could take, approximate costs of digging and the various methods of construction. These results were presented to the governor and the Massachusetts state legislature. Despite its thoroughness, the report indicated that if a canal was ever built, federal financial assistance would be necessary. This painstaking study did little to further the prospect of actually digging a canal.

The two-year study *did* accomplish one very important thing, however. It recommended that all documents, studies and surveys having to do with the proposal to dig a canal through Cape Cod be combined in a single document. The result was the issuance of Public Document No. 41, which became the foundation of all future endeavors to dig

the elusive Cape Cod Canal. Another notable contribution of the committee's work was a map of the Cape Cod coast showing shipwrecks from 1843 to 1859. According to the report, 108 ships were lost at sea during this period trying to sail through the treacherous waters around Cape Cod. More than 150 lives and $1.8 million worth of property were lost.

Building a canal through the Cape would reduce insurance rates among maritime shippers, increase the speed of the journey by eliminating delays due to storms or fog and reduce the loss of lives and personal property. All together, the report indicated that a savings of more than $1 million a year would be realized if a canal was dug. Armed with these impressive figures, the Massachusetts state legislature convinced three federal officials to again study the feasibility of digging a canal. General Joseph Totten of the Army Corps of Engineers, Naval Commander Charles A. Davis and Professor A.D. Bache, superintendent of the Coast and Geodetic Survey Office, were engaged to study the proposal. This impressive group determined that a canal through Cape Cod would be relatively easy to dig and inexpensive, since the land through which the intended canal would be dug was not being used. They recommended that a top engineer be hired to study the possible construction of a canal.

One of the country's leading engineers, George R. Baldwin, was hired. Baldwin surveyed the land and studied all the past surveys, studies and proposals compiled in Public Document No. 41. He concluded that if a canal were to be dug along the approach he suggested it should be wide and deep enough to accommodate large ships. His specifications called for a canal with the width of 240 feet, a channel of 120 feet and a depth of 18 feet. Baldwin suggested that if a canal were to be dug with a more northerly entrance, it would cost in the vicinity of $10 million. A more southerly entrance would cost less, but not much ($9.5 million). Neither estimated cost sat well with the Massachusetts state legislature. While conducting his survey, Baldwin discovered gravel, clay and sand in the test bores. This, he concluded, meant that large boulders along the route he proposed would not create any problems. As it turned out, his conclusion was wrong. Despite the magnitude of Baldwin's study, it was never acted upon and once again the idea of digging a canal through Cape Cod lay dormant. Baldwin's most influential contribution to the building of the Cape Cod Canal was his suggestion that the canal be dug with an approach channel at the Back River, but instead of turning easterly, as most of the other surveys suggested, Baldwin suggested the canal should continue in a northerly direction and enter the mouth of the Monument River. When the Cape Cod Canal was finally dug, starting in 1909, it was George R. Baldwin's approach that was ultimately used.

THE CAPE COD SHIP CANAL COMPANY

In 1870, a group made up of some of Boston's bluest bluebloods and some of New York's finest financial wizards, led by Alpheus Hardy, formed a company called the Cape Cod Ship Canal Company. Hardy and his group, after petitioning the Massachusetts

state legislature for a charter, proposed digging a canal from Barnstable to Buzzards Bay. The Cape Cod Ship Canal Company agreed to begin work within two years and to complete the canal within seven. The Massachusetts legislature granted the charter with the stipulation that the federal government help finance the project by building a breakwater on the east side of the canal. Among other details included in the charter was the agreement that Hardy's company would pay for any damages caused to the herring fishing industry that building the proposed canal might cause. The Cape Cod Ship Canal Company also agreed to build free access bridges over the canal, to operate free ferries, relocate all the roads and railroads that were altered and pay all land damages that might arise because of the construction of the proposed canal. Although they were steep orders, Hardy and his company agreed to them all. The company was given permission to issue up to $10 million worth of stock at $100 per share. The land taken during the digging of the canal would not be taxed until two years after the canal was finished. The charter that was granted to Hardy and the Cape Cod Ship Canal Company became the prototype of every other charter that was granted after it.

Even the federal government seemed satisfied with the charter and assigned Colonel J.G. Foster of the Army Corps of Engineers to conduct yet another survey of the proposed canal's operation. Because of his understanding of hydraulics, Foster recommended a canal free of any locks. He concluded that the locks would cause too many delays, which would subsequently cause increased traffic in the canal leading to more accidents. Instead of locks, Foster recommended that guard gates should be built along the banks of the canal to protect it from high tides. Foster estimated that the canal could be completed within three years. To protect the eastern waterway, Foster proposed building a four-thousand-foot breakwater at a projected cost of $2 million. He cited that hundreds of ships had been lost attempting to navigate around Cape Cod over the previous ten years. He also concluded that the canal would have as many benefits militarily as it would during peacetime for commerce and shipping purposes.

The Massachusetts legislature passed a resolution proposing that the federal government provide the funding for Foster's proposed breakwater. This, like many of the resolutions before it, was never acted upon. The original charter granted to the Cape Cod Ship Canal Company was extended in 1872 for three more years, and in 1875, it was extended for another year. During this period, not a shovel of dirt on the proposed canal was ever dug. In 1876 the charter was extended for another two years and still no work began on the canal.

THE LIFE-SAVING SERVICE

Semper Paratus, "Always Ready," is the official maxim of the United States Coast Guard, but their unofficial motto has been, "The book says you have to go out. It don't say you got to come back."

The United States Coast Guard was established in 1872. It was originally known as the Life-Saving Service. The most dangerous coastline under the command of the

Life-Saving Service was Cape Cod, infamous to all seamen as "the graveyard of the Atlantic." Even after the Cape Cod Canal opened in 1914, there were approximately 156 shipwrecks recorded off the Cape during the ten-year period from 1907 to 1917.

None of the recorded sailing charts were trustworthy because of the shifting sandbars. Charts would have to be updated yearly in order to stay accurate. They weren't. Mariners choosing to navigate around the Cape took their lives and those of their passengers in their own hands.

The Life-Saving Service established more than 250 lifesaving stations along the East and West Coasts and in the Great Lakes region to rescue crews and passengers from shipwrecks.

For those men who joined the Life-Saving Service on Cape Cod, it was safer to be a lifesaver than to be one of the crew stranded on a wreck. Guarding the entire Cape was impossible, so service was established all along the treacherous shoreline. There were nine lifesaving stations built on the Cape: Race Point, Highlands, Peaked Hill Bars, Pamet, Cahoon's Hollow, Nauset, Orleans, Chatham and Monomoy Point.

The lifesavers spent endless hours patrolling the shore during storms and at night, when wrecks were more likely. The shore patrols were strenuous and exhausting. Distress calls from stranded ships propelled them into immediate action. The lifesaving crews would have to haul the lifesaving equipment by hand or by wagon. It was tough going in the sand and storms. From the shore they were prepared to launch their rescue boats, which were small but sturdy vessels called surfboats. When the Life-Saving Service was first created, the government supplied them with wooden flat-bottomed boats, but the boats proved useless when trying to launch into the pounding Cape surf during a storm. Quickly, the lifesaving boats were exchanged for boats built by Cape Codders who knew the waters. The new Cape Cod rescue boats were smaller than a whale boat but similar in style, with a keel, narrowed at both ends and deep. More importantly, the new rescue boats were lightweight and could be launched in the Cape Cod surf and breakers. The lightweight rescue boats accommodated five lifesavers at the oars and a helmsman. The rescue boats were only big enough to save five people at a time, requiring the lifesavers to make a multitude of trips in the treacherous storm-tossed waters off the Cape Cod coast.

The record of the Life-Saving Service from its inception in 1872 until 1915, when it was incorporated into the newly formed United States Coast Guard, is astounding. Through their heroic efforts, hundreds of shipwrecked victims were saved and only on two rescue attempts did any members of a lifesaving crew lose their lives in a rescue attempt.

In 1902, seven years before work on the Cape Cod Canal began, six of the seven men from the Monomoy Life-Saving Station and five members of the crew of the stranded coal barge *Wadena* drowned during a seasonal March storm. The *Wadena* ran aground on a shoal and the crew stayed aboard to salvage what they could from the stranded barge. The barge was hit by a series of massive waves. Responding to a distress signal sent from the crew of the *Wadena*, the lifesaving crew at Monomoy launched a boat in the heavy seas to rescue the men. It took them more than an hour to reach the stranded

vessel. The lifesavers were able to get all five of the *Wadena* crew safely on board the rescue boat, but as they tried to maneuver around the stranded barge, the rescue boat was struck by a massive wave. The lifesaving crew tried desperately to right the boat, but another wave swept over the small, crowded boat and it flipped over into the raging waters. Most of the rescued men and the lifesavers managed to hold onto the overturned boat, but one by one they were swept into the sea. Only Seth Ellis, one of the lifesavers, managed to hold on. He was rescued when a Chatham fisherman, sailing a small, fourteen-foot dory, made it to the overturned boat and pulled Ellis to safety. Six of the lifesaving crew and all five of the *Wadena* crew were drowned.

HERSCHEL'S STUDY

The most influential study of the canal during the 1870s was conducted by Clemens Herschel, the former president of the American Society of Civil Engineers. The canal he proposed was far less extravagant than any of the others proposed. According to Herschel's study, a sixty-five-foot channel approximately eighteen feet deep could be dug for a mere $2 million. He projected that a canal of this size would be able to accommodate up to 90 percent of Cape Cod shipping. He further projected that, with an estimated four million tons of cargo expected to pass through the canal on a yearly

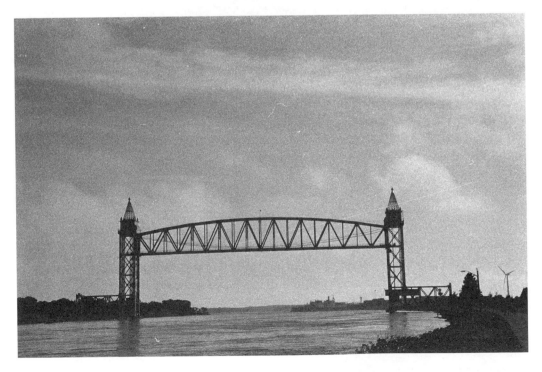

The Cape Cod railroad bridge is lighted at dusk. *Courtesy of Nate Conway.*

basis, tolls of ten to fifteen cents per ton would produce a yearly operating profit of $100,000—more than enough to operate the canal. Herschel agreed with Foster that the proposed canal should not have locks because it would reduce the number of ships able to use the canal. It would also eliminate the ocean current running through the canal, leading to freezing.

Even with Herschel's study in hand, Congress refused to allocate any money for the digging of the canal. Finally, after nearly a decade of inaction, charter extensions and countless studies and resolutions, it took the threat of competition to begin the actual work on the Cape Cod Canal.

Henry Whitney, a successful Boston businessman and the president of the Metropolitan Steamship Company, applied for a charter from the Massachusetts legislature for the purpose of digging a canal through Cape Cod. In April 1880 Whitney's charter application was approved with the stipulation that if Alpheus Hardy and the Cape Cod Ship Canal Company did not spend at least $100,000 on the construction of the proposed canal before November 1, 1880, then all the land and materials owned by Hardy's company would be turned over to Whitney's company without any monetary compensation. The specter of this drove Hardy and the Cape Cod Ship Canal Company to act.

On Wednesday, September 15, 1880, at seven o'clock in the morning, James Keenan, a general laborer for Hardy's company, dug a wheelbarrow full of dirt from a place called Town Neck near the town of Sandwich. It was the first shovel ever put to the Cape Cod soil in the long and laborious effort of digging the Cape Cod Canal. Within a week, a crew of more than a hundred Italian laborers from Boston and New York were at work on the canal, using picks and shovels to begin digging in Sandwich. After two weeks, there were more than four hundred Italian laborers working on the canal. The laborers' worksite was a series of tents. It was established, in part, to give the impression that work had actually begun on the canal. In this way, Hardy and the Cape Cod Ship Canal Company would not lose their cherished charter. But there was trouble brewing.

The Neapolitan Revolt

He also told us of the steamer Cambria's *getting aground on his shore a few months before we were there, and of her English passengers who roamed over his grounds, and who, he said, thought the prospect from the high hill by the shore "the most delightsome they had ever seen," and also of the pranks which the ladies played with his scoop-net in the ponds. He spoke of these travellers with their purses full of guineas, just as our provincial fathers used to speak of British bloods in the time of King George the Third.*

—*Henry David Thoreau*, Cape Cod

What was to become known as the Neapolitan Revolt began on October 13, 1880, when the Italian laborers hired to work on the canal stormed the company's office in Sandwich and took the son of the company's owner hostage. The laborers had not been paid since coming to Cape Cod and their food and water had run out. Hardy's company refused to pay or feed them as they had previously agreed. Holding the owner's son for ransom, the laborers demanded their pay. Fortunately, the mob of Italian workers, who could speak little English, was convinced by an interpreter to release its hostage and return to camp. It was reported in the *Yarmouth Register*—the region's weekly newspaper—that at one point in the confrontation one Italian laborer climbed on top of a mound of dirt that had been dug from the canal, and wearing a dunce cap and waving an Italian flag, whipped his fellow workers into a state of frenzy. Luckily, bloodshed was averted. At first, the Sandwich residents feared for their lives. They armed themselves and extra police details were called out. According to the *Register*, "Sandwich was for a week under arms."

In early October, a hundred workmen employed on the Cape Cod Canal project went on strike because one of the laborer's bosses had been fired. The Italian workmen vowed not to return to work unless the former boss was reinstated.

According to a report in the *New York Times*, "This is thought to be the beginning of a general strike as it is said there is dissatisfaction all along the line."

On October 20, 1880, then–Massachusetts Governor Long received a telegram from officials of the town of Sandwich stating that the Italian laborers working on the Cape Cod Canal had begun to riot. The governor ordered in the state police. According to reports, the riot began because the laborers had not been paid. This was confirmed by Sandwich town officials.

The rioters gathered in front of Central House in Sandwich, a rooming house where the contractors were reportedly staying. They demanded to be paid, but there was no response by the contractors. Fearing more trouble, more than eighty town residents were sworn in as special police officers. The Massachusetts State Police arrived in Sandwich with more than thirty officers, but the laborers had by then returned to their camp where things had settled down somewhat. The workers complained that they had not been paid and they refused to work any longer on the canal until they were paid the wages they were owed. According to the workers, they had not been paid since they began working on the project nearly a month prior. Things only got worse.

On October 21, 1880, Sandwich police learned of a plot by the Italian canal workers to kidnap and hold a company official hostage until such time as they were paid the wages owed them. Sandwich and state police kept a watchful eye on the laborers and vowed to thwart any such attempt.

On October 24, 1880, reports coming out of Sandwich indicated that the Cape Cod Ship Canal Company would be dissolved due to lack of financing. Since the company was unable to meet its obligation under its charter, which required the company to spend $100,000 on the canal project before November 1, 1880, they would lose their charter.

The Italian laborers were not paid, and plans to transport them back to New York began. The charter held by the Cape Cod Ship Canal Company was then awarded to yet another company, Cape Cod Canal Company. However, Governor Long demanded that the new company be required to establish a bond under the alien law providing that workers who were not citizens but who were brought into the state would not become public charges. Long required the new company to provide a bond of up to $300 for each worker. The bond came too late for the original Italian laborers who had not been paid by the Ship Canal Company.

As the truth about what had happened to the Italian laborers became known, the resentment of Sandwich residents gave way to sympathy. Hardy's company had not paid the workers or fed them since they arrived on the Cape. The Italians, far from their homes, were strangers in the sea-swept community. Unable to speak English, they were eyed with suspicion. For several days, bands of workers wandered the streets of Sandwich begging for food or work. Little by little, the Sandwich residents found odd jobs for the laborers or fed them outright. All the work on the canal came to a standstill. Finally, the Massachusetts state legislature intervened. With money provided by the legislature, the laborers were sent back to their homes in Boston and New York. By November 1, 1880, the last of the Italian laborers were gone from Cape Cod. The legislature also reimbursed the town of Sandwich for the cost of feeding the laborers during the revolt, but refused to pay any of the costs associated with the extra police details that were called out during the Neapolitan Revolt.

In 1880, the *Yarmouth Register* wrote:

> *They have, all things considered, acted full well, if not better, than the same number of Yankee or Irish would have done.*

MORE TESTING

This ugly episode in the history of the Cape Cod Canal threw wide open the door to Whitney and his charter proposal. Hardy and his Cape Cod Ship Canal Company had been given a deadline of November 1, 1880, to begin work on the proposed canal or face the loss of their charter. Despite the soil that had been dug by the Italian laborers, Hardy's company had not met its obligations. The charter was awarded to Whitney and his company. With the successful Whitney at the helm of the new company, Congress expressed renewed interest in the Cape Cod Canal project. Although Whitney and his company now had the charter to dig the canal, Whitney said he was not about to spend millions of dollars on the project. He wanted more time to test the region. The legislature granted him and his company a one-year extension.

Two significant studies were done during this period. One was conducted by Lieutenant Colonel G.K. Warren of the Army Corps of Engineers and the other by Whitney's own engineers. Based on the study done by Warren, and soil borings done by Whitney's engineers, Warren concluded that a five-hundred-foot channel in Buzzards Bay, dredged to approximately twenty feet deep, would cost an estimated $350,000. The digging of the canal on the other side of the Cape would be more costly. Warren estimated that, because of the heavy clay found on the eastern side of the Cape, it would cost approximately $900,000 to dig the canal on the eastern side. Altogether, however, the cost estimates proposed by Warren were far less than any previous ones. Teetering on the cusp of becoming "the Father of the Cape Cod Canal," Henry Whitney faltered. He, like others before him, failed to act. Although the cost figures presented by Warren were reasonable, a report given to Whitney by one of his engineers showed that quicksand had been discovered along the proposed canal route. Because of this, Whitney withdrew from the project and, once again, the idea of digging a canal through Cape Cod was abandoned. But not for long: Secretary of the Navy William Chandler from New Hampshire convinced President Chester Arthur that a Cape Cod Canal would be an asset to the country's military defenses. President Arthur included the digging of a Cape Cod Canal in his plans for the country's coastal waterways. He made it one of his highest priorities.

A congressional committee reported favorably on the idea of digging a Cape Cod Canal as part of the country's military defense. It recommended that the federal government appropriate funds for digging the canal. This legislative bill never passed Congress. The biggest hurdle facing any person or company interested in digging the canal was money. Every group who petitioned the Massachusetts state legislature for

a charter to dig a canal had the best intentions. Sadly, none were able to substantially finance their proposals and the federal government was reluctant to appropriate any funding.

LOCKWOOD

By 1883, a new group of potential investors was granted a charter. The group, calling itself the Cape Cod Ship Canal Company, was named after the 1880 chartered company headed by Alpheus Hardy. New conditions were added to this company's charter, including the stipulation that the company spend $25,000 on digging the canal within four months. Alfred Fox, a member of the company from New York, claimed to have capital from Canadian investors to finance the project. In July 1883 the new company subcontracted with an East Boston industrialist, Frederick Lockwood, who owned a machine shop in East Boston, to begin construction on the canal.

Lockwood owned the license to a new type of dredge that had been developed on the West Coast. Lockwood was confident that with the new dredge he could finish the job, but soon problems developed. Fox was unable to secure the financing he had been promised by his Canadian investors. In an all-out effort to get the project off the ground (or in the ground) the company signed a contract with Lockwood to dig the canal. Eager to become a partner in the company, Lockwood put up $200,000 and agreed to pay

The railroad bridge looms over the town of Bourne today. *Courtesy of Nate Conway.*

any of the outstanding debts owed by the company. Lockwood obtained his financial backing from Boston financier Quincy Adams Shaw. Precious time had been lost during these financial dealings and the company had to spend $25,000 on the canal before the end of October or it would lose its charter. It was doubtful that the company would meet its obligation.

Lockwood's dredge was still in Boston waiting to be towed to Sandwich. Not to be thwarted in its endeavor, the company came up with an ingenious plan. It would build a wharf in Sandwich along the nonexistent opening of the proposed canal. Tons of lumber were shipped to the Sandwich site and the wharf was built along the phantom canal opening. The cost of building the wharf was $40,000, which far exceeded the company's financial obligations. Since the wharf was completed within the four-month deadline, the company did not lose its charter, despite the fact that it had not dug so much as a shovelful of dirt for the proposed canal.

Although Lockwood's partnership with the Cape Cod Ship Canal Company infused needed cash into the operation, the company became bogged down in legal negotiations that tied it up for the next ten years. There were a series of lawsuits and hearings before the Massachusetts legislature and the whole debacle was rife with charges and countercharges.

Frederick Lockwood claimed he had invested more than $150,000 of his own money in the project without any form of reimbursement. Although Quincy Adams Shaw had put up the initial investment, he refused to spend any more money on the project. Lockwood tried to raise the needed money on his own. He took an option on fifty thousand shares of the company's stock at fifty cents per share. He claimed that the purchase of the shares entitled him to exclusive control of the company. The other members of the company were not about to relinquish control. The whole ugly mess ended up in the courts where it languished for more than a decade. In the midst of all the legal and financial problems, some minor headway was made in the actual digging of the canal. Lockwood's dredge was towed from Boston to Sandwich, where it began work. The monstrous machine was fitted with two seventy-five–horsepower engines and more than thirty dredging buckets. The seemingly endless chain of buckets dug the Sandwich dirt, sand and clay out, lifting it more than fifty feet in the air where it was dropped into a drain. Hundreds of curiosity seekers turned out on Scusset Beach on the day Lockwood's dredge began working. The dredge broke down frequently and was in constant need of repair. Lockwood made the repairs himself but left the day-to-day operation of the dredge to Cornelius Driscoll, a well-known and admired Cape Cod fisherman. Because of the legal and financial problems, the dredging of the canal ended in June 1890. Lockwood petitioned the legislature for an extension on his charter and was granted four more years. Confronted with growing legal costs and his own personal financial ruin, Lockwood was forced to abandon the project. In 1899, Lockwood lost his East Boston machine shop to a devastating fire.

Visible Progress

Despite Lockwood's troubles, his dredging machine had made some substantial progress. By the time the dredge was forced to cease operation at its Sandwich site, nearly 800,000 cubic yards of earth had been excavated. After the dredge was towed away, there was a 7,000-foot-long ditch dug at the depth of approximately 40 feet and almost 200 feet wide. The beginning of the Cape Cod Canal was now visible to the naked eye.

Lockwood had also managed to purchase more than a thousand acres of Cape Cod property where the canal was going to be dug. It would ultimately be almost all of the land needed for the digging of the canal. However, it was not until the end of the nineteenth century (1899) that another charter of significance was issued. This time the legislature issued a charter to a group of investors calling themselves the Boston, New York and Cape Cod Canal Company. The leader of this group was Dewitt Clinton Flanagan. Flanagan's wealth came from the manufacturing and sale of beer. His new canal company was required to make an initial investment of $200,000 in the project. The company was allowed to raise $12 million through the sale of stocks and bonds. Unlike previous charters that were granted, no construction timetable was included in the charter. This allowed Flanagan and the other owners of the Boston, New York and Cape Cod Canal Company time to raise the needed capital. It also gave Flanagan enough time to find the right person to actually complete the project. It took five years to do it, but Flanagan ultimately found the right person for the job. That person was New York financier August Perry Belmont Jr. It was Belmont who accomplished what so many had dreamed of doing before—building the Cape Cod Canal.

In *Walden*, Henry David Thoreau wrote:

> *All endeavor calls for the ability to tramp the last mile, shape the last plan, endure the last hours' toil. The fight to the finish spirit is the one characteristic we must possess if we are to face the future as finishers.*

The Boston, New York and Cape Cod Canal Company

Dewitt Clinton Flanagan appointed Dr. Corthell as the chief engineer along with Charles Thompson. They were assigned the task of surveying the land surrounding the intended canal. Flanagan then sought financing from the Maryland Trust Company of Baltimore. The trust named Alfred Rives as its proprietary engineer for the project. Rives had served as superintendent of the Panama Railroad during the building of the Panama Canal. Both Corthell and Rives served as engineers on the project for the Trust Company.

Unfortunate financial situations associated with the depression of the national economy at the time caused the Maryland Trust to withdraw its financial support for the project, and Flanagan was forced to use his own money to deposit $200,000

with the Massachusetts state treasurer's office in order to stop the charter from being terminated. The money was held by the treasurer's office to ensure payments needed for the annexing of land and any associated damages that might arise from it. Faced with holding a valid charter for the building of the canal but no financing, Flanagan turned to August Belmont Jr.

The legislative act incorporating the Boston, New York and Cape Cod Canal Company was known as Chapter 448, the Acts of 1899. It was later amended in 1900 and then again in 1910. This charter and its subsequent amendments allowed for the company to issue capital stock and bonds not to exceed $6 million. It gave the company the right to construct and operate a canal from Cape Cod Bay to Buzzards Bay, including any and all buildings and structures used for the operation of the canal such as docks, breakwaters and wharves, and to operate and maintain any steamships or other vessels.

The charter spelled out in detail the minimum depth (twenty-five feet) and minimum bottom width (one hundred feet) and the angle and slope of all the land along the canal and its minimum water surface (twenty feet). It gave Flanagan's company the power to take land necessary for the building of the canal as well as holding the company liable for any associated damages. Further obligations assigned to the charter included reconstruction of portions of the Old Colony Railroad that would be affected by the construction of the canal, including any bridges crossing the canal.

The company was obligated by the charter to maintain, without any charges, all ferries, bridges, tunnels or highways used in the construction and operation of the canal, as well as to construct highways to connect with the canal crossings and to replace those highways damaged by the construction of the canal.

The financial obligations of the company, already met by Flanagan himself, included the $200,000 deposit made to the Massachusetts treasurer's office as well as $25,000 paid to the Barnstable County treasurer as a guarantee that any land damages associated with the building of the canal would be paid in cash.

On the positive side, the charter gave the company the authority to charge tolls for the use of the canal and for towing rates. Calculated out by Flanagan, the issuance of rates would turn a hefty profit for the company regardless of all the other provisions and obligations.

The complex charter also defined who had control over the various aspects of the canal construction and subsequent operation. The Harbor and Land Commission was given control over any general plans associated with the canal's construction. The Railroad Commission was given authority over the relocation of the Old Colony Railroad and any associated bridges or tunnels and oversight of the operation of any bridges across the canal. Even the Cape Cod county commissioners, as well as town selectmen, were given control over the relocation of highways, highway crossings and the condemnation of various parcels of property.

Despite the restrictive parameters of the charter, August Belmont decided to begin construction on the canal in 1909. He established the essential network needed to finance the operation, and structured the Cape Cod Construction Company, which was

awarded the contract to build the canal. In essence, Belmont and Flanagan's company, the Boston, New York and Cape Cod Canal Company, would be paying itself to construct the proposed canal.

In addition to Belmont, the board of directors and officers for the company included Charles Allen, F.R. Appelton, E. Mora Davison, A.L. Devens, W.A. Harriman, E.W. Lancaster, L.F. Loree, W. Miller, F. DeC. Sullivan, Frederick Underwood and H.P. Wilson. Also included on this illustrious board was the noted William Barclay Parsons, who would serve as the chief engineer of the canal project. Executive officers of the company included Belmont as president, Miller and Devens as vice-presidents, John J. Coakley as treasurer and U.A. Murdock as secretary. They all served on the board and as officers throughout the building of the canal.

With his charter in place and his handpicked board of directors, Belmont began construction of the Cape Cod Canal in earnest. The digging of the canal began in Barnstable Bay, approximately three miles north of Sandwich. Plans called for the canal to cross the low-lying marshes of the Scusset River, passing through Bournedale and following the general alignment of the Monument River into Buzzards Bay. The construction of a straight channel from the mouth of the Monument River into the deep waters of Buzzards Bay was prohibited because of boulders and shallow shoals in Buzzards Bay. There would have to be two turns in the canal in order to connect the two harbors. These turns would later be eliminated when the Army Corps of Engineers reconstructed the canal in the 1930s. But, until then, Belmont's original Cape Cod Canal would more or less zigzag through the bared and bended arm of Cape Cod.

The Face of the Waters

August Belmont Jr. and the Building of the Cape Cod Canal

And the earth was without form, and void; and darkness was upon the face of the deep.
And the Spirit of God moved upon the face of the waters.
—*Genesis,* Old Testament

Work Begins

Still one after another the mackerel schooners hove in sight round the head of the Cape, "whitening all the sea road," and we watched each one for a moment with an undivided interest. It seemed a pretty sport. Here in the country it is only a few idle boys or loafers that go a-fishing on a rainy day; but there it appeared as if every able-bodied man and helpful boy in the Bay had gone out on a pleasure excursion in their yachts, and all would at last land and have a chowder on the Cape.

—Henry David Thoreau, Cape Cod

When Flanagan first brought the Cape Cod Canal project to Belmont's consideration, Belmont immediately consulted with William Barclay Parsons, the leading engineer of the period. Parsons was a member of the Panama Canal Commission and had known Belmont from their association during the building of the first New York City subway. Parsons immediately began studying the plans and proposals.

Although so many had failed over the past three hundred years to make the Cape Cod Canal a reality, Belmont seized the opportunity. Paramount among the reasons why he undertook the enterprise was his undying belief that, if the New England region was to flourish as a major manufacturing and trade base, it would be crucial for raw materials like coal, timber, cotton and other goods to be easily transported. Not only had the centuries-long history of shipwrecks cost an extraordinary number of lost lives and property, but also, in many instances, it had weakened the region's ability to compete. The loss of raw materials had far-reaching effects on the New England economy. Belmont, who through his financial investments had a vested interest in keeping New England prosperous, saw the building of the canal as a way to enhance the region's prosperity.

Another factor Belmont took into consideration was the dramatic changes that had occurred within the transportation industry. The shipping of raw materials along the treacherous Cape Cod coastline had depended primarily on clipper ships. By 1906,

much of this raw material needed in manufacturing was being transported by barges, which could hold more freight than could the schooners. The problem with the barges was that they were exceedingly more helpless, at the whim of bad weather and the tides, in navigating the rough waters around the Cape. The Cape Cod Canal would circumvent this problem. With a canal in place, the barges could theoretically transport more raw materials to New England manufacturers more frequently. Keeping these lines of transportation open and flourishing was of the utmost importance in Belmont's calculations.

In the large scope, the building of the Cape Cod Canal was not being done in isolation. It was projected to be the furthermost link in the network of improved inland waterways stretching from the Panama Canal northward.

Following extensive engineering work carried out by William Barclay Parsons, the first block of granite for the canal breakwater was dropped into the waters along the proposed canal route on June 19, 1909.

A government permit for building the two breakwaters in Cape Cod Bay arrived in Sandwich on June 20, 1909, and work was officially underway. A half-dozen schooners loaded with granite began to dump their cargoes off the Sandwich coast. Some work had already commenced along an inland area, but no work on the potential opening of the new canal had been attempted until the schooners arrived. The boats that had sailed down from Maine bringing the granite were unable to dump their cargo into the bay for the building of the breakwater because government approval was required. The secretary of war finally issued the permit and the unloading began.

PARSONS'S VIEW

Speaking before the Boston Chamber of Commerce in May 1910, approximately a year after the first work on the canal began, the chief engineer for the project, William Barclay Parsons, told the gathering,

> *I feel some diffidence in prophesying the commercial outcome and the results to your section of the country. I am afraid that my enthusiasm might carry me away. I do believe, however, that it will mark the greatest forward step in local commerce since the introduction of steam to coastwise trade.*

Parsons went on to tell the gathering,

> *This is a private enterprise, supported by private capital invested under a state charter and under the immediate control of your own state commissioners, asking for neither federal, nor state, nor municipal aid. It will charge rates of toll, which rates are expected to be remunerative. But they cannot be remunerative unless they are also remunerative to the consumer. For the company to make money, you also make money. This canal will be an adjunct to Eastern harbor; its traffic will be a part of your commercial life. I believe I*

William Barclay Parsons was the chief engineer for the Cape Cod Canal project.

am not overstepping the bounds of my authority when I say that Mr. Belmont, himself a Harvard man and partly a New Englander by descent, through whose influence this enterprise is becoming a reality, and his associates, welcome the interest shown today by this Chamber, and will further welcome any suggestion, inquiries or co-operation that may tend to the development of those matters that are in common, and in which any benefit accruing must necessarily be shared both by the canal company and the commerce of New England.

Parsons explained that routes through the Cape's Back River and a previously proposed Hyannis route for the canal had been rejected.

The route that has been selected is to follow the Monument River at the head of Buzzard's Bay, widening, deepening and straightening it, and then cutting through the low ridge that forms the divide between the watersheds of Buzzard's and Barnstable Bays and reaching the shores of Barnstable Bay on the Scusset marshes just west of the town of Sandwich.

Buzzards Bay had a fine, "land-locked harbor," according to Parsons, and the only construction work necessary there would include deepening the existing channel "along the easterly shore of the bay to a point just southwest of Wing's Neck light, where the 26-foot contour is reached."

There is no harbor of any consequence between Plymouth and Provincetown. At Sandwich the shore is a straight unbroken beach, exposed to the north to northeast gales. In order to protect the mouth of the canal from the literal drift that takes place during the north or northeast storms, the plans contemplate a breakwater running out from the shore for a distance of 3,000 feet, which places the outshore end at a depth of 30 feet at low water. This breakwater is intended to make a harbor behind which vessels can lie at anchor. A wide and straight channel will be dredged parallel to the breakwater, which will be of sufficient length to permit tugs with vessels in tow to straighten out to enter the canal even in rough weather. It will also guard the canal from the moral drift, which otherwise would close its mouth and would further prevent waves from rolling into the canal, which, if not thus stopped, would probably be transmitted for a long distance before being absorbed.

WILLIAM BARCLAY PARSONS

Born in 1859, William Barclay Parsons was one of the country's preeminent civil engineers. A graduate of Columbia University, he founded Parsons, Brinckerhoff, Quade and Douglas, one of the largest civil engineering companies in the country. In 1894, Parsons became the chief engineer for the New York Rapid Transit Commission.

He was responsible for building the Interborough Rapid Transit Subway (IRT), which opened in 1904. Parsons Boulevard in Queens, New York, is named in his honor.

According to the noted engineer, "The underlying principles of the present state of world culture, or civilization as it is usually and erroneously called, rest on engineering."

Parsons's company built docks in Cuba and hydroelectric plants across the United States. He served as a consultant to the Panama Canal Commission, and although he recommended a canal route across Nicaragua at sea level, his ideas were disregarded by then-President Theodore Roosevelt. After serving as the chief engineer of the Cape Cod Canal project, Parsons became the primary surveyor of China's thousand-mile route from Hankow to Canton. His vast knowledge and impeccable reputation as an engineer and businessman made him indispensable to August Belmont Jr. during the construction of the Cape Cod Canal.

JEREMIAH'S DRAIN

Ironically, Belmont's canal was not the first man-made channel dug on Cape Cod. The first, now long-forgotten, waterway was known as Jeremiah's Drain and was located along the border of Orleans and Eastham. Jeremiah's Drain assisted Cape sailors for nearly two hundred years before Belmont finished his canal.

Certain geographical indications showed that there was a saltwater river running through the reedy marshlands on the Orleans side of the bay straight through to the east side along Nauset Harbor. The waterway was especially dominant during high tides. According to some Cape Cod historians, some of the Cape's earliest explorers, Gosnold included, may have been deceived by the waterway, leading to the erroneous opinion that Cape Cod was an island to begin with. Of course, this was not true, and Jeremiah's Drain was only the result of seasonal flooding and heavy rains.

Still, during the earliest periods of the colonization of Cape Cod, sailors were reluctant to navigate the treacherous waters rounding Provincetown and were especially concerned about the nearly impassable currents off the Truro coastline. Faced with this problem, not to mention the amount of time such a trip around Provincetown would take, colonists and sailors took it upon themselves to lend a hand to this naturally occurring waterway.

In 1717, a narrow channel was dug through the property of Jeremiah Smith in Truro that connected Boat Meadow Creek on the bay side to the Town Cove, giving sailors a water passageway to Nauset Harbor. The canal was barely wide enough for one boat to pass at a time, but it was faster and less dangerous than the trip around Provincetown. The depth of the little canal was at the whim of low and high tides, but still, at its new hand-dug depth, it managed to service boats with a capacity of twenty tons. A whole day could be cut off the usual travel time by using Jeremiah's Drain.

In 1797, when Orleans was founded, Jeremiah's Drain served as the northernmost border for the new community. In 1804, this first canal was widened to accommodate

larger vessels, and by the War of 1812 it served as a protected transportation route for the colonists who used it to ship supplies out to the ocean, allowing them to avoid seizure by the larger British ships that were patrolling off the Cape Cod coast.

Ultimately, interest in Jeremiah's Drain waned, although in the early 1820s a company calling itself the Eastham and Orleans Canal Proprietors applied for a charter from the state legislature for the purpose of digging a more sophisticated canal through the original location, but speculation determined that a larger canal along the Orleans route wouldn't dramatically decrease the dangers posed by the outer shoals all along the Cape Cod coast. The idea was never acted upon and Jeremiah's Drain slipped quietly into Cape Cod history.

THE MARCONI STATION AT SOUTH WELLFLEET

Even as the prospects for digging the Cape Cod Canal were being discussed, an equally monumental event took place on Cape Cod. On January 19, 1903, the Marconi wireless station, known also as the South Wellfleet transmitting station, sent a message from President Theodore Roosevelt to Edward VII, king of England. Although not the *first* transatlantic transmission, it made history as the first transatlantic message to be sent from the United States.

Italian inventor Guglielmo Marconi was successful in sending messages across the English Channel, and in 1902 he sent one across the Atlantic from England to Nova Scotia. He selected a number of sites around the world for the purpose of building transmitting stations and Wellfleet, on Cape Cod, was chosen as one of these sites. Marconi chose the location at Wellfleet because of the barrenness of the site overlooking the vast sea.

The Wellfleet station was built in 1901, but the huge transmitting towers, as well as the station itself, were destroyed in one of the many powerful storms that hit Cape Cod. The station was rebuilt, including four 210-foot-high towers used to support the huge antenna. The towers were built out of wood and sat atop concrete bases. A network of heavy steel cables buttressed the towers. The station had the power to transmit a distance of approximately 1,500 to 3,500 miles.

Inside the station was a twenty-thousand-volt condenser along with the antenna-tuning device, as well as a coil and the rotary motor. A forty-five-horsepower generator provided twenty-two hundred volts of electricity that could be increased to the nearly twenty thousand volts that were needed to transmit. The station in Wellfleet had a six-man crew, including two engineers as well a manager and three operators.

Marconi convinced President Theodore Roosevelt to take part in the experiment to send a wireless message from Cape Cod to England's King Edward VII. Roosevelt's message was tapped out in Morse code and sent to the station in Poldhu on the English coast of Cornwall.

Roosevelt's message read:

> In taking advantage of the wonderful triumph of scientific research and ingenuity which has been achieved in perfecting a system of wireless telegraphy, I extend on behalf of

the American People most cordial greetings and good wishes to you and to all the people of the British Empire.

King Edward responded, over a distance of some three thousand miles, making history once more for Cape Cod.

The Wellfleet station was also involved in another, more tragic affair. On the night of April 14, 1912, an operator at the Cape Cod station received an SOS distress signal from the *Titanic*—the world's most technologically advanced ship. The message from the sinking vessel read: "sinking fast...putting women and children off in lifeboats... cannot last much longer...come quickly."

According to some maritime historians, the *Titanic* was the first ship ever to use the SOS distress call. When America entered the war in 1917, the Wellfleet station was closed. In 1920 the four towers were dismantled and the buildings abandoned.

PROMISES TO KEEP

Speaking before the Atlantic Deep Waterways Convention in Richmond, Virginia, in October 1911, Commodore J.W. Miller, the vice-president of the Cape Cod Canal Construction Company, told the audience that the new canal would be completed in 1913 as planned. According to Miller, more than 25 million tons of shipping were at the mercy of the elements each year off the Cape Cod coast, and the new canal would end the need for navigating around the dangerous Cape. He told the audience that the new canal would substantially reduce the time for all vessels leaving Boston to points south.

Speaking about the canal, Miller said:

> As a matter of fact, it is not a canal at all, but a short connection of eight miles through a sandy isthmus with an elevation of only 29 feet above sea level; a connection joining two portions of a much traveled ocean route....No locks and little current will hamper its passage. Its channel will be 30 feet at high water—deeper and broader than the Manchester Kiel and the original Suez Canal.
>
> From the deep water in Buzzards Bay to the end of the breakwater at the eastern end will be a distance of only thirteen miles. It will be lighted electrically as a street for quick transit during the night. At its eastern end there is already built a breakwater containing over 400,000 tons of granite.

At the time he spoke, almost half the work on the canal had been completed using eight large dredges and several steam shovels. Over a thousand acres of land had been purchased along the banks of the proposed canal for the purpose of establishing a variety of factories that had already requested to locate along its banks.

DIFFERENT TIDES

The canal was designed to connect two entirely different types of bays, Cape Cod Bay and Buzzards Bay. The Cape Cod Bay was, and remains, virtually a straight link to the Atlantic Ocean. Its opening is approximately twenty-one miles wide and spherical, with a bowed and lengthy shore. Its depth ranges from approximately a dozen to more than twenty fathoms deep. The bay's floor is mostly flat with no unexpected or dangerous shoals or sandbars.

Buzzards Bay, conversely, is much different. It is longer than the Cape Cod Bay, measuring approximately fifty miles, with its opening a meager seven miles wide. It measures approximately ten fathoms deep at its opening, slipping down to a mere two fathoms toward its shoreline end.

Both bays are influenced by uniquely different tide patterns, and connecting them would prove to be an almost insurmountable problem. The characteristics of the tidal currents flowing through Buzzards Bay are created as part of a tributary of the Atlantic tides, which runs north up the coast of Cape Cod at a less-than-powerful rate. The tides pushing their way through the Cape Cod Bay travel along the Atlantic Coast at a stronger and faster rate, propelled along by the deeper waters offshore. Both of these currents meet off the Vineyard Sound, creating a whirlpool of vastly changing currents that sweep along off the Cape Cod coast and wreak havoc on ships using the route around the Cape.

Engineers for the canal project were faced with an unusual set of hydrodynamic problems because of the considerable magnitude and differences between the two bodies of water. According to a 1909 report prepared by the Corps of Engineers and provided to the canal's chief engineer William Barclay Parsons:

> *The numerous and extensive shoals lying eastward and southeastward of the southeasterly elbow of Cape Cod, constitute probably the greatest danger to navigation to be found on any of the coastwise routes of the Atlantic coast of the United States north of Hatteras. In view of the numerous vessels passing around these shoals they are probably a greater menace to navigation than Hatteras. Their dangerous character is shown both by the large number of wrecks annually occurring there and by the large number of light vessels and other aids to navigators traversing the shoals.*
>
> *From Nantucket Sound to the ocean, two channels lead through the shoals. The north or Pollock Rip Channel is the most used, as it is shorter, is somewhat protected from easterly storms by the shoals outside it, and is closer to the shore; but it is quite circuitous and narrow in places and the tidal currents are strong and varying in direction. The second or south channel leads through the shoals in nearly due east direction from Nantucket (Great Point) Lighthouse. It is somewhat deeper than the Pollock Rip Channel and much wider, but it is not so direct for coastwise vessels and carries a vessel much farther from the shore. This channel is considered in the United States Coast Pilot for the Atlantic coast as the dividing line between Nantucket and Monomoy Shoals, the shoals lying to the northward of the channel being called the Monomoy Shoals, while those to the southward are called the Nantucket Shoals.*

CHAPTER SEVEN

The Portland Gale

It is generally supposed that they who have long been conversant with the Ocean can foretell, by certain indications, such as its roar and the notes of sea-fowl, when it will change from calm to storm; but probably no such ancient mariner as we dream of exists; they know no more, at least, than the older sailors do about this voyage of life on which we are all embarked. Nevertheless, we love to hear the sayings of old sailors, and their accounts of natural phenomena, which totally ignore, and are ignored by, science.
—*Henry David Thoreau,* Cape Cod

It was not just the dangerous shoals around Cape Cod that wreaked havoc and disaster on ships in the region. Storms also played an important role in making Cape Cod one of the most dangerous sailing routes in the world.

In 1853, Cape Cod and Provincetown were hit by a storm that wrecked more than twenty ships anchored in Provincetown Harbor. In 1871, a squall of enormous proportion swept across Cape Cod, damaging hundreds of ships and killing dozens of sailors.

But it was probably the epoch storm of 1898 that is most indelibly etched into the collective Cape Cod memory. It is referred to as the Portland Gale after the tragic sinking of the steamship *Portland* outward bound from Boston for Maine. The storm washed parts of wreckage from the *Portland* ashore in North Truro and Provincetown.

That cold November in 1898, Cape Codders ruled the seas. Clipper ships from the Cape sailed tons of cargo and passengers around the world and whaling fleets from Provincetown and Nantucket transported a wealth of whale oil from the farthest oceans. And it wasn't simply the seas over which Cape Cod had dominion. Cape Cod became the country's largest producer of strawberries in the country. The cranberry industry was flourishing. In Sandwich, the Sandwich Glass Works had become the greatest manufacturer of glassware. Business and industry were booming on the Cape, but it all came crashing down in a few short years and the Portland Gale, in retrospect, looms as a premonition of what was to come.

By the turn of the century, only a few short years away, clipper ships no longer ruled the sea and had been replaced by steamships. Whale oil was replaced by crude oil discovered in the Midwest. Even the Sandwich Glass Works fell on hard times.

THE SINKING OF THE *PORTLAND*

On November 26, 1898, there were reports of the seas being tossed by a savage north wind. By midday, there were reports coming out of New York City of a storm bringing with it heavy falling snow and powerful headwinds. The convergence of these two growing storms produced what many later referred to as the "hundred-year storm."

Cape Cod was no stranger to storms, nor was it a stranger to shipwrecks. Thousands of wrecks littered the Cape Cod coast, but the sinking of the *Portland*, a 291-foot-long, 2,280-ton paddlewheel steamship, has gone down in the annals of Cape Cod disasters as the *worst* of all shipwrecks.

The Portland Gale is assumed to have been caused by two gathering storms that converged over southeastern New England and Cape Cod. One storm traveled northerly in direction. A second storm raced down from the Great Lakes Region, bringing with it hurricane winds. According to reports, sometime between the hours of 9:00 p.m. and 11:00 p.m. the two powerful storms collided, becoming what is known as the "hundred-year storm." The winds shifted out at sea, increasing from forty miles per hour to seventy miles per hour. Moving steadily from north to northeast, the storm reached a velocity of ninety miles per hour as reported off the Cape Cod coastline and farther south near Provincetown.

The Cape and Islands were pounded by sleet, rain, smashing tides and snow. Still, the storm hadn't reached its capacity. At five o'clock on the morning of November 27, 1898, the tempest reached its most powerful scope. According to reports:

> At daybreak a foot of snow was on the ground and the storm continued unabated. The railroad lines were hopelessly blocked and in other areas swept away completely. Telegraph lines were down and Cape Cod found herself cut off from the rest of the world. And out there, on the raging seas, hundreds of vessels and thousands of sailors battled for their lives throughout the long night and the relentless stormy days to follow.

In its violent wake, the storm would take with it the *Portland*—her passengers and crew all were lost at sea somewhere off the Truro coast. The damage caused by the Portland Gale included the loss of some two hundred ships and nearly five hundred people in addition to those who were lost aboard the *Portland*.

On land, trees were uprooted and homes, businesses and buildings were damaged or completely destroyed. The streets of many Cape Cod communities were flooded over. People would talk about the storm for many years, using it as a yardstick to compare other storms that swept across the Cape. And the sinking of the *Portland* and the loss of all its passengers remained a vivid tragedy to most Cape Codders.

The Portland Gale

Of 136 passengers and a crew of 40 men, there was not a single survivor. To this day, not all the facts surrounding the wreck of the *Portland* are known and the story of its sinking remains the topic of much debate among ship and shipwreck historians.

Nearly fifty years later, in 1945, deep sea diver Al George of Malden, Massachusetts, found the wreck of the *Portland* located seven and a half miles off the coast of Provincetown and sunk in 140 feet of water. He brought from the wreck a stateroom key, clearly marked with the ship's name.

Ironically, George's discovery was based on information provided to him by the noted New England shipwreck historian Edward Rowe Snow, but the discovery provided no further clues as to how and why the disaster occurred.

"It would seem as though the *Portland* had hit bottom on her beam ends and then through the years had worked her way into the sand until she is buried almost completely. Only the bare hull of the ship seems in position," George wrote of his discovery.

According to George, "It was a strange experience standing there alone with the ill-fated *Portland* and probably what remained of the passengers and crew still imprisoned in her sand-covered hull."

The *Portland* went down on the night of Saturday, November 26, or early the following Sunday, November 27, 1898. It is estimated that the steamer was still afloat sometime early Sunday morning, since Captain Samuel Fisher of Provincetown's Race Point Life-Saving Station recorded several blasts from a steamer's whistle that Sunday morning.

The sighting of two steamers and a schooner off the Provincetown coast were also recorded that morning during a lull in the ferocious storm. The storm subsided for a brief time and then recovered its full force later that Sunday morning and continued on into the early evening. As early as 7:00 p.m. that evening, with the storm subsiding, wreckage from the *Portland* began to wash ashore along the Provincetown beach. The next morning, Monday, November 28, 1898, the entire Provincetown shore was covered with debris from the wreck. Only thirty-six bodies from the *Portland* were recovered of all that washed ashore in the storm. Watches found on the bodies were stopped between 9:30 and 10:00 a.m., giving credence to the idea that the *Portland* was still afloat, floundering at sea, that Sunday morning.

The *Portland* was a wooden side-paddle ship, weighing more than twenty-two hundred tons. She was built in 1890, expressly for the purpose of providing passenger service between Boston and Portland, Maine. The ship measured nearly three hundred feet in length and had a forty-two-foot beam. The *Portland* had a top speed of twelve knots per hour and was usually able to make the run from Boston to Portland in eight hours, depending on the weather. Like many ships of her kind, broad-built side-wheelers, the *Portland* was a fair-weather ship, not intended for rough seas and severe storms.

It had been the practice of the ship's captain to keep the vessel in port if the weather was threatening. If the weather became too dangerous while it was out at sea, the ship took refuge in the nearest port. At no time during its run from Boston was the *Portland* ever too far from a safe port of refuge. It was, however, up to the captain of the vessel to determine when to put into port based on the weather conditions.

The captain of the ill-fated *Portland*'s last voyage was Hollis H. Blanchard. The controversy over Blanchard's judgment that cold November day in 1898 as he prepared to leave Boston Harbor is still debated.

THE DAY BEGINS

The day began pleasantly enough. The sky was clear, the weather cold and there was a slight offshore breeze. However, as the day wore on, the sky over Boston Harbor darkened and the threat of a pending storm was in the air. Weather reports indicated that a storm out along the Great Lakes region was about to join forces with an equally volatile storm roaring in from the Gulf of Mexico. The effects of it had not yet been felt in Boston, so the crew of the *Portland* prepared for the voyage, while streams of passengers came aboard.

Since the voyage came on the weekend following the Thanksgiving holiday, there were more passengers than usual. Many of them were returning home to Maine after spending the holiday in New York, Massachusetts and points farther south. Ironically, some passengers canceled their accommodations for one reason or another. Among them was the wife of Captain William Thomas of Bailey's Island, Maine, the captain of the fishing boat *Maud S*. Captain Thomas was out to sea the night the *Portland* sailed. With his wife aboard the vessel, Thomas was obviously watching for the steamer, and he caught sight of it that evening at approximately 9:30 p.m. Thomas and his fishing boat were a mere two miles away from the steamer as it churned its way up the coast. Thomas noted in his log that it appeared that the *Portland* was running closer to shore than usual. Nothing at that time led Captain Thomas to believe that Captain Blanchard was taking on a dangerous or foolhardy journey. Still, it was with great relief that Thomas learned later that his wife, invoking her privilege to change her mind, decided *not* to sail with the *Portland* that evening.

There were other fortunate ones. Anna Young of Boston reported that, while she was aboard the *Portland* and the last whistle had sounded for all visitors to go ashore, she received a telegram from her mother warning her about a pending storm and asking her to disembark.

"Carrying my child, I ran for the gangplank just as they started to lift it, and they waited for me," Mrs. Young said. "When I got ashore I heard the final whistle of the *Portland* as she left the wharf."

George Gott of Brookline, Massachusetts, said that the ship's cat caused him to change his mind. While Gott was standing on India Wharf, waiting to board the ship, he noticed the ship's black cat systematically removing her litter of kittens from the ship. She slipped aboard and carried them, one after another, off the ship to safety. This was enough for Gott. If the *Portland* didn't seem safe enough for the ship's cat, it surely wasn't safe enough for him. Gott decided not to sail that night and changed his reservation.

Others were not so fortunate, including Captain Blanchard. The manager of the Portland Steam Packet Company, John F. Liscomb, supposedly received warning of the pending storm and attempted to contact Blanchard by telephone from his offices in Maine, but he was unsuccessful. Liscomb was able to reach Captain Alexander Dennison, the captain of the *Portland*'s sister ship, the *Bay State*. Liscomb told Dennison to advise Captain Blanchard not to leave Boston until 9:00 p.m. that evening, when the scope of the storm could better be determined. There may have been a rivalry between Blanchard and Dennison, since Blanchard was in the habit of calling Dennison the "kid pilot" because of his youth.

Still, Dennison advised Blanchard of the orders, but Blanchard maintained that if he left on time he would be able to reach Portland well before the storm hit. Some contend that it was Blanchard's hubris that made him sail out of port, despite the warnings given him, in order to show up the young captain. Although only conjecture, it is rumored that Blanchard wanted to prove his sea superiority over Dennison by reaching Portland Harbor safely, while Dennison was still cradled in Boston Harbor.

Edward Rowe Snow interviewed Captain Blanchard's granddaughter, who told him that her grandfather, after being confronted along the Boston Wharf and warned of the pending severe storm, said, "I have my orders to sail and I am going!" They were the last words spoken by Captain Blanchard before he sailed out of Boston Harbor to his watery grave.

A government investigation was undertaken to determine what had happened to the *Portland* and why. Initially, the investigation sought to fix the blame on Captain Blanchard. However, there was nothing substantial to indicate that Blanchard had acted anything other than appropriately. There was no reason, according to the investigation, for the captain not to leave port. According to reports, the storm that hit the New England coast that evening was swift, sudden and unpredictable. Captain Blanchard could not have known what he was sailing into when the *Portland* steamed out of Boston Harbor at seven o'clock on the evening of November 26, 1898.

WHEN THE STORM HIT

It is speculated that the *Portland* was a mile or two away from Cape Cod when the storm hit. It is likely that, faced with the rising gale, Blanchard headed out to open sea to ride out the storm. Given the structure of the ship and the severity of the storm, it is also likely that the huge steamer began listing to the starboard, causing her portside paddlewheel to rise out of the water. This also would explain why the vessel headed farther and farther out to sea along the coast of Cape Cod. It is, however, only speculation. The last time the *Portland* was seen afloat was when Captain Thomas of the fishing vessel *Maud S* caught sight of her that evening.

When the eye of the hurricane passed over Cape Cod around 9:30 a.m. the next morning, bringing with it a deathly still calm, the *Portland* was still floundering eight to ten miles off the Provincetown coast. When the storm returned with all of its massive fury later that morning, the ship and its passengers and crew were lost forever.

For years following the disaster, relatives and friends of those lost aboard the *Portland* gathered at India Wharf in Boston Harbor to hold memorial services. Each November 26 at 7:00 p.m., the group, known as the Portland Association, gathered at the wharf, where the names of the victims were read aloud and flowers were dropped into the water as a remembrance.

The group's last memorial service was held in 1948 and a memorial plaque was erected along the Provincetown coast, commemorating the lost souls of the ill-fated *Portland.* Her legacy is probably best summed up in the words of Edward Rowe Snow, who wrote:

> *Perhaps it is just as well to let the old steamer rest for the remainder of her existence at the bottom of the sea, undisturbed by visits from the world above the surface....In any event, the last voyage of the Portland will remain forever New England's greatest saga of the sea.*

The memory of tragic shipwrecks, like that of the *Portland*, was embedded into the mind of August Belmont Jr. as he undertook the monumental task of building the Cape Cod Canal.

August Belmont Jr.

The single road which runs lengthwise the Cape, now winding over the plain, now through the shrubbery which scrapes the wheels of the stage, was a mere cart-track in the sand, commonly without any fences to confine it, and continually changing from this side to that, to harder ground, or sometimes to avoid the tide. But the inhabitants travel the waste here and there pilgrim-wise and staff in hand, by narrow footpaths, through which the sand flows out and reveals the nakedness of the land. We shuddered at the thought of living there…The walker there must soon eat his heart.

—*Henry David Thoreau,* Cape Cod

August Belmont Jr. was born February 18, 1853, in New York City. He was the second child of August and Caroline Belmont. His father was one of the country's leading bankers, a Prussian Jew who came to America in the capacity of the diplomatic service and began his career in high finance working for the Rothschilds. August Belmont Sr. made a vast fortune and became known for his horse racing stables, an interest that his son later developed as well. The Belmont Park racetrack in New York is named after him. In 1887, August Belmont became ill and suffered on and off for three years until his death in New York in 1890. He left an estimated $50 million to his wife and his four surviving children.

August Jr. attended private schools and later graduated from Harvard University in 1874, despite some dubious academic concerns. He admitted that he was a poor student, and he had to spend considerable time under the guidance of a special tutor in order to graduate. Belmont, an avid runner while in college, is credited with inventing the spiked running shoe for track and field. While a member of the Harvard track team, he hired a local shoemaker to put spikes on his running shoes to provide better traction. Soon, the spiked running shoe became standard running gear for track teams all across the country. He joined his father's international banking enterprise (August Belmont & Co.) the year after he graduated from Harvard.

His contributions to his father's ongoing financial concerns were enormous, so much so that by 1883 he was managing the daily operations of the company. Following the

death of his father in 1890 he became president of the company. During this period, he was credited with financing a $63 million loan for the second administration of President Grover Cleveland. The loan was done in concert with one of America's premier financiers, J.P. Morgan. He maintained close relationships with J.P. Morgan as well as John D. Rockefeller.

In 1881, he married Elizabeth Hamilton Morgan. The Belmonts had two children, August Belmont III and Raymond. His wife Elizabeth was born in 1862 and was the daughter of Edward Morgan, who was a former member of the banking business Matthew Morgan & Sons. Her mother was a member of the old New York Hamilton family dating back to Alexander Hamilton. She was only thirty-five years old when she died.

August Jr. had known Elizabeth since childhood when they lived in adjoining homes on Fifth Avenue in New York City. They were married at a large ceremony held at the Church of the Ascension in New York City. Prior to the birth of their two sons, she had been a leading member of New York City high society. After their birth, Elizabeth disappeared from the social spotlight and spent much of her time raising the Belmont children.

Like his father, Belmont loved horse racing. In 1902 he purchased 650 acres on the Queens-Nassau County line to build one of the most opulent racetracks in the country. Belmont Track and the Belmont Stakes set the standard in horse racing. The Belmont Stakes, run each June in Elmont, New York, is part of American racing's Triple Crown, which also includes the Kentucky Derby and the Preakness Stakes. Every year in June

August Belmont Jr. was a man of vast interests including horse racing.

the finest three-year-old thoroughbreds in the world arrive in New York City to run in what has been called "the third jewel of the Triple Crown"—the Belmont Stakes. The race at Belmont Park is often called "the Test of the Champions." It is run on a one and a half mile track at Belmont Park.

August Belmont Jr. has been given credit for saving thoroughbred racing after the repeal of the racing law in New York State. In 1895, racing was almost banned in New York, and Belmont played an important role in passing legislation that saved the sport. The new law established a state racing commission, with Belmont as chairman, to regulate racing under Jockey Club rules. Belmont failed to prevent New York Governor Charles Evans Hughes from halting racetrack gambling in 1911, but he successfully led the effort to restore the sport in 1913.

Belmont served as the chairman of the Jockey Club and was the owner of many renowned racehorses, including Man O' War, known as the "fastest horse since Pegasus." Belmont sold Man O' War to S.D. Riddle, a Maryland horse breeder, for $5,000. Under Riddle's ownership, Man O' War became the greatest of all racehorses in the world. From 1919 through 1920, Man O' War won twenty out of twenty-one horse races and set five world records.

In his business dealings, August Jr. attended to even the most minute financial aspects with which his company became involved. Belmont was known for walking through his New York offices and collecting stray pencils and pens, or anything that was remotely left askew, and for haranguing his clerks for wasting the company's property.

In 1910, twelve years after the death of his first wife, he remarried the renowned opera star Eleanor Robson. Belmont was twenty-six years older than Robson. They had no children. With her admission into New York high society, attendance at the opera became mandatory. August and Eleanor became regular patrons of the Metropolitan Opera. After his death in 1924, she survived him by many years. Eleanor became known as "Mrs. Metropolitan Opera" because of her vast financial support for the opera. Eleanor Belmont died at the age of one hundred in 1960.

During the First World War, Belmont volunteered and was commissioned as major in the flying corps. He was sixty-five years old. While he was overseas, Eleanor tended to his many financial affairs. She also took care of his racing concerns. It was Eleanor who named one of their new horses "My Man O' War" in honor of her husband. When Belmont later sold the horse, the "My" in the horse's name was dropped and Man O' War went on to become a legend in the world of horse racing.

August Belmont Jr. was less conservative and more philanthropic than his father. During his tenure as president of the company, he negotiated the financing for the Interborough Rapid Transit Company and subsequently made a fortune on the investment. Under the agreement, the City of New York paid Belmont $35 million to cover construction costs, plus $1.5 million to buy land for the various stations. Belmont agreed to buy the cars, rails, signals and other equipment with his own money. When the system opened, Belmont would pay an annual rent equal to interest on the construction bonds.

The primary financial interests of Belmont's company were held in railroads and transportation. He served for a period of time as the chairman of the Louisville & Nashville Railroad. He had his own private railroad car, "the Mineola."

Appalled by the number of trolley lines and elevated trains cluttering the New York City streets, he proposed building an underground train system. Belmont went on to build the Fourth Avenue subway, the first subway system in New York City. Built in 1904, the subway only ran from Fourteenth to Thirty-fourth Street.

According to Clifton Hood, author of *722 Miles: The Building of the Subways and How They Transformed New York*, "Belmont's foul temperament was his main failing. The fat little banker was arrogant, pompous, mean-spirited and quick to anger. He sometimes flew into a rage when not accorded the obsequious treatment he thought was due a gentleman of his elevated station."

A LABOR OF LOVE

Although a shrewd businessman, building the Cape Cod Canal was more than just a business proposition for Belmont. It was to be a labor of love—a lasting memorial to his maternal grandfather, Commodore Matthew Perry of Bourne. In 1853, Commodore Perry opened the doors of trade with Japan when he sailed his battleships into Tokyo Bay. Matthew's brother, Captain Oliver Hazard Perry, was the hero of the Battle of Lake Erie in 1813.

Belmont's father married Caroline Perry, the daughter of Matthew Perry. The seafaring Perrys of Bourne gained great respect for their naval prowess. Matthew Perry's homestead was along the proposed route of the Cape Cod Canal.

Much like Captain Perry, August Belmont also met the enemy, but this time the enemy was centuries of inaction, lack of money and millions of cubic yards of sand, clay, rocks and mud.

Along with hiring the most famous engineer in the country, William Barclay Parsons, Belmont also contracted with another friend and former business associate, Michael Degnon. Both Degnon and Parsons had worked with Belmont on the construction of New York's first subway system.

Flanagan and Belmont met many times to discuss the feasibility of building the Cape Cod Canal. Flanagan was adamant about the canal's ability to turn a sizable profit once it was completed. Flanagan cited the estimated twenty-three million tons of cargo sailing around the Cape. With just an eight-cent toll per ton, the canal could show a profit of approximately $2 million per year. Even more revenue would be realized in the passenger and freight business using the railroad lines that serviced the region. Flanagan estimated another million dollars in revenue from the railroads.

Flanagan pointed to the obvious national defense implications of the canal, which would allow the United States Navy to increase its preparedness during times of war. All of Flanagan's arguments were well-received by Belmont. They

reinforced Belmont's own business and sentimental reasons for undertaking the canal project. Still, being a cautious businessman, Belmont sent his chief engineer, William Barclay Parsons, along with the noted maritime authority C.S. Simms, to Cape Cod to explore the feasibility of digging the canal.

Parsons and Simms arrived on Cape Cod in February 1906 to begin their survey. Their immediate findings were not favorable. Assistant engineer Charles Thompson was consulted. Thompson had served as an assistant engineer on the previous failed attempt to dig a canal through Cape Cod. He was hired by Belmont and Flanagan because of his experience and knowledge of the region.

Thompson showed Parsons and Simms all the studies he had conducted on the canal. Everything appeared in order except for one study that reported on a test boring showing pockets of quicksand along the canal's intended route. This was not a good sign. If it was quicksand, Parsons decided he would advise Belmont against undertaking the project. Before he reported back to Belmont, Parsons conducted his own series of test bores. After these tests were done, Parsons was convinced that Thompson's report of quicksand in the area was wrong. There *was* no quicksand.

Parsons began designing what he felt would be the best possible route for the proposed canal. He decided that an open, sea level canal would be the best alternative. Because Buzzards Bay was fraught with rocks, many of which would have to be blasted and dredged, he designed a route that followed the shoreline, cutting through Phinney's Harbor with an opening along Wing's Neck.

Simms dutifully studied the flow of seafaring traffic in and around the Cape. He determined that nearly twenty-eight million tons of cargos were shipped around the Cape's outer shoals. Financially speaking, the figures were staggering. Simms estimated that if only half the ships sailing around the treacherous Cape Cod waters used the canal, paying a mere four cents per ton, the proposed canal would show a profit of almost $500,000 per year. After maintenance and operating costs were deducted, the canal could show a profit of nearly $300,000 per year. It was a hefty and appealing sum.

Simms advised Belmont that the proposed canal would be "handsomely self-supporting" and counseled him to begin work on the project immediately.

Belmont decided that, in order to dig the Cape Cod Canal, there needed to be two distinct companies involved. One company was needed to actually dig the canal, while the other was needed to operate the canal once it was completed. Belmont calculated on being in control of both companies.

The Cape Cod Construction Company was organized by Belmont in 1907. Although the contract to dig the canal was put out to bid, it was, naturally, Belmont's company that was awarded the contract. His company agreed to do all the work for $11 million, with half this amount paid in bonds and the other half paid in stock options in the canal. To acquire the money he needed to dig the canal, Belmont circumvented normal legal procedures. He would ultimately end up regretting it.

FUNDING THE CANAL PROJECT

In 1909, Belmont proclaimed, "I promise in digging the first shovelful not to desert the task until the last shovelful has been dug." He would remain true to his word, but first he needed to finance the whole operation.

Belmont issued a confidential prospectus for the Boston, New York and Cape Cod Canal Company. This company would run the canal once it was completed. Subscribers bought nearly $6 million worth of bonds. Belmont never sought to sell any of the bonds to the general public. This money, in turn, would be paid to Belmont's other company, the Cape Cod Construction Company, to actually dig the canal. With his finances secured, Belmont began work in earnest.

"During the progress of this great work and as we approached the day for its dedication to public use, I have been possessed of the thought that we, foreigners to Massachusetts, hailing from New York, were doing something for New England which New England was not able to do for herself," Belmont said.

In late 1909, a hundred Italian laborers from Boston arrived in Sandwich and began work. More than 350 feet of earth was dug and loaded onto railroad cars to be transported to a manufacturing plant in nearby Sagamore that needed the landfill.

Assistant engineer Charles Thompson worked as the real estate agent on the project. Although Belmont owned nearly 70 percent of the land he needed along the canal route, he still required another four hundred acres of land to successfully complete the project.

Thompson set about securing the land rights. He managed to purchase the land needed outright, with what most owners found to be fair and reasonable offers. In the few instances where landowners were not satisfied with the purchase price, they had the option of taking the issue to the Barnstable County commissioners to settle the terms of the inequitable sale. If the sale could not be settled adequately by the county commissioners, the landowners had the right to take their cases to a jury trial in civil court. Few landowners took things this far. Most settled with Thompson or were awarded a fair asking price by the Barnstable County commissioners.

Along with the hundred Italian laborers working on the site, the double-masted schooner *Annie F. Lewis* dropped anchor off Scusset Beach with a cargo of Maine granite on board. The granite was used to build the breakwater at the end of the canal. Soon, work commenced on both ends of Cape Cod Canal.

On June 22, 1909, August Belmont Jr. ceremoniously dug a shovelful of dirt from the ground in Bournedale, at the site of his maternal grandfather's home, Commodore Perry's farm. Lifting the sterling silver Tiffany shovel, Belmont vowed to onlookers never to abandon the Cape Cod Canal project. It was not an idle promise. Belmont's plan was to complete the canal within three and a half years. He was not far off his calculations.

Despite Belmont's vow, many observers remained skeptical. They had good reason to be. For more than three hundred years people had proposed building a canal through Cape Cod, but nothing ever came from these proposals. This time, Belmont promised, it would be different.

The *Yarmouth Register* newspaper reported that despite the opening ceremony, there was "a noticeable lack of enthusiasm among the spectators when the official spoonful of sod was chiseled from Mother Earth and fell with a dull thud on the turf."

Belmont countered with his own observation: "It is a poor and stupid argument that the past failures to build this canal should still nurse skeptics."

Digging Begins

*I admired the skill with which the vessel was at last brought to her place in the dock,
near the end of Long Wharf. It was candle-light, and my eyes could not distinguish the
wharves jutting out toward us, but it appeared like an even line of shore densely crowded
with shipping. You could not have guessed within a quarter of a mile of Long Wharf.
Nevertheless, we were to be blown to a crevice amid them,—steering right into the maze.
Down goes the mainsail, and only the jib draws us along. Now we are within four rods
of the shipping, having already dodged several outsiders; but it is still only a maze of
spars, and rigging, and hulls,—not a crack can be seen.*

—*Henry David Thoreau,* Cape Cod

Despite all of Belmont's best intentions, work on the canal did falter. The Cape Cod
Canal Construction Company did not have equipment of its own and needed to
subcontract it all. Belmont turned to a former associate for help.

Michael Degnon, who had previously worked for Belmont during the construction
of the New York City subway, was urged by Belmont to form the Cape Cod Canal
Construction Company. Degnon's company then subcontracted with Belmont for the
construction of the two breakwaters proposed for the east end of the canal. In turn,
Degnon contracted with the Gilbert Transportation Company in Connecticut for
granite to be shipped down the coast from Maine.

The summer of 1909 was nearly over before the first dredge arrived at the site. The
Kennedy was towed to Buzzards Bay. It was an old dredge with an endless cycle of noisy
buckets. Much to the chagrin of Cape Cod residents, the noisy dredge was kept working
day and night.

The *Kennedy* dredge was quickly followed by *Dredge No. 1*, belonging to the Coastwise
Dredging Company. With its buckets churning, *Dredge No. 1* worked ahead of the
Kennedy in the area between Mashpee Island and Monument Beach. Working day and
night, *Dredge No. 1* was able to excavate to a depth of twelve feet along the canal route.

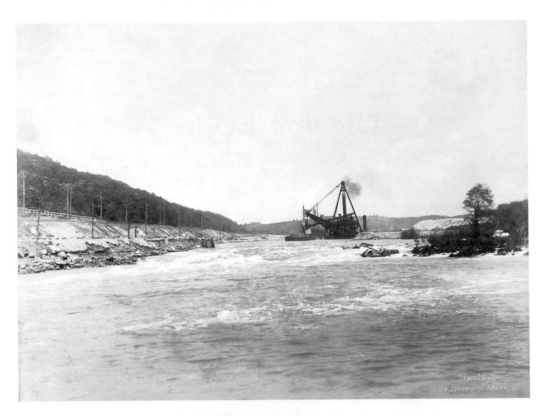

The swift-moving currents in the canal hampered work on the project. *Courtesy of the Town of Sandwich Archives.*

On the far eastern side of the construction site, the *General Mackenzie* arrived in mid-October to begin work on the canal. This huge dredge had the ability to dig thirty feet deep, sending sand and soil flying five hundred feet away.

Digging on the Sandwich end of the project was vital because the ships working to secure the breakwater were forced to work out in the open sea without shelter from storms. The two closet safe harbors for the ships hauling granite down from Maine were Provincetown Harbor, some twenty miles away, and Plymouth Harbor, sixteen miles away. Neither location was suitable to protect the granite fleet. Digging through on the east side to create a safe port would provide the needed safe harbor. It would also make it possible to continue the dredging throughout the winter months since the man-made harbor would give the dredges shelter from the fierce Cape Cod winter storms.

The *General Mackenzie* dredge ran into problems as soon as work began. Arriving at the site so late in the season, the dredge was hit by a series of winter storms, forcing contractors to tow the huge vessel to the safety of Provincetown Harbor. Out of a total of sixty days on the job, the *General Mackenzie* was only able to complete eight full days of work. This barely made a dent in efforts to dig a safe harbor on the east side of the canal. In late November, a terrific gale hit the Cape Cod coast and the *General Mackenzie* was nearly sunk. Contractors decided to put the huge dredge into storage until the early

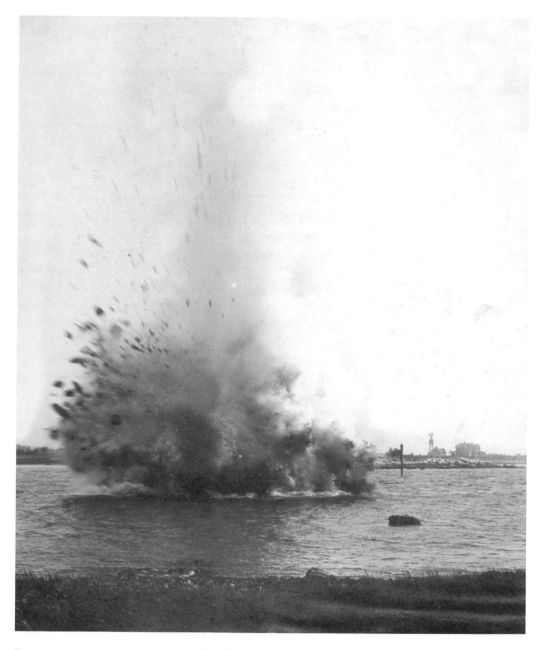

Dynamite had to be used to clear boulders from the canal route. *Courtesy of the Town of Sandwich Archives.*

spring. It was towed to Provincetown Harbor where it spent the winter. The two dredges on the western end of the canal were also put into storage for the winter.

Things were not going as planned for Belmont and he didn't like it. With all the dredges stored away, no work was being done on the canal, and although more than forty-five thousand tons of granite had been dumped into the Barnstable end of the canal for the breakwater, it hardly made a difference in the construction of the needed fortification.

The only noticeable positive sign was the appearance in late October of bridge-building materials. The subcontractor for the proposed Buzzards Bay railroad bridge, Holbrook, Cabot and Rollins Corporation, began immediate work on building the piers for the proposed railroad bridge across the canal. Working day and night, the railroad piers were in place by the following spring.

The number of laborers working on the project grew to more than a thousand men and produced the highest payroll in Cape Cod's economic history. If the canal was ever to be completed on time, Belmont knew he had to increase the output of the dredges. In order to increase production, he brought in a smaller dredge, the *Nahant*. But even bringing this small dredge to the site proved difficult. In order to locate the dredge, a series of steam-powered excavators had to be used to dig a channel for the vessel. Finally, the *Nahant* made it to its location and began work.

The *Nahant* began digging toward Cape Cod Bay in late January 1910, attempting to dig a channel to accommodate the much larger *General Mackenzie* when it came out of cold storage in the spring. Much of the work done by the *General Mackenzie* the year before had filled in with sand and had to be re-dug by the *Nahant*. The small dredge worked continuously, day and night, through the cold winter months, and in two and a half months, it managed to dig through to the open sea, opening up a safe harbor for the *Mackenzie*. In early April 1910, the *General Mackenzie* began work once more on the eastern end of the canal. Work progressed quickly once the *Mackenzie* was in place. It was able to swiftly cut through sand, clay, tree stumps, stones and other debris that was in its way. Then another dredge was added. *Dredge No. 9* was put to work digging ahead of the *General Mackenzie*, clearing a seventeen-foot ditch in front of the larger vessel.

After Belmont made a change in the company supplying the granite for the breakwater, work there also began in earnest. Ships filled with the heavy granite were soon filling the waters and unloading their cargo of great stone into the sea.

On the western end of the canal, another dredge was added. The *Bothfeld*, described as a huge, floating steam shovel, began work digging deep into the bottom of the proposed canal. By Labor Day 1910, there were six dredges working around the clock on the western side of the canal and two working on the eastern side. The two teams of dredges and workmen quickly approached the town line between Sandwich and Bourne. They would reach their destination by the fall of 1910, barring no further mishaps. With all that had been accomplished on the eastern side, the canal fleet no longer had to flee to either Provincetown or Plymouth Harbors. The fleet could take refuge in the newly dug, man-made safe harbor on the east side of the canal. By the end of 1910, 150,000 tons of granite had been stacked into the breakwater, completing nearly 50 percent of the project.

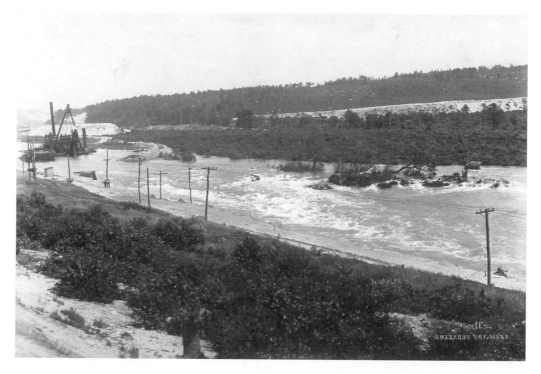

Many of the dredges used to dig the canal were plagued by the dangerous currents. *Courtesy of the Town of Sandwich Archives.*

By the end of 1910, a canal had been dug from Barnstable Bay to the Sandwich and Bourne town lines. Nearly three million cubic yards of land had been excavated.

"Three cheers and a tiger for August Belmont and the other officers of the Cape Cod Canal Company!" proclaimed the *Yarmouth Register* in a 1910 editorial. Much had been accomplished, but still more lay ahead.

A New Era Begins

In December 1910, the first commercial vessel was towed into the safety of the man-made canal harbor. The *Cassie*, an old coal barge, was the first vessel to use the new refuge. A new era in Cape Cod maritime history began.

The canal that had been dug from Barnstable Bay to the Sandwich and Bourne town lines was only a mere one and a half miles long, but its impact was felt throughout the Cape Cod community and among Belmont's many associates. Things were looking up. Belmont estimated that nearly three million yards of earth had been excavated and the project was one quarter completed. It was further than any other project had gone in the nearly three hundred years of talk about digging a canal. Belmont was determined to go the distance.

As the work on digging the canal continued, work on building the bridges across it was in full swing. The railroad bridge was begun in earnest in 1909 and was completed

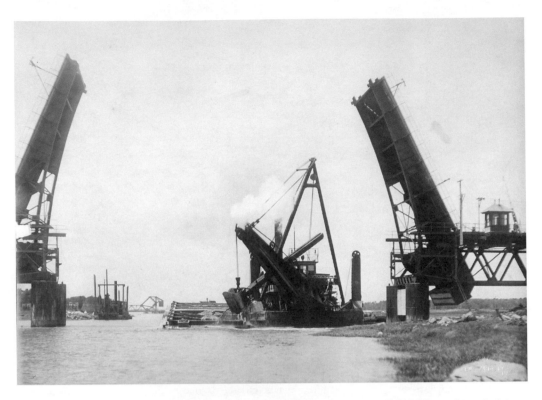

The Bourne Highway Bridge had to open to accommodate the *Governor Warfield* dredge as it worked digging the canal. *Courtesy of the Town of Sandwich Archives.*

in November 1911. The Bourne Highway Bridge, located east of the railroad bridge, was an electrically operated drawbridge. It was completed in the spring of 1911 and included a single track for trolley cars. It was the second of the three bridges that would ultimately span the Cape Cod Canal. The third and final bridge to span the canal was a small drawbridge built in Sagamore in 1911. All three bridges were designed to accommodate motor, rail and foot traffic across the canal.

Steam shovels, workmen, giant slabs of granite, dredges and sheer engineering determination defined the continued work of Belmont and his Cape Cod Canal Construction Company. Despite mechanical failures, inclement weather and continued setbacks, August Belmont Jr. all but willed the Cape Cod Canal into existence.

Chief Engineer William Barclay Parsons misjudged the existence of boulders along the digging route. As the dredging continued, huge rock formations were uncovered, slowing down the operations. Finally, skin divers were used to set dynamite charges on the various boulders, which the dredges or other machinery were incapable of handling. Once the dynamite was set, the skin divers retreated to safety and blew the dynamite charges. It was the only way to remove the enormous obstructions and it slowed the entire digging operation.

To speed the construction along, Parsons recommended building a narrow set of railroad tracks along the proposed canal route so that railroad cars could be filled

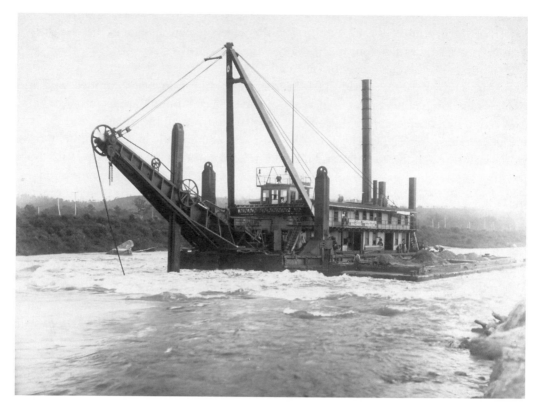

The *Governor Warfield* dredge worked day and night digging the canal. *Courtesy of the Town of Sandwich Archives.*

with earth and boulders and carry them away to the canal's sloping sides. Two large "dipper" dredges were built at the canal construction site. The *Governor Herrick* was built in Sagamore and the *Governor Warfield* was assembled in Buzzards Bay. These two enormous dredges slowly began to cut a swath through Cape Cod, digging steadily from each end toward the center.

BELMONT'S CANAL

There were actually two Cape Cod Canals dug. August Belmont's was the first. The original canal, engineered by Belmont and his company, did not follow the same route as the present-day canal. Belmont's canal began in the shoal waters in Buzzards Bay at Phinney's Harbor. It curved east of Mashpee Island. It was a winding canal, tempered by strong tidal currents, and had a width of only approximately 100 feet. It was not the huge, eye-catching canal that tourists view today. The present-day Cape Cod Canal was constructed during a five-year period, from 1935 to 1940. This new construction resulted in a much expanded, deeper, less winding canal. The new canal measures 540 feet wide and 32 feet deep. The canal was straightened through Buzzards Bay. The

length of the canal today is 17.4 miles. It is the widest sea level canal in the world. It is a far cry from August Belmont Jr.'s 100-foot-wide, 25-foot-deep passage. Still, Belmont's was the first and there can only be *one* first.

By the end of 1912, nearly 300,000 tons of granite had been emptied into the breakwater, completing almost 80 percent of the project. About 40 percent of the total excavation had been completed. Railroad construction was all but finished and the two bridges were nearly 75 percent done. Progress was being made at a rapid rate. Crews worked all through the summer and fall and straight through the winter of 1912.

Three more dredges were added in the winter of 1912. The three new dredges, the *Capitol*, the *National* and the *International*, ran into boulders and heavy clay digging through Sagamore Hill. It was the most difficult digging that had gone on so far in the whole operation and it slowed construction.

On the west side of the project, Belmont kept one dredge working all through the winter, deepening the channel for the larger vessels that would return in the spring. When the fleet of dredges did return in the good weather, they were also slowed by the discovery of huge boulders, some weighing more than a hundred tons. The dredges weren't able to handle them and neither were the steam shovels. Divers had to be sent down to blast them away with dynamite.

By December, the four-mile stretch at Buzzards Bay was completed. Tugboats, barges and other assorted equipment could go up beyond where the present-day railroad

Today, the Cape Cod railroad bridge is used by hundreds of commuters, as well as by tourists during the summer. *Courtesy of Nate Conway.*

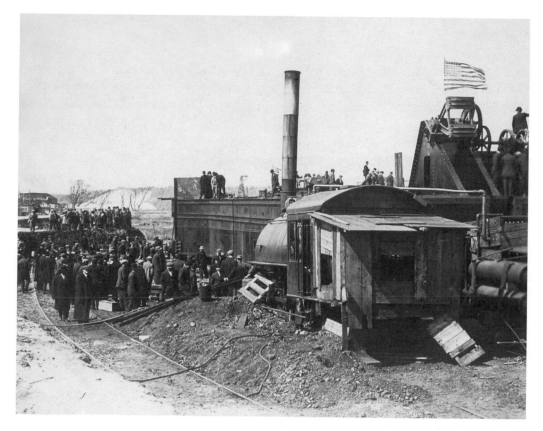

Railroad beds were laid along the length of the canal to haul away earth and debris. *Courtesy of the Town of Sandwich Archives.*

bridge is located, making it a safe haven for all the equipment involved in the digging of the canal.

The winter of 1912 was hard and cold, but it produced very little ice so the digging continued day and night. Three enormous steam shovels were brought in to begin work on the land between Bourne and Bournedale. The earth that was dug was hauled away by train.

The sandy neck between Barnstable and Buzzards Bay that connected Cape Cod to the rest of Massachusetts was going through a transformation of historic proportion. The sandy neck was situated squarely in the way of safe passage for New England and New York shipping trade moving both north and south. Vessels moving precious cargos, materials and passengers were all forced to navigate around the perilous outside tip of the peninsula, a passage that was responsible for thousands of shipwrecks and the massive loss of human lives and raw materials.

1912

By the summer of 1912, the Cape's sandy neck was quickly becoming a memory, at long last. Keeping to his word, August Belmont Jr. had continued the work of cutting a canal through the Cape from shore to shore. Along with eliminating forever the need to risk life and limb trying to sail around the dangerous Cape Cod coastline, Belmont's canal would constitute one of the most important waterways in the projected national chain of safe channels along the Atlantic Coast from New England to Florida, according to a *New York Times* dispatch dated July 1912.

Never far from anyone's mind were the obvious benefits that once finished, the Cape Cod Canal would potentially strengthen the defenses of the cities of New York, Boston and Newport, Rhode Island, if ever they became targets of attack from hostile forces. The start of World War I was two years away, but the rumblings of war could be felt already in America. The war began on August 4, 1914, when Germany invaded Belgium. The attack followed a chain reaction of events that began with the assassination of Archduke Francis Ferdinand of Austria-Hungary on June 28, 1914. Austria-Hungary threatened to attack Serbia, which was protected by

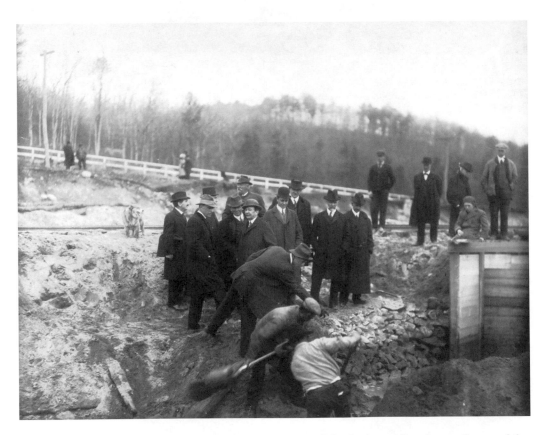

Dignitaries gathered at the canal site to observe the progress of the dredges and workmen. *Courtesy of the Town of Sandwich Archives.*

Digging Begins

Russia. Germany allied itself with Austria-Hungary against Russia, which was allied with France, the United Kingdom, Belgium, Serbia and Montenegro. The United Kingdom went to war against Germany on August 4, 1914, after German troops entered Belgium. America managed to stay out of the war until June 4, 1917, when President Woodrow Wilson declared war on Germany.

Although the building of the Cape Cod Canal had been deferred for centuries, for one reason or another, the actual digging of the canal presented no real engineering problems for Belmont's company. But even the chief engineer of the project foresaw the military benefits of the canal, even though Belmont himself had indicated no tendencies toward allowing the United States government to use or operate the canal for military purposes. Belmont viewed the canal strictly in business terms. Chief engineer Parsons, however, had a somewhat different view.

According to Parsons:

> *The Canal as planned is quite sufficiently deep to take all the smaller vessels of the navy, even to cruisers. The battleship is a vessel that one thinks of instinctively as a vessel that would naturally seek deep waters and avoid narrow channels. There might however arise a contingency when the canal would be of the greatest value to the country in time of war.*

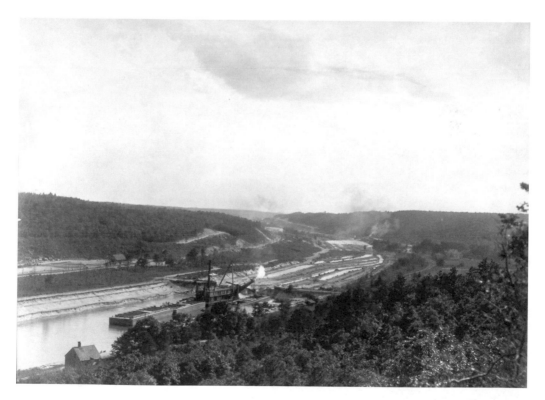

The *Governor Herrick* dredge maneuvered through the canal, digging its way through Sandwich. *Courtesy of the Town of Sandwich Archives.*

There were three naval stations on the Atlantic Coast where battleships could be anchored. They included the harbors of Boston, New York and Newport. According to Parsons:

> *No enemy could successfully maintain a blockade line from Maine to New York. However, in the case of an attack by a hostile enemy fleet, Newport and New York are connected through the sound. Newport and Boston connected only outside the Cape. Boston therefore would be cut off from either of the two points. Should, however, the Cape Cod Canal be large enough to take battleships, the naval authorities could move from any of these three points, and so, concentrate at any point the whole of their naval force by an outside route free from obstruction by the enemy.*

Parsons argued that although it was not the intention of the Cape Cod Canal Company to initially construct a canal deep enough to accommodate battleships, which would require the twenty-five-foot-deep canal to be dug to a depth of approximately thirty-five feet, if the government determined it needed the canal in time of war for use by battleships, the necessary depth could be easily achieved. According to Parsons, it could be adequately deepened without interfering substantially with any ongoing navigation of the canal.

"I feel some diffidence in prophesizing [*sic*] the commercial outcome and results in New England. I do believe, however, that it will mark the greatest forward step in local commerce since the introduction of steam to coastwise trade," Parsons said.

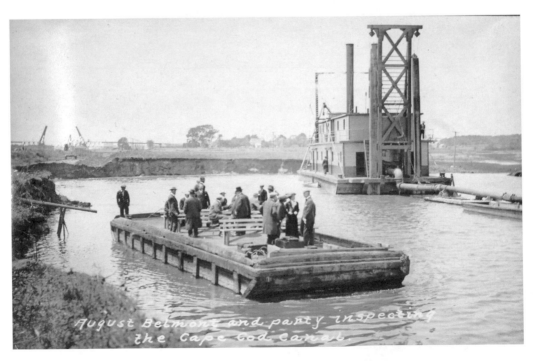

August Belmont Jr. and other dignitaries regularly examined the progress being made on the canal aboard one of the many barges. *Courtesy of the Town of Sandwich Archives.*

Parsons wasn't the only one who saw the military advantage of the soon to be completed Cape Cod Canal. Rear Admiral Colby M. Chester of the United States Navy was one of the most vocal proponents of the military benefits of the canal. He advocated early on for the government to take control of the canal. According to Chester, the canal's use by battleships in time of war could spell the difference between victory and defeat for America's navy.

Chester said:

> *My proposition then is this: That Congress and the Executive should be advised to give up the idea of constructing a channel through the Monomoy shoals (off Chatham), and devote the money it would probably cost, say $4,000,000, towards the construction of that part of the Cape Cod Canal that has been made through the navigable waters of the United States, pay the canal company for the work already done on the channel and breakwater (upon such basis as may seem just and equitable), and deepen the channel to a depth of forty feet, under the direction of the United States Army Engineers.*

Chester's idea of the government taking over the control of the canal would come to fruition only in 1928, while his proposal for the Army Corps of Engineers to oversee the deepening of the canal to accommodate navy warships would become a reality in 1935.

According to Admiral Chester:

> *There would probably be enough money coming to the company by this arrangement to enable it to dredge the eight mile strip of canal which runs through the State of Massachusetts to a depth of thirty-five feet and to increase its width to 160 feet, which dimensions have been anticipated in building the bridges that span the canal.*

Despite these many urgings, Belmont was not anxious to sell the rights to the not yet completed canal. He, as others on the board of directors of the Canal Company, hoped first to realize some profit from the enterprise through commercial traffic going through the channel.

Although Belmont and his many backers, as well as navy authorities, viewed the canal as a potential asset, not everyone was in favor of the new canal. Naturalists and fishermen had their doubts about it. Fishermen questioned whether fish would now use the canal. Buzzards Bay had long been one of the best fishing haunts on the eastern seaboard. The shoals between Cape Cod and Nantucket Island served as a shelter for the fish where they could escape the cold water currents.

1913

In November 1913, in a letter to the *New York Times*, J.W. Miller recounted the shipwrecks off the Cape Cod coast during a two-day storm in early October of that year. According to Miller, the barge *Sumner R. Mead* piled up on the tip of the Cape. The

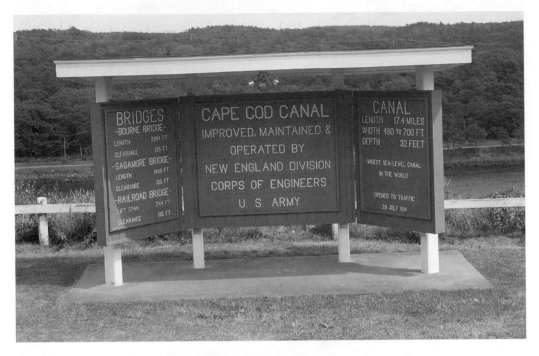

The Army Corps of Engineers operates the Cape Cod Canal today. *Courtesy of Nate Conway.*

Oakland sank off the Pamet River and the whole crew drowned. The barge *J.B. Thomas* sank and the schooner *George Pearl* wrecked on a sandbar. The *Henrietta A. Whitney* was badly damaged in the gale and the *Henry D. May* hit Stone Horse Shoal and went aground after colliding with a tow of barges. Four other schooners trying to navigate off the Cape Cod coast were also damaged during the violent storm. According to Miller, a total of 4,173 tons of cargo was lost and seven people died. He calculated that the storm had caused a more than ten-day delay in shipping at a cost of $56,000. Based on his overall calculations, including repairs, time lost and gross tonnage lost, Miller contended that more than $100,000 was lost because these vessels were forced to navigate around the treacherous Cape Cod peninsula.

According to Miller's calculations, if the Cape Cod Canal had already been built, none of these losses would have occurred because the ships could have found safety from the storm in the waters of the canal. Miller calculated that a net savings of approximately $81,000 would have been realized if the vessels had had access to the canal.

"The story of loss around these dangerous reaches records the sacrifice to date of at least 1,000 lives and 3,000 ships," Miller wrote. "Fortunate it is for men and ships that this first decade of the twentieth century found men ready to build the Cape Cod Canal. They will finish it before 1915."

Belmont, Flanagan and Miller were all astute businessmen. According to their best estimates, once the Cape Cod Canal was completed, vessels passing through it would

be transporting 8,000,000 tons of coal, 300,000 tons of stone, 250,000 tons of Nova Scotia plaster, 200,000 tons of lumber, bricks and ice and 2,000,000 tons of other "high class merchandise" yearly.

No less than 50,000 vessels with a total cargo of approximately 25,000,000 tons circled Cape Cod yearly, bringing goods and merchandise to Southern ports. It was estimated that nearly 500,000 passengers were among the precious cargo on board these ships. All of these ships and passengers were predicted to be diverted through the soon to be completed Cape Cod Canal.

In November 1913, as work on the canal continued, J.W. Miller reported to the board of directors of the Cape Cod Board of Trade that the official opening of the Cape Cod Canal was scheduled for July 4, 1914. By February of that year close to 75 percent of the canal had been completed. Two massive dredges working in the canal and approaching each other from opposite ends, Cape Cod Bay and Buzzards Bay, were within eight thousand feet of each other in Bournedale. A fifteen-foot-wide trench stretching for nearly a mile had been dug between the two behemoth dredges. The trench would be flooded when the two dredges finally cut through the last barriers. It wouldn't be long. In April 1914 the sluiceway in Foley's Dike, connecting Cape Cod Bay and Buzzards Bay, was opened and the waters from both sides rushed together.

August Belmont and other dignitaries rode the train to Cape Cod from their offices in New York City to hold the small but historic ceremony. With Belmont were J.W. Miller,

Buildings were erected along the canal site to accommodate the ongoing work. Pictured here are a machine shop, blacksmith shop and storehouse along the canal site. *Courtesy of the Town of Sandwich Archives.*

chief engineer William Barclay Parsons and W.A. Harriman from the company's board of directors. The group took a powerboat out to Foley's Dike where Belmont, standing atop the dike, ceremoniously poured together two bottles of water, one bottle containing water from Cape Cod Bay and the other containing water from Buzzards Bay, and proclaimed, "May the meeting of these waters bring happiness and prosperity to our country and save some of the misery which the waters of the Cape have caused in the past."

Belmont and Parsons then went to Sands Dike, which held back the water from both sides, and pulled away the boards, releasing the waters.

The merging of the two waters was largely symbolic since the canal was not opening for business. The actual destruction of the dike was not scheduled until the summer. Parts of the canal still needed to be dredged down to the twenty-five-foot depth. Still, the symbolic gesture carried a great deal of weight. Within a few short months, the often dreamed of Cape Cod Canal would become a reality.

1914

At a luncheon before the Boston Chamber of Commerce at the end of April 1914, August Belmont Jr. assured the audience that the canal would be navigable for smaller vessels by midsummer and it would merely take two or three more months to make the canal ready for larger commercial vessels.

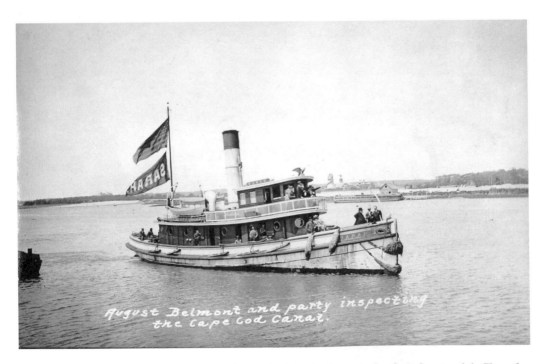

Steam shovels were used to dig the canal to its required depth of twenty-five feet. *Courtesy of the Town of Sandwich Archives.*

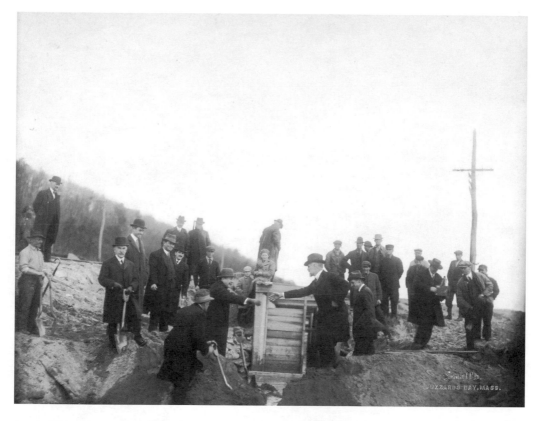

August Belmont Jr. (pictured at left) and his chief engineer, William Barclay Parsons, shake hands over the success of the canal project. *Courtesy of the Town of Sandwich Archives.*

"It is our purpose," Belmont said, "to make the canal practically a river, furnishing a waterfront where industries can develop and grow. It is doubtful whether the canal would have paid twenty years ago because of the large proportion of sailing vessels at that time. Eighty-eight percent of the tonnage today is under its own power and can go through the canal without assistance." Toll rates for use of the canal would be announced shortly, he assured the members of the chamber.

At the end of May 1914, toll charges for passage through the Cape Cod Canal were set. All the vessels that could use the canal were divided into three distinct classes. The first class included vessels carrying crude materials in bulk cargo lots. The second class included vessels engaged in commercial trade carrying passengers and freight. The third class included pleasure crafts such as yachts, motorboats and any other vessel not engaged in commercial trade. The toll rates would vary from a minimum of $3 for a pleasure craft under sixteen feet to $478 for a passenger steamer. The charges would be fixed based on overall tonnage.

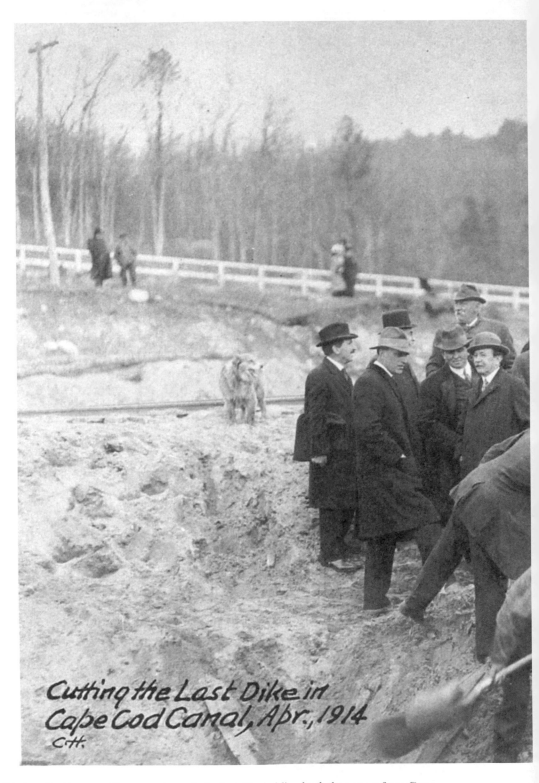

Cutting the Last Dike in Cape Cod Canal, Apr., 1914. C.H.

Workers finally were able to cut through the last dike holding back the waters from Cape Cod and Buzzards Bay. *Courtesy of the Town of Sandwich Archives.*

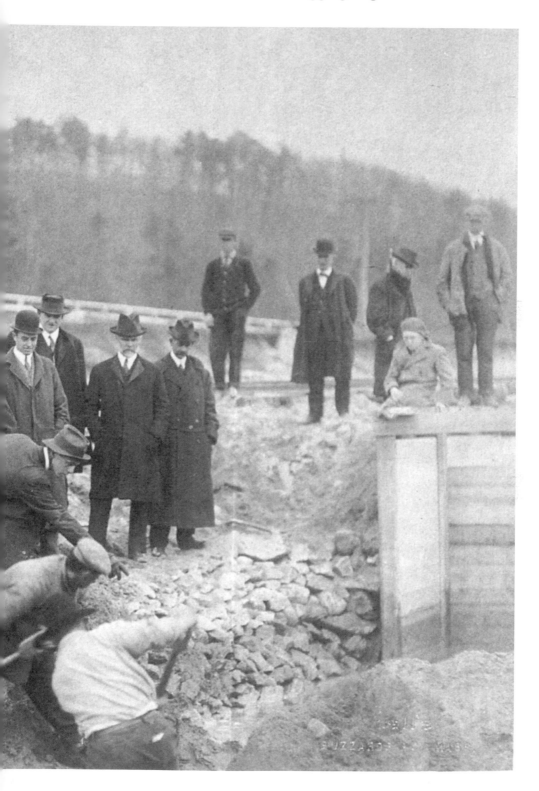

The Grand Opening

It was even more cold and windy to-day than before, and we were frequently glad to take shelter behind a sand-hill. None of the elements were resting…Even the sedentary man here enjoys a breadth of view which is almost equivalent to motion. In clear weather the laziest may look across the Bay as far as Plymouth at a glance, or over the Atlantic as far as human vision reaches, merely raising his eyelids; or if he is too lazy to look after all, he can hardly help hearing the ceaseless dash and roar of the breakers. The restless ocean may at any moment cast up a whale or a wrecked vessel at your feet….No creature could move slowly where there was so much life around.

—*Henry David Thoreau,* Cape Cod

On July 4, 1914, the 275th anniversary of the founding of Sandwich, Massachusetts, and the 138th anniversary of Independence Day, the last barrier between the east and west sides of the canal was broken and the once impossible dream of the Cape Cod Canal, after nearly three hundred years of discussions, surveys and setbacks, became a reality. Once the two waterways were connected the *Bourne Independent* newspaper declared, "Cape Cod Now An Island!"

It had taken five years to complete, but it was finally finished. More than fourteen million cubic yards of earth had been excavated. The canal ran nearly eight miles long, a hundred feet wide and fifteen feet deep. With the Buzzards Bay entrance nearly five miles long, the total approximate length of August Belmont Jr.'s Cape Cod Canal was thirteen miles. On the east side, the huge, granite, three-thousand-foot breakwater was finished to the north of the canal opening. To the south, a man-made jetty stretching a thousand feet long and eight feet high was completed. Two highway bridges and one railroad bridge had also been built. More than six miles of railroad track had been laid and more than five miles of new highway built. It cost an estimated $11 million to complete. Six lives were lost in the construction of the canal.

During its construction, the digging of the Cape Cod Canal produced one of the largest payrolls in the Cape's history, boosting Cape Cod's economy more than it ever

**PRELIMINARY INFORMATION REGARDING OPENING OF
THE CANAL ON WEDNESDAY, JULY 29th, 1914**

Special Train to leave Boston about 9:00 A. M. with the guests of the Company, arriving at (Fairhaven) New Bedford about 10:30.

New Bedford can also be reached by steamer direct from New York via New Bedford Line, or by Fall River Line.

Fleet. Leave New Bedford 11:00 A. M., proceed through Buzzards Bay and canal, returning to the western approach about 2:00 P. M. After certain ceremonies, to be arranged later, take place on shore, the special train will leave Buzzards Bay Station about 4:00 P. M. on return trip to Boston, probably stopping at Tremont and Middleboro to make connections for New York boats.

In answer to many inquiries the information is given that ample accommodations for motors will be provided along the banks of the canal for parties who prefer to witness the fleet as it passes in review.

On receipt of acceptance of the enclosed invitation, further detailed information will be sent regarding the opening ceremonies.

Please state whether you wish to be on board the fleet, or desire automobile space along the banks.

Invitations for the grand opening of the canal were sent to hundreds of local dignitaries, friends and family. *Courtesy of the Town of Sandwich Archives.*

had. During the first year of work on the canal in 1909, there were two hundred men working on the project. Work for unskilled laborers paid nearly two dollars per day, a good wage at the time. However, there was no overtime and there were no bonuses. Men working on the dredges received up to thirty dollars a month plus board. Workers stayed on the job around the clock, every day except the Fourth of July and Christmas. They even worked on Sunday, causing some furor in several of the more deeply religious Cape Cod communities. Belmont averted any problems by hiring local residents related to county, state and local officials to fill the Sunday work schedule.

Two years after work began on the canal, the workforce numbered four hundred men, a majority of the laborers coming from the Boston Italian community. By 1912, there were nearly a thousand men engaged in the Cape Cod Canal workforce.

Since all the mechanical equipment used was powered by coal, much of the coal had to be furnished from outside the region as Cape Cod was not able to supply the huge amounts needed to fuel all the dredges, steam shovels and other equipment. Huge coal contracts were awarded to wholesalers in Boston, New Bedford and Providence, Rhode Island.

Construction costs far exceeded the original estimates, and according to company reports, every subcontractor hired lost money on the project. The project's primary contractor, Michael Degnon's Cape Cod Canal Construction Company, lost so much money on the canal project that the company went bankrupt.

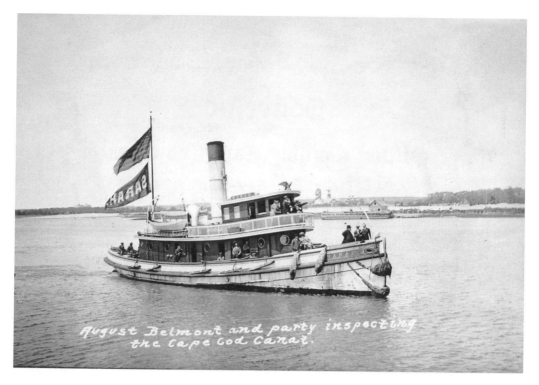

August Belmont Jr. inspected the canal from the tugboat *Sarah*. *Courtesy of the Town of Sandwich Archives.*

The grand opening of the Cape Cod Canal was held on July 29, 1914. The decision to open the canal earlier than scheduled—the canal had not yet been dug to its designated twenty-five-foot depth—was prompted by Belmont's desire to take advantage of the summer ship traffic and its potential tolls. Belmont also wished to hold the grand opening to impress many of his influential friends at the New York City Yacht Club and garner publicity.

Invitations were sent to prominent politicians, business leaders, shipping executives, canal investors and the United States Department of the Navy. Among the many dignitaries who accepted Belmont's invitation for the grand opening of the canal was Franklin D. Roosevelt, who was serving as the assistant secretary of the navy.

August Belmont Jr. was sixty-one years old at the time of the grand opening. He assembled an armada of ships for the opening, including private yachts, excursion boats and several navy destroyers. All of the vessels gathered outside the canal entrance off Wing's Neck. Belmont rented a two-hundred-foot excursion steamer, the *Rose Standish*, for the event. It was the lead boat in the parade of ships.

Among the ships in the procession were the USS *McDougall*, with Franklin D. Roosevelt on board; as escorts, the destroyers *Walke*, *Terry*, *Rowe*, *Perkins*, *Sterrett* and the *Monaghan*; the revenue cutters, the *Gresham* and the *Acushnet*; along with the private vessels, the *Oneida*, *Linta*, *Alice*, *Sultana*, *Thelma* and *Gloucester*. The *Gresham* greeted the procession of ships with a twenty-one–gun salute.

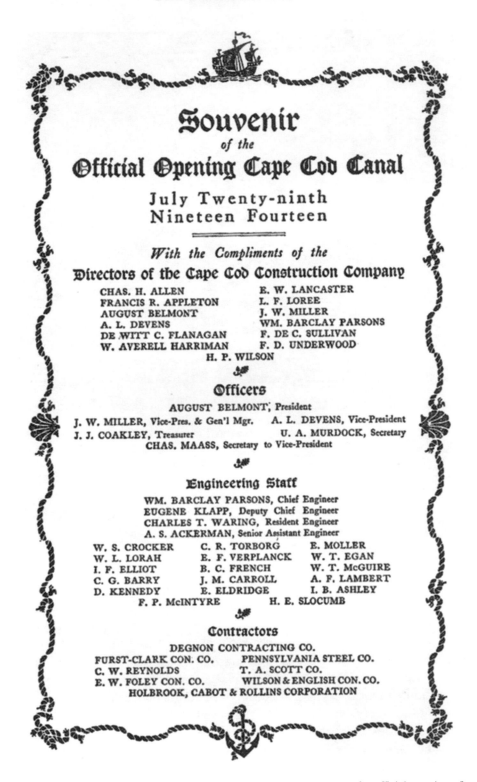

Souvenir
of the
Official Opening Cape Cod Canal

July Twenty-ninth
Nineteen Fourteen

With the Compliments of the
Directors of the Cape Cod Construction Company

CHAS. H. ALLEN	E. W. LANCASTER
FRANCIS R. APPLETON	L. F. LOREE
AUGUST BELMONT	J. W. MILLER
A. L. DEVENS	WM. BARCLAY PARSONS
DE WITT C. FLANAGAN	F. DE C. SULLIVAN
W. AVERELL HARRIMAN	F. D. UNDERWOOD

H. P. WILSON

Officers

AUGUST BELMONT, President

J. W. MILLER, Vice-Pres. & Gen'l Mgr. A. L. DEVENS, Vice-President

J. J. COAKLEY, Treasurer U. A. MURDOCK, Secretary

CHAS. MAASS, Secretary to Vice-President

Engineering Staff

WM. BARCLAY PARSONS, Chief Engineer
EUGENE KLAPP, Deputy Chief Engineer
CHARLES T. WARING, Resident Engineer
A. S. ACKERMAN, Senior Assistant Engineer

W. S. CROCKER	C. R. TORBORG	E. MOLLER
W. L. LORAH	E. F. VERPLANCK	W. T. EGAN
I. F. ELLIOT	B. C. FRENCH	W. T. McGUIRE
C. G. BARRY	J. M. CARROLL	A. F. LAMBERT
D. KENNEDY	E. ELDRIDGE	I. B. ASHLEY

F. P. McINTYRE H. E. SLOCUMB

Contractors

DEGNON CONTRACTING CO.

FURST-CLARK CON. CO.	PENNSYLVANIA STEEL CO.
C. W. REYNOLDS	T. A. SCOTT CO.
E. W. FOLEY CON. CO.	WILSON & ENGLISH CON. CO.

HOLBROOK, CABOT & ROLLINS CORPORATION

A grand opening souvenir was made available to many who came to the official opening of the Cape Cod Canal. *Courtesy of the Sturgis Library.*

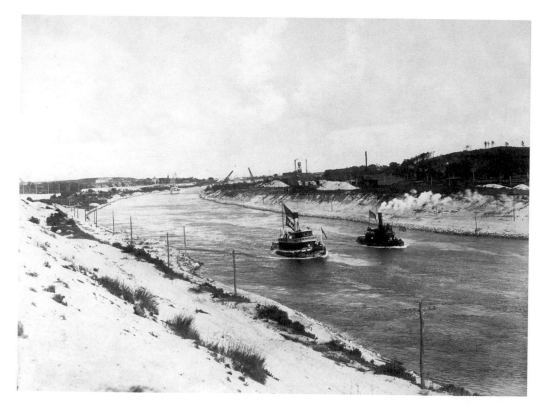

The naval parade made its way through the Cape Cod Canal at the opening ceremonies. *Courtesy of the Town of Sandwich Archives.*

President Woodrow Wilson sent his appreciation. "Allow me to convey through you my hearty congratulations on the completion of a great work which should be of direct benefit to the commerce of the country," Wilson wrote.

Belmont's huge, side-paddle steamship *Rose Standish* was packed with Belmont's family, friends and dignitaries, many of them coming from New York and Newport, Rhode Island, for the occasion. The *Rose Standish* was the first passenger ship to sail through the Cape Cod Canal. The banks of the canal were lined with well-wishers, waving flags, cheering and saluting the procession of boats as it made its way through the canal. Anchored along the banks of the canal were dozens of tugboats, fishing boats and an assortment of private yachts. August Belmont Jr. couldn't have been prouder.

"Through our efforts the graveyard of the Cape Cod coast is now closed," Belmont said during the official dedication ceremony on shore. "Personally, should it serve no other purpose than the saving of thousands of lives from perishing off the Cape, I shall feel my own efforts are repaid," he proclaimed.

The *Rose Standish* triumphantly plowed through a red, white and blue bunting that was stretched across the width of the canal. The sounds of ship horns, whistling, bells and a smattering of music echoed along the corridor of the canal as the procession of ships made its way through.

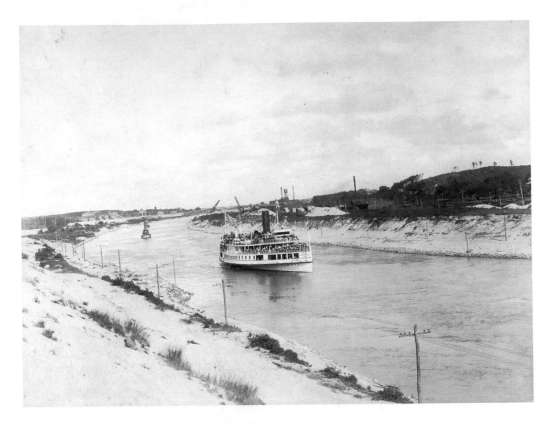

August Belmont Jr.'s flagship, the *Rose Standish*, led the way through the canal at the grand opening ceremonies. *Courtesy of the Town of Sandwich Archives.*

Near the eastern end of the canal, Belmont's own yacht, the *Scout*, came alongside the *Rose Standish* and picked up Belmont and several prominent guests, including Massachusetts Governor David Walsh and Seth Low, the former New York City mayor. Low served as the main speaker at the grand opening. The yacht took Belmont and the others ashore at Sandwich for the official grand opening ceremony. The armada continued ceremoniously through the canal to Cape Cod Bay where the promenade of ships turned around and traveled back through the canal once more to Buzzards Bay.

At the grand opening ceremony on shore, Massachusetts Governor Walsh spoke, as did Assistant Secretary of the Navy Franklin Roosevelt, former Massachusetts Governor Curtis Guild, former New York City Mayor Seth Low and Belmont himself. Massive praise was heaped upon Belmont and his associates for their remarkable accomplishment by all the speakers. After nearly three hundred years of debate, thanks to August Belmont Jr., the Cape Cod Canal was now a reality. Massachusetts Governor David Walsh hailed Belmont as a man of courage and conviction.

The main speaker at the ceremony, former New York Mayor Seth Low, told the crowd that it was appropriate that New York people dug the Cape Cod Canal that had eluded Massachusetts residents for so long because New York had a track record

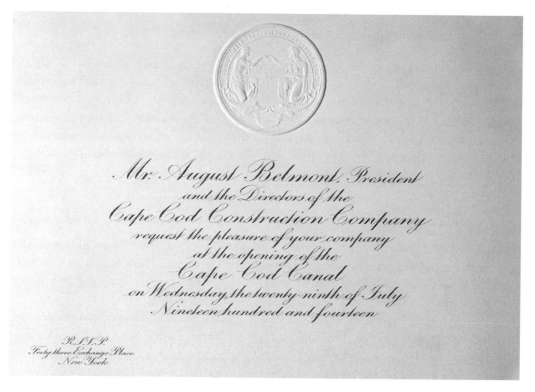

Mr. August Belmont, President
and the Directors of the
Cape Cod Construction Company
request the pleasure of your company
at the opening of the
Cape Cod Canal
on Wednesday, the twenty-ninth of July
Nineteen hundred and fourteen

R.S.V.P.
Forty three Exchange Place
New York

Invitations were sent out to hundreds of Cape Cod residents for the grand opening of the canal.

of building successful canals (the Erie Canal). Low cited Belmont's experience building New York City's first subway system and his sense of devotion to improving all forms of transportation. Digging the Cape Cod Canal, Low told the crowd, was an opportunity for Belmont to once again improve the country's mode of transportation.

In his speech, Belmont said:

> During the progress of this great work and as we approached the day for its dedication to public use, I have been possessed of the thought that we, foreigners to Massachusetts, hailing from New York, were doing something for New England which New England was not alive to doing for herself.
>
> Yet now, as I stand before you, fresh from a warm reception at Sandwich, where they are celebrating the founding of that old town 275 years ago by Edmund Freeman, one of my ancestors, I feel of the soil here and that after all, New England has had much to do with the building of her own canal. The illusion that I am a Massachusetts man is complete.

When the official ceremony ended, the crowds slowly dispersed, some going back home to Boston, others to New York and still others to their homes on Cape Cod. Belmont's guests on board the *Rose Standish* were taken to New Bedford Harbor where

Belmont arranged for a further celebration. The Cape Cod Canal was officially opened.

Ironically, despite all of his best efforts to garner the most publicity possible for the opening of the canal, Belmont's efforts were thwarted by events he could never have foreseen. On the same day as the opening of the canal took place, in Europe, the czar of Russia mobilized troops in anticipation of war with Germany. And in Germany, the Kaiser prepared his navy for war. News of the Cape Cod Canal grand opening was relegated to the back pages of most newspapers in light of the threat of the pending world war.

OPEN FOR BUSINESS

The Cape Cod Canal officially opened for business on the next day, July 30, 1914. The first vessel to use the canal was the twenty-six-foot yacht, the *Mashantan*. The ship paid a toll of eight dollars to pass through the canal. The total revenue from the first day of operation was fifty-one dollars, coming mostly from curiosity seekers.

It was not until two weeks later, August 12, 1914, that the first commercial vessel traveled through the canal. The tugboat *Albert J. Stone*, towing three railroad barges, passed successfully through the canal in ninety minutes. It moved steadily against the current without any problems.

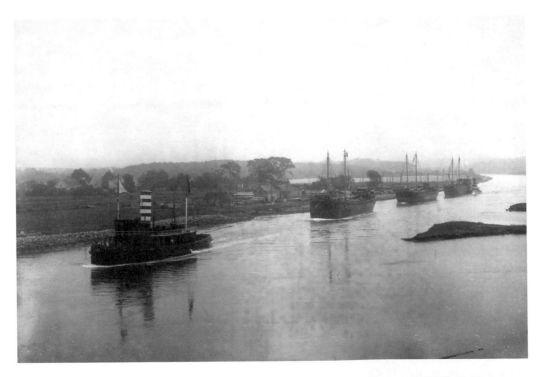

The first commercial traffic began using the canal the day after the grand opening. It included barges towed through the canal by tugboats. *Courtesy of the Town of Sandwich Archives.*

Although the canal was purported to be fifteen feet deep, it was advised that only ships with a twelve-foot depth use the canal. The dredging of the canal continued during the operation of the canal. The situation made it difficult both on the workers who were dredging and on those using the canal for safe and swift passage. Barges often had to be cleared out of the way in order to let ships pass. This was costly and time consuming, but the dredging had to be done in order to make the canal more passable. This process continued through early March of 1916, when the Cape Cod Canal officially reached a depth of twenty-five feet.

Other important innovations were added to the canal as time went on to make the passage safer and more efficient. Electric lights were strung the length of the canal on both sides. Erected at intervals of five hundred feet, the lights illuminated the canal for passage at night. Moorings were erected at both ends of the canal so ships waiting to pass through could tie up. Belmont's canal was not wide enough to accommodate two ships passing in opposite directions. Sailing east or west, only one ship could pass at a time. The United States Lighthouse Service set up a fog and light signal at the breakwater on the eastern side of the canal and set out buoys that lighted the Buzzards Bay channel. All these renovations, plus the continued dredging of the canal, made it fully operational in September 1916.

Tolls for the use of the canal were based on the need to pay for the operation of it. Prior to reaching its maximum depth, most of the traffic using the canal was pleasure ships—yachts, excursion vessels and motorboats. Of the nearly six hundred ships that used the canal in 1914, four hundred were pleasure crafts. An exception to this was the passage of the 350-foot Dutch steamer *Tenbergen*, which was the largest ship to use the canal. It was also the first foreign ship to make safe passage through it.

In 1915 many more fishing vessels and railroad barges began using the canal. More than twenty-five hundred ships were recorded using the canal in 1915, and less than half of them were pleasure boats. By 1916, nearly five thousand ships had used the Cape Cod Canal.

Toll rates for the use of the canal included the high rate of sixteen dollars for schooners at a minimum of a thousand gross tons and a four-cent charge per cargo ton over the minimum weight. Barges were charged a rate of three dollars empty and four dollars loaded. These tolls remained in force throughout 1918.

Passenger Steamships

The canal soon attracted the attention of the commercial steamship lines. By using the Cape Cod Canal, the steamship lines were able to reduce the Boston to New York passenger service from 330 miles to 260. By reducing the number of miles it took to reach their destination, the steamships were able to reduce the travel time. Passage from Boston to New York, using the Cape Cod Canal, could be made within three hours.

In addition, it was a much smoother trip for passengers. Prior to using the canal, passenger trips around Cape Cod were made through rough waters, rocky currents and

foggy waterways. The new Cape Cod Canal route had great appeal. It was shorter and safer, and depending on the weather conditions, it allowed steamship lines to extend their travel season into late November.

Use of the Cape Cod Canal by passenger lines increased the number of passengers twofold from 1915 to 1916. From approximately 68,000 passengers making the Boston to New York trip in 1915, a record 140,000 people made the same journey in 1916. Agreements were signed with the steamship lines for use of the canal. Although not initially profitable, the Cape Cod Canal benefited from favorable publicity by the many passengers using the route. But not everything was running smoothly.

ACCIDENTS IN THE CANAL

From 1914 through 1918, there were fourteen accidents along the canal route. The worst of these included the sinking of the *William Chisholm* in early July 1916. The ship, loaded with a cargo of coal, smashed into the bank at Bournedale and sank. Luckily, the wreck went down along the bank and not in the middle of the canal. The Cape Cod Canal Company was able to keep the passageway clear for other vessels. But only smaller ships and barges were able to pass. Normal traffic on the canal was not resumed until the end of the month when the wreck of the *William Chisholm* was finally cleared away.

It was not just the delay in canal traffic that hurt the canal. There was an onslaught of bad publicity. The owners of the *William Chisholm* filed a $350,000 lawsuit against the Cape Cod Canal Company, claiming the waterway was unsafe and dangerous. This kind of news spread quickly.

If the sinking of the *William Chisholm* was the beginning of the end for the Cape Cod Canal Company, the sinking of the *Bayport* in December 1916 was the final nail in its coffin.

Although the *Bayport* was being towed through the canal by a tugboat, the ship hit the canal bank and sank. Salvage operations began immediately, but the *Bayport* sunk in the middle of the canal, blocking traffic through the canal completely. In order to clear the canal, the *Bayport* had to be dynamited. The entire process took three long months during which the canal was closed down.

The sinking of the *William Chisholm*, followed closely by the sinking of the *Bayport*, began tongues wagging in the maritime community. The reputation of the canal was now in question.

Seafaring men began to question the narrowness of the canal. They complained of the treacherous current that flowed through it. Hemmed in by the banks of the canal, unlike the open sea, they complained that they were unable to maneuver through the canal the way they should. They argued that because of the limited width of the canal and its current, there was no room for ships to navigate safely through it. Ship captains feared that they might smash their vessels into the banks or bridges, or worse—they had the abiding fear that the drawbridges might not open in time to pass.

Ultimately, there was the sheer stubbornness of the independent-minded Cape Cod seamen to contend with. They knew the waters around Cape Cod were dangerous and laden with potential disasters, but they were dangers that they were familiar with. The Cape Cod Canal presented dangers that were new to them. Many captains were more inclined to face the potential dangers of the open sea than the ones the canal presented.

In the end, in order to attract business, the Cape Cod Canal Company was forced to reduce its tolls. But not even reduced rates attracted the kind of seafaring business the company needed to make the operation of the canal a success. In a mere four years, from 1914 to 1918, the brilliant flame of hope and prosperity that the Cape Cod Canal once presented was economically extinguished. The owners of the Cape Cod Canal Company determined that the canal *had* to be sold. The only question was *when* and for how much.

MILITARY GAMES

The military importance of the Cape Cod Canal was apparent from the very start. In November 1914, two submarines, the *K-5* and *K-6*, part of the new fourth division of the Atlantic submarine flotilla, sailed from Boston to Newport, Rhode Island, in just over nine hours, using the Cape Cod Canal to cut off sixty miles from the route and avoiding rough waters around the Cape. The subs' ultimate destination was Pensacola, Florida, where they were scheduled to take part in training missions involving battleships and destroyers. The subs were the latest additions to the Atlantic-based flotilla and were built at the Fore Plant in Quincy, Massachusetts. The United States Department of the Navy extolled the military advantages of the Cape Cod Canal as part of the country's overall defensive system.

According to a spokesman for the navy:

> *The important part that submarines are playing in the European war emphasizes their importance in our own plans for national defense; and this canal, which permits them to pass freely between the waters of Long Island Sound and Cape Cod Bay, becomes a strategic feature that could hardly be overstated.*
>
> *Not only submarines, but destroyers and light vessels of all kinds could freely use it without exposure in time of war attack by an enemy's forces. In peace times it affords a comfortable and convenient passage during weather that often renders passage by the outside route hazardous.*

During naval training missions in July 1915, two years before America entered the war against Germany, the United States Atlantic Fleet was deployed to cover most of the important strategic points of defense. Notable among the mimic naval maneuvers conducted along the Atlantic Coast during the war games was the use of the Cape Cod Canal. Several submarines were deployed off the Cape Cod coast, assigned to

guard the entrance to the canal from a possible hostile enemy fleet. The war games and the success of using the Cape Cod Canal to eliminate a seventy-mile trip around the tip of the Cape, affording access to Buzzards Bay and the strategic naval district within Narragansett Bay, only added to the attractiveness of the canal for use by the government.

By 1918, a year after America officially entered World War I, the activities of enemy submarines in the North Atlantic preying on unarmed and slow marine traffic caused renewed interest from the merchant shipping industry in the government buying the canal. It had to be widened and deepened in order to provide the merchant vessels with a safe inland shipping route.

In late July 1918, President Woodrow Wilson ordered that the Cape Cod Canal be taken over in light of the increased German U-boat (submarine) attacks in the North Atlantic. Wilson signed a proclamation ordering the Railroad Administration to take over the operation of the canal.

One of the first orders of business the Railroad Administration undertook was dredging the canal to a greater depth to accommodate the towing of much-needed coal destined for New England. More than ten million tons of coal could be moved safely through the canal with the Railroad Administration's alterations to the canal. Other merchant marine vessels were rerouted through the canal to protect them from enemy attacks. It was the beginning of the end of private control of the Cape Cod Canal.

THE GOVERNMENT TAKES OVER OPERATIONS

The takeover of the Cape Cod Canal by the United States government was not prompted by money, but by war. What was one of the only recorded attacks by a foreign enemy on American soil during a state of war happened on Cape Cod in the spring of 1918. The *Perth Amboy*, a tugboat, and the string of barges it was towing off the coast of Orleans, Massachusetts, was attacked and sunk by a German submarine on Sunday, July 21, 1918. This attack led to the takeover of the canal by the United States Railroad Administration under Secretary of War Newton D. Baker.

In the spring of 1918, at the height of America's involvement in World War I, the German navy began operating several submarines, called U-boats, off the coast of New England. Although the damage inflicted by these U-boats was minimal, the fear of their presence caused many shipping fleets to seek the protected waters of the Cape Cod Canal. Although the possibility of the government's takeover of the canal, either by outright purchase or some other means, had always loomed on the horizon, it was the sinking of the *Perth Amboy* that finally made it happen.

"The Cape Cod Canal...was an important section in the inside route from New York to New England which was extensively used on account of German submarines," Congress was informed.

The possibility of government control of the canal had been ongoing since the canal was first built. It was first brought to the forefront in 1911, but August Belmont Jr.

stood firm against any government interference. Throughout the digging of the canal, Belmont did not seek any financial support from the government. "We are satisfied with it, and need no help to construct it, and want none," Belmont said.

Even as far back as 1907, it was suggested that the government might be encouraged by military and commercial interests to take over the operation of the Cape Cod Canal. It was true that the government was interested in the canal as part of its overall inland waterway plans, but no one ever acted on it. Before and throughout its construction, Belmont opposed any takeover by the government. It was not until 1915 that he reconsidered his opposition to government ownership. Ongoing construction and operational costs, along with less than desired profits from its operation, caused Belmont to rethink his position.

In 1915, the Massachusetts Senate began hearings on the possibility of acquiring the canal. The major stumbling block was the cost of purchasing the enterprise. Belmont wasn't about to sell the canal at a loss.

That same year, United States Secretary of the Navy Josephus Daniels toured the canal and reported back to Congress that the purchase of the canal would be a favorable idea. In 1916, a bill before Congress was introduced directing the navy secretary to explore the feasibility of improving the Cape Cod Canal for full naval operations. The canal was still too small to accommodate larger vessels or two vessels passing in opposite directions.

When the United States declared war in 1917, Massachusetts Senator John Weeks introduced a bill calling for the government to take over control of the canal for military purposes. The bill called for the secretaries of war and the navy to begin negotiations into the cost of buying the canal. The bill also allowed the government, should the negotiations fail, to authorize condemnation hearings for the purchase. Condemnation hearings allowed the government to secure certain property by the right of eminent domain and allowed a jury to decide the fair market value of the property. The jury in a condemnation trial simply had to affix a monetary value to the property in question, in this case the Cape Cod Canal.

Hearings on the proposed takeover of the canal were favorable. The chief of the United States Naval Operations reported that the canal had tremendous strategic value in light of the German submarine operations off the New England coast. United States Secretary of Commerce William Redfield reported to Congress that the declaration of war had greatly enhanced the overall value of the canal. Testimony from private shipowners also supported government control. Finally, the secretaries of the navy, commerce and war were directed by Congress to enter into negotiations with the owners for the purchase price of the canal. August Belmont Jr. agreed to provide all necessary financial and engineering information.

The noted and reputable firm of Price Waterhouse and Company was hired to examine the financial assets of the canal operation. The company did a complete and thorough audit of the records. "The value of the Canal from a military point of view as well as commercial uses is very large. The price the United States should pay for the Canal if it decided to purchase said canal should not be greater than $8,265,743.04," the Price Waterhouse final report read.

That price was unacceptable to the owners of the canal and Belmont in particular, since he had put up most of the money for the construction of the canal—an estimated $9 million.

"It seems to me from every point of view desirable that we should acquire the canal and maintain it as a genuine artery," President Wilson said.

But the money that the government offered was not enough to cover the Cape Cod Canal Company's financial obligations. However, $8.2 million was all the government would offer. Because of Belmont's refusal to accept the offer, condemnation proceedings began. The fair price for the purchase of the Cape Cod Canal would now be in the hands of a jury. The outbreak of World War I ended the proceedings.

The Beginning of the End

The sun rose visibly at such a distance over the sea, that the cloud-bank in the horizon, which at first concealed him, was not perceptible until he had risen high behind it, and plainly broke and dispersed it, like an arrow. But as yet I looked at him as rising over land, and could not, without an effort, realize that he was rising over the sea. Already I saw some vessels on the horizon, which had rounded the Cape in the night, and were now well on their watery way to other lands.

—*Henry David Thoreau,* Cape Cod

America entered the war against Germany in April 1917. Diplomatic relations with Germany ended on February 3, 1917, when a German submarine torpedoed and sank the American ocean liner *Housatonic.*

Amcrican troops did not land in Europe until June. The war ended on November 11, 1918, five months after the sinking of the tugboat *Perth Amboy* off the coast of Orleans, Massachusetts, on Cape Cod. It was the sinking of the *Perth Amboy* that led the government to finally take over the operation of the Cape Cod Canal.

Eleven-year-old Jack Ainsleigh was waving an American flag from the bow of the rescue ship as it entered Nauset Harbor in July 1918. Jack and his father had just been rescued after the barge *Landsward*, under the command of Jack's father, was sunk by German U-boats off the coast of Orleans, Massachusetts. The crowds on shore cheered wildly as young Jack Ainsleigh and his wounded father came ashore. It was Sunday, July 21, 1918, and the crew of the *Landsward* had survived the first foreign attack on the American shore since the Battle of 1812.

The tugboat, the *Perth Amboy*, was towing four barges, including the *Landsward*, from Gloucester, Massachusetts, to New York City, when a German submarine surfaced and began firing. The boats were only three miles off the coast of Orleans, near the tip of Cape Cod. It was ten thirty on a Sunday morning. There was no precious cargo on any of the barges. Only one barge was loaded, and this one was only hauling stone. The

captains of the various vessels, their families and their crews were all aboard—a total of forty-one men, women and children. Five men were wounded in the surprise attack, including Jack Ainsleigh's father.

Taking place in broad daylight in the middle of summer, the incredible shelling of the *Perth Amboy* attracted an awestruck audience to the shore. Dozens of Cape Codders and summer vacationers rushed to the Orleans shoreline and watched in horror as the German submarine fired shell after shell at the convoy of barges. According to reports, 147 rounds were fired by the submarine at the convoy. One shell hit American soil in Orleans, luckily without injuring anyone. The *Perth Amboy* was severely burned in the German shelling, but it managed to survive the attack. The four barges were not as fortunate. All four barges were sunk.

A fog on the outer shore kept the approaching German U-boat hidden from the American convoy. It wasn't until an alert deckhand on the *Perth Amboy* saw a funnel of water streaking toward the tugboat that anyone knew they were under attack. The deckhand watched in horror as the German torpedo streaked past the *Perth Amboy* and exploded out at sea. The submarine, which was still submerged, fired two more torpedoes, but both also missed their mark. The submarine rose out of the depths, still concealed by the fog, and began a barrage of the convoy. One shell after another rained down on the barges and the tugboat. One of the barges, hit at the waterline, sunk immediately. The *Perth Amboy* was hit several times and burst into flames.

When the German U-boat first began firing, young Jack Ainsleigh ran to the cabin and grabbed his father's .22-caliber rifle. Eleven-year-old Jack ran to the bow of the *Landsward* with the rifle and a small American flag that he waved defiantly at the German submarine. The boy aimed and fired off several rounds. Luckily, his father managed to drag the boy to safety just as a shell landed on the bow of the barge. Captain Ainsleigh was wounded by shrapnel in the arm during the attack, but young Jack was unharmed.

Rescue efforts began almost immediately despite the ongoing attack. Captain Robert Pierce of the Orleans Lifesaving Station launched a rescue boat to save the victims. By the time Pierce and his crew reached the scene, all four barges had been sunk and only the *Perth Amboy* remained afloat, but it was on fire. Lifeboats from the four barges and the tugboat were already launched with the frightened and wounded victims on board. When it had finished its destructive shelling, the German submarine slowly submerged beneath the waves and slipped away, by all accounts heading south.

According to Captain Pierce of the lifesaving station, the rescue attempt at first seemed foolhardy. "It looked rather hard to be sent twelve miles away in a small surf boat to a German submarine firing heavy guns on a tow of barges," he said.

But, according to Pierce, orders were orders. "I had no excuse," he said.

All forty-one of the passengers and crew were rescued. On shore, Captain Ainsleigh was treated for his injuries by a vacationing Cape Cod physician. The other wounded passengers were sent by a special train to Boston to be cared for.

The *Perth Amboy*'s captain, Jim Tapley, recounted that the convoy of barges left Portland, Maine, on July 20, 1918, headed for New York. Tapley was towing three barges out of Portland and picked up a fourth in Gloucester, Massachusetts.

Captain Tapley was napping when the first German shells began to rain down on the boats. He quickly ran on deck. "It was not long before there was a second explosion and then I discovered that a shell had exploded only a short distance from us," Tapley said.

Soon a third and a fourth shell hit the tugboat. "At the time, I was partially stunned but soon regained consciousness to find both doors blown off the pilothouse and a large hole in the roof over my head," he recounted.

"The last shell," he said, "had set the tug on fire around the pilothouse, which was burning rapidly."

According to Tapley, the lifeboats were launched immediately. All seventeen members of his crew made it safely off the ship, heading for shore.

"The submarine continued to shell the barges, sinking all four of them and doing considerable damage to the tug, which remained afloat and afire," Tapley said. "Upon leaving for shore, we were met by the Coast Guard boat, which gave first aid to the injured man and, as soon as we landed, he was rushed to the hospital at Boston where after a long time he was discharged."

American Intelligence officials investigated the shelling, but they could not understand why the German U-boat would bother with a fleet of nearly empty barges. There was no cargo on board and certainly no military supplies. It was speculated that the real targets of the submarine were the northbound coal ships, the *Arlington* and *J.D. King*, both of which were loaded with a rich cargo of coal. This would have been a prize catch for the Germans, but the two ships slipped safely past the Orleans coast hours earlier, concealed in the same fog bank that hid the German U-boat from view.

The *Perth Amboy* was towed to Vineyard Haven on Martha's Vineyard for repairs. For several days following the attack, the New England shipping fleet waited in safe harbors along the coast until the threat of the German U-boat attacks subsided.

Shortly after the attack, the U.S. government took over control of the Cape Cod Canal. They kept control of it until February 1919. The government lost more than $700,000 during its wartime control of the canal.

CONDEMNATION HEARINGS

In April 1919, following the end of World War I, the government filed a petition to begin a condemnation trial on the Cape Cod Canal. The process of condemnation allowed the government to acquire the canal through eminent domain and to ask a jury to determine the price of the property.

In June 1919, Massachusetts Senator Henry Cabot Lodge introduced a bill into Congress asking that the United States government take over the operation of the canal despite no wartime threat. Lodge's bill recommended that the government receive credit

for the money it spent during the war on improvements to the canal and suggested that Belmont and his investors be paid $10 million for the canal.

Not everyone in Congress was pleased by the bill. United States Senator William Kirby of Arkansas called Lodge's bill "a systematic attempt to unload on the Government an undesirable and bankrupt commercial project." Regardless of Senator Kirby's shortsightedness, the Cape Cod Canal condemnation trial began in the United States District Court in Boston.

The trial began in October 1919, with the selection of the jury. The job of the jury was to decide a fair price for the sale of the canal to the government. The government's lawyer, former Boston Mayor Nathan Matthews, asked that the jury return a "just verdict."

Sherman Whipple, the lawyer for August Belmont Jr. and the Cape Cod Canal Company, argued that the owners of the canal merely wanted "their money back in the kind of dollars they spent." Whipple asked the jury to award the Cape Cod Canal Company $25 million as a fair market value for the purchase of the canal.

The trial lasted from October through November and included a host of impressive witnesses from both parties. The jury retired on November 18, 1919, to deliberate and came back with a finding on the very same day.

"The jury finds that on said date the value of said property was the sum of sixteen million, eight hundred and one thousand, two hundred and one and eleven-hundredths ($16,801,201.11) dollars." After ten years (1909–1919) the value of the Cape Cod Canal was finally established. The amount was far less than either Belmont or his fellow investors wanted, and Belmont stood to lose most of all.

"I have to do most all the financing for the Cape Cod Canal," Belmont said during the condemnation trial. Belmont had personally invested more than $4.2 million in the Cape Cod Canal. This was without computing interest. With interest, Belmont's personal investment in the Cape Cod Canal came close to $8 million. But the actual sale of the canal to the government would take another nine years.

After the war, the government, through the U.S. Railroad Administration, tried to return the operation of the Cape Cod Canal to Belmont and the Cape Cod Canal Company, but Belmont refused to take back control of the waterway. "We decline to accept it on the grounds that the Government had already taken it and the condemnation proceedings ended our right and title to the canal," Belmont said.

In February 1921, the Circuit Court of Appeals reversed the $16,801,201.11 condemnation judgment and remanded the case back to the district court for a new trial. The grounds for the new trial were cited as errors in testimony regarding the value of the canal property. Before the trial began, the government undertook a new study of the canal. It was begun shortly after the appeals court ruling in 1921 and was completed in late November 1922.

"We ask a just verdict for the amount of the present value of the property regardless of what you think is a fair price, in justice to the company and in justice to the people of this country," Nathan Matthews told the hearing committee.

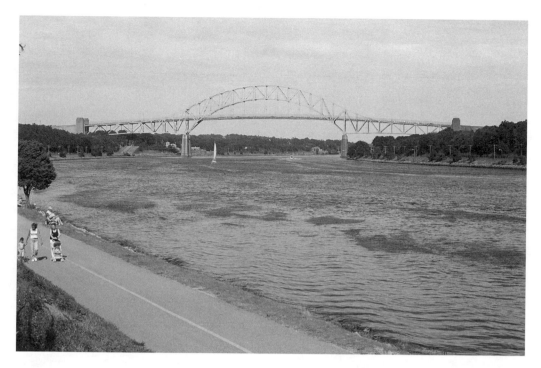

Even today, swift currents plague the canal. *Courtesy of Nate Conway.*

Colonel Edward Burr of the Army Corps of Engineers conducted the study. Burr studied the history, operation and finances of the canal. He reported that the operation of the Cape Cod Canal was a failure because it was not wide or deep enough to support the maritime traffic it needed to in order to make it profitable. He also attributed the failure of the operation to the strong currents running through the canal and the low bridges spanning it. Despite this, Burr reported that the Cape Cod Canal should be bought by the government.

Burr concluded that the canal was of commercial and agricultural importance to the country and that the use of the canal reduced travel time and limited the number of potential hazards arising out of sailing around Cape Cod's outer shore. In order to make the canal a complete success, Burr recommended that it be widened and made deeper in order to accommodate more maritime traffic. Private financing for these improvements was not available, he reported.

Lastly, Burr concluded that the government's policy had always been to maintain waterways of national importance and that the Cape Cod Canal, with the necessary improvements, would be of great national importance from both a commercial as well as military point of view.

While Colonel Burr was undertaking his study, the government and Belmont's company continued to negotiate the sale of it. In July 1921, a contract between the two parties was agreed upon. The government agreed to pay $11.5 million for the canal. The Cape Cod Canal Company agreed to this price, even though it was lower

An aerial view of the
Cape Cod Canal shows
the vastness of the project.
*Courtesy of the Army Corps of
Engineers.*

than the amount awarded during the condemnation trial. Primarily, the agreement was reached because the longer the sale of the canal dragged on, the more money the Canal Company lost.

According to the agreement, Belmont's Cape Cod Canal Company would receive $5.5 million in cash and the government would assume the payment of another $6 million in bonds. At the next Congressional session in December 1921, a bill was introduced to allocate the money to pay for the canal. An editorial in the *Boston Herald* claimed, "It is practically certain that Congress will ratify the bill." However, the bill introduced into the U.S. House of Representatives and the one introduced into the U.S. Senate were different, which presented a major obstacle for its passage. The House version only allocated $9 million for the purchase of the canal. The Senate version called for the original amount of the agreement—$11.5 million. The bills ended up in conference committee where they languished and were not acted upon before Congress adjourned. Nearly a full year later, Congress again tried to act on the canal appropriation, but again nothing was done. In 1924, the appropriation bill for the purchase of the Cape Cod Canal was once again introduced in Congress, this time with the backing of President Calvin Coolidge. Coolidge was a former governor of Massachusetts and knew the worth of the canal. With his backing, the House version of the allocation passed.

"The taking of the Cape Cod Canal is in accordance with a moral obligation which seems to have been incurred during the war," President Coolidge told Congress. Still, the allocation bill did not come to fruition. The U.S. Senate tabled discussion of the appropriation bill and adjourned.

THE CANAL CLOSES

In March 1921, the Cape Cod Canal was officially closed as a result of the controversy over its ownership. The Railroad Administration had relinquished its administrative and operational control over the canal and Belmont's company, the Boston, New York and Cape Cod Canal Company, claimed that no orders from the government had been issued for them to resume their previous operations of the canal. Belmont's company refused to let ships pass through the canal because it had not been granted any authority to do so. The dispute between the government and Belmont's company had grown out of the question of the value of the canal. Neither side was able to agree upon a potential purchase price for the canal. The government ultimately seized the canal by eminent domain and a jury fixed the sale price at approximately $17 million. The government had offered Belmont a mere $8.5 million for the canal, and the whole affair was sent back to the courts and was pending a decision when the brouhaha over the closing of the canal occurred in March of that year.

President Calvin Coolidge sent a telegram to the secretary of war ordering him to continue the operation of the canal under government control in order to facilitate the coal shortage in the northeast. The canal was subsequently reopened to traffic, once more under the authority of the government.

The Beginning of the End

By June 1921, the secretary of war recommended to Congress that the government purchase the Cape Cod Canal for $11.5 million, which was $5 million less than what the federal courts had allowed. New negotiations with Belmont, on behalf of the Boston, Cape Cod and New York Canal Company, over the asking price had been favorable. Belmont agreed to the $11.5 million price tag recommended to Congress by the secretary of war. Determining the value of the canal had been tied up in the federal courts for years. The initial value set by the courts was $16.8 million, but this award was later overturned by the Circuit Court of Appeals. Direct negotiations outside of the courts with Belmont and company proved to be more fruitful than the intricacies of the courts.

In December 1921, a bill was introduced into the United States House of Representatives to buy the Cape Cod Canal for $9 million. The government had deemed that the acquisition of the canal was desirable and that the cost was reasonable.

An agreement that needed to be ratified by Congress was also sent to the House. The agreement called for the transfer of the Cape Cod Canal from the Boston, New York and Cape Cod Canal Company to the federal government. Along with the canal itself, the sale would include 932 acres of land owned by the company. The ultimate passage of the bill, like everything else associated with the Cape Cod Canal, would take forever.

In 1926, House Bill #8392 for the purchase of the Cape Cod Canal was introduced in Congress and was reported out favorably. In December 1926, the U.S. Senate approved

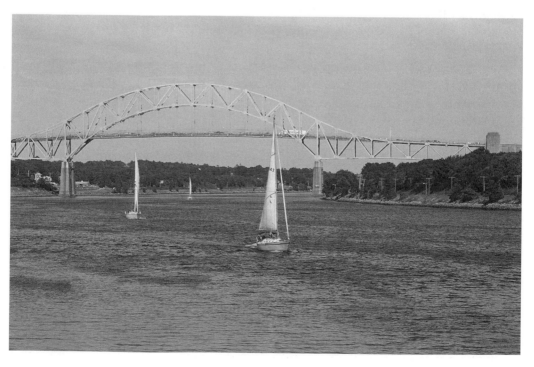

Pleasure crafts are a frequent sight on the canal today. *Courtesy of Nate Conway.*

the bill. In January 1927, both the House and the Senate ratified a bill providing for the purchase of the canal for $11.5 million. The government would pay $5.5 million cash to the Cape Cod Canal Company and assume $6 million in issued bonds. Despite the allocation, another roadblock to the sale of the canal arose. This time, the government's attorneys found problems with the land titles. Many of the land titles went back two or three hundred years. Many records were lost. It took the government another full year before all the land titles were deemed clear and legal.

On March 28, 1928, all the deeds surrounding the sale of the Cape Cod Canal were recorded. The sale of the canal was completed. By April 1928, the Cape Cod Canal was fully owned by the United States government.

THE FINAL SALE COMES TOO LATE FOR BELMONT

The sale of the Cape Cod Canal in April 1928 came four years too late for August Belmont Jr. On December 9, 1924, Belmont suffered a stroke while working at his New York office. He died on December 10, 1924, at the age of seventy-one.

August Belmont Jr. lived much of the last years of his life on a 1,100-acre estate in North Babylon, New York. After his death, his widow Eleanor sold most of the estate. Following her death in 1979, the remaining 158 acres, including the family mansion, lake and farm buildings, fell into the hands of the New York state government. Under the control of planner Robert Moses, the estate was enlarged back to 459 acres and turned into Belmont Lake State Park. The mansion served as headquarters for the Long Island State Park Commission until 1935 when it was leveled to make way for the current building.

August Belmont Jr. was buried in the Belmont family plot of Island Cemetery on Farewell Street in Newport, Rhode Island, near the Belmont Chapel and in front of the marble monument and sarcophagi erected by Oliver Belmont for August Belmont and Caroline Belmont.

According to the *New York Times*, "His was a life richly colored and abundantly lived. Never again, in all likelihood, can a single mortal span cover so much that is vital and picturesque."

A monument, made of white quartz, was erected to the memory of August Belmont Jr. along the furthermost section of the Sagamore Bridge. It has since been moved to a place of prominence along the canal. The inscription on the monument reads:

In memory of August Belmont, February 18, 1853–December 10, 1924, whose vision, initiative and indomitable courage made possible the first complete construction of the Cape Cod Canal connecting Buzzards Bay and Cape Cod Bay which was officially opened for traffic July 29, 1914, from his maternal grandfather Commodore Matthew Calbraith Perry he inherited a warm allegiance to the interests of New England and his deep concern for those that go down to the sea in ships.

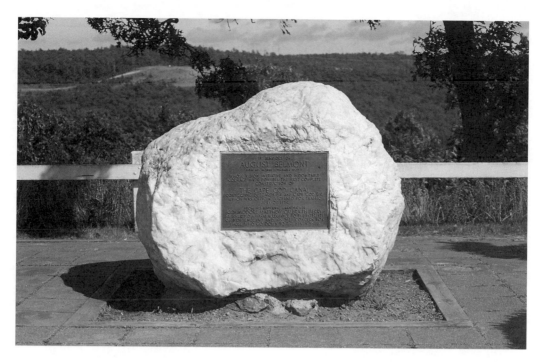

The August Belmont Jr. monument stands today as a testament to his accomplishment. *Courtesy of Nate Conway.*

Shortly after his death, the creditors for the Cape Cod Canal Company made a recommendation to file for bankruptcy. Belmont's wife, Eleanor, rejected the proposal outright. The decision was based not only on the memory of her husband's determination to hang onto the canal against all odds, but also because bankruptcy would mean that the canal would be sold at a tremendous loss. It was being sold at a loss already. Bankruptcy would only reduce the sum paid for it. Finally, four years after August Belmont's death, the canal was sold.

Belmont's estate received approximately $4.5 million from the sale of the canal. Based on his overall investment, including interest, Belmont's estate lost close to $5 million on the sale.

THE ARMY CORPS OF ENGINEERS MAKES IMPROVEMENTS

Following the sale of the canal to the government, a host of improvements were made to Belmont's canal. Congress gave authority to the United States Army Corps of Engineers to take over the operation of the Cape Cod Canal as well as initiate needed improvements. In March 1928 work on the many improvements began.

The Army Corps of Engineers contacted various shipping companies to determine what the various users of the canal saw as navigational problems with the existing canal.

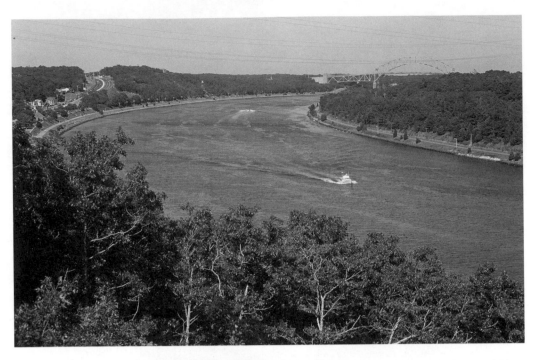

Millions of tourists each year come to view the panoramic view of the Cape Cod Canal. *Courtesy of Nate Conway.*

To begin with, the tolls associated with the canal passage were eliminated. One of the things the engineers learned from listening to ship captains was that the bridges that spanned the canal presented serious problems for mariners. These moveable bridges were usually positioned in the down, or highway access, position, which meant that ships and barges had to navigate rough currents waiting for the bridges to be opened so they could pass through the canal. This situation put the ships and barges in a dangerous and precarious navigational situation since the currents were so strong and the passageway so narrow.

The Army Corps of Engineers decided on eliminating the existing moveable bridge spans and constructed two new bridges, the Bourne and Sagamore Bridges. They were built at a height above the canal that would not obstruct the passage of larger vessels. Locations for the two elevated sites were determined and plans were designed to construct two fixed bridge spans at a height of 135 feet and a horizontal clearance of approximately 500 feet to alleviate dangerous congestion in the canal.

The existing railroad bridge presented a more difficult problem. The railroad tracks and train terminal in Buzzards Bay provided the necessary train grades. Moving the railroad bridge would be impractical because a fixed-level bridge would not give the trains enough traction to pass over the canal adequately.

Instead, the corps settled plans that would call for a vertical-lift railroad bridge in the same location with a huge center span to accommodate large vessels using the canal

for passage. The vertical and horizontal height and width would be the same as the two planned fixed-span highway bridges. The vertical lift was intended to be left in the raised position so it would not hinder passage, and it would be lowered to allow rail traffic on and off the Cape.

The architectural firm of Cram and Ferguson from Boston was hired to oversee the design and the appearance of the two bridges. Fay, Spofford and Thorndike, another firm from Boston, supervised the construction of the bridges. The Sagamore Bridge was built approximately three miles in from the eastern end of the canal opening and the Bourne Bridge was constructed approximately two miles in from the western end of the canal opening. The bridges were built simultaneously, and a grand opening dedication was held in June 1935. The Bourne Bridge won the American Institute of Steel Construction's Class "A" Award of Merit as "the Most Beautiful Bridge Built During 1934."

A vertical-lift railroad bridge was built close to the western end of the canal, near the site of the original railroad bridge constructed by Belmont. At the time it was built, it had the longest lift span in the world. It was supported by nearly 300-foot-high towers. The bridge was kept in the raised position, 135 feet above the canal. It was William Barclay Parsons's firm, Parsons, Klapp, Brinckerhoff and Douglas, and Mead and White of New York that designed the plans for the railroad bridge. The U.S. Army Corps of Engineers began work on the railroad bridge in December 1933, and two years later, the first of the Cape Cod trains rolled over its tracks. It remains to this day the only way of traveling across the Cape Cod Canal by rail.

1933

Despite all the planning, it wasn't until passage of the National Industrial Recovery Act of 1933 that nearly $5 million were appropriated for construction of the three proposed bridges and other improvements to the existing canal. With federal funding, the Cape Cod Canal bridge and improvement project ended up employing nearly seven hundred skilled and unskilled workers as part of the national employment initiatives carried out during America's Great Depression of the 1930s.

Within two years, the bridges were built. In June 1935 both highway bridges were unlocked to foot and automobile traffic. In December 1935 the vertical-lift railroad bridge was finished as well.

Construction of the bridges was not the most difficult part of the government's canal improvement program. It was the widening and deepening of the existing canal that posed the biggest problem. In order to determine the feasibility of the work necessary, the Massachusetts Institute of Technology (MIT) was hired to build a hydraulic replica of the proposed canal changes in order to examine the idea of building a straight approach through the Buzzards Bay portion of the existing canal to replace the awkward curving channel that currently existed through Phinney's Harbor. Based on

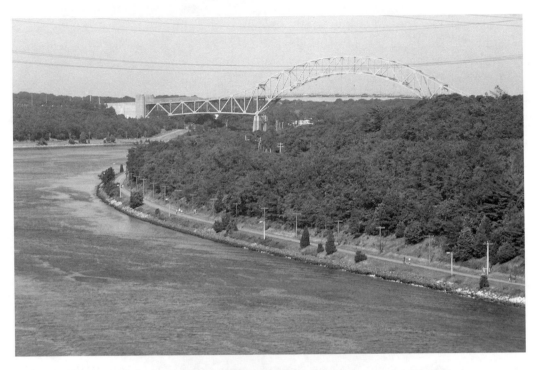

From a distance, the Bourne Bridge looms over the Cape Cod Canal. *Courtesy of Nate Conway.*

the information and statistical data attained from the MIT model canal study, the Army Corps of Engineers was confident that a straight channel approach through Buzzards Bay would work and that, by using dikes, dredging of the canal would require minimal effort.

Work was begun in 1935 and completed in 1940. Improvements included increasing the width of the canal to 540 feet and digging the canal's depth to 32 feet. Excavation for the new canal ran parallel to the existing canal, with heavier support materials laid on the banks. The excavation moved inland and dredges deepened the channel. More than forty million cubic yards of earth, sand and rocks were removed in the process of digging the new canal approach. Only a mere sixteen million cubic yards had been dug during Belmont's effort. The existing canal remained operational throughout the new construction.

The Army Corps of Engineers rebuilt the existing channel and replaced it with a straight waterway into Buzzards Bay starting above Hog and Mashnee Islands. In order to stop soil from eroding into the new canal approach, a two-mile dike was built from Stony Point on the north to the two islands at the south. The two islands were ultimately connected to each other with a causeway built from material dredged from the new channel.

The new canal approach from Hog Island was nearly 5 miles long and 500 feet across. The newly improved Cape Cod Canal was now 17.4 miles long as compared to Belmont's 13-mile canal.

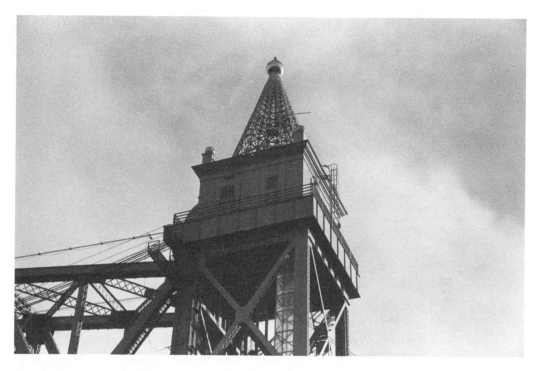

The Cape Cod railroad bridge is supported by two huge towers. *Courtesy of Nate Conway.*

Although the idea for construction locks was entertained, it was abandoned by the Army Corps of Engineers when, during the unusually cold winters of 1933 and 1934, the canal became blocked with ice flows. It didn't freeze over entirely because of the swift current passing through it. Locks on the canal would have only further hampered the current, making it more likely to freeze during the winter. The idea of locks went by the wayside.

When construction was completed, the Cape Cod Canal was the widest man-made sea-level channel in the world. The improvements made during this period ended up attracting more than three times as much canal traffic and increasing the total cargo tonnage passing through the newly improved canal to nearly ten times the amount that had previously passed through. The amount of cargo tonnage rose to nearly eight million tons in 1940, up from three tons in 1935, while the number of vessels passing through the canal rose from approximately eleven thousand ships in 1935 to nearly fifteen thousand in 1940.

By the time the entire project was completed, the price had risen from its initial price tag of approximately $5 million to nearly $20 million. The Cape Cod Canal as seen today by the millions of visitors that frequent it each year is the result of the improvements made by the Army Corps of Engineers.

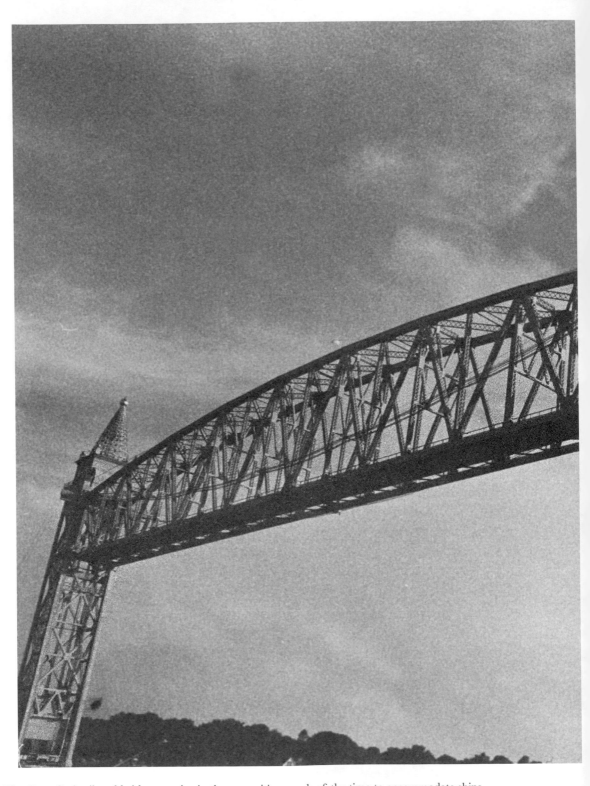

The Cape Cod railroad bridge remains in the up position much of the time to accommodate ships passing through the canal. *Courtesy of Nate Conway.*

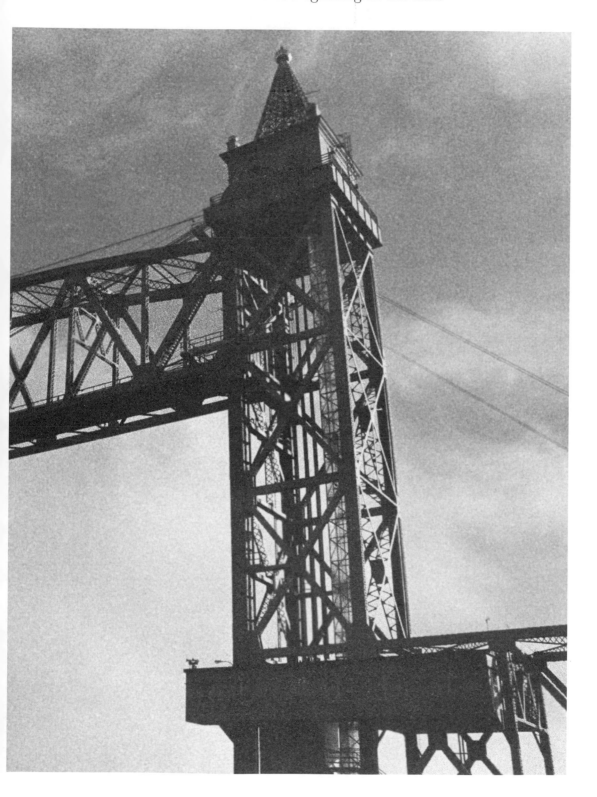

Epilogue

As early as the 1600s, the construction of a canal across Cape Cod had been deliberated. It ultimately took the vision, determination and financial commitment of August Belmont Jr. to make the dream of a Cape Cod Canal a reality. Today, the Cape Cod Canal is one of New England's leading tourist attractions, drawing millions of visitors each year.

"The true memorial to August Belmont, however, is the waterway which his foresight, perseverance and sacrifice constructed; it has served humanity and a nation in peace and war," author William Reid wrote in 1961.

The Cape Cod Canal stands today as a lasting tribute to the man who built it: August Belmont Jr.

Bibliography

Archer, Gabriel. *Gosnold's Settlement at Cuttyhunk*. Boston: Old South Work, 1902.

Ashley, Clifford W. *The Yankee Whaler.* Garden City, NY: Halcyon House, [1926] 1942.

Atlas of Newport, Rhode Island. Springfield, MA: L.J. Richards & Co., 1893. Plate B.

"August Belmont." *Newport Mercury*, December 13, 1924.

"August Belmont Dead." *Newport Daily News*, December 11, 1924

Bailyn, Bernard, and Lotte Bailyn. *Massachusetts Shipping 1697–1714: A Statistical Study*. Cambridge, MA: Harvard University Press, 1959.

Beale, Thomas. *The Natural History of the Sperm Whale...* [and] *Rise and Progres of the Fishery.* London: Jan Van Voorst, 1839. Reprint, London: Holland Press, 1973.

Belmont, August. *Letters, Speeches and Addresses of August Belmont*. New York: Privately printed, 1890.

Belmont, Eleanor Robson. *The Fabric of Memory.* New York: Farrar, Straus and Cudahy, 1957.

Belmont, Robson. *The Building of the Cape Cod Canal 1627–1914*. N.p.: Privately printed, 1961.

Bragdon, Kathleen. *Native People of Southern New England*. Norman: University of Oklahoma Press, 1996.

Brown, Richard B., and Jack Tager. *Massachusetts, A Concise History*. Amherst: University of Massachusetts Press, 2000.

Carmody, Deirdre. "Eleanor R. Belmont Dies at 100; Leader in Charities and the Arts." *New York Times*, October 25, 1979.

Chamberlain, B. B. *These Fragile Outposts*. New York: Doubleday, 1964. Reprint, Parnassus Imprints, 1982.

Church, Albert Cook. *Whale Ships and Whaling.* New York: W.W. Norton & Co., 1938.

Colonial Society of Massachusetts. *Seafaring in Colonial Massachusetts*. Boston: Colonial Society of Massachusetts, 1980.

Dexter, Lincoln A., comp., ed. *Now Cape Cod and the Islands, Massachusetts According to the Relations by Gabriel Archer and John Brereton*. N.p.: Self-published, 1982.

Ellis, Richard. *Men and Whales*. New York: Knopf, 1993.

Fawsett, Marise. *Sandwich: The Oldest Town on Cape Cod*. East Sandwich, MA: Self-published, 1969.

Finch, Robert. *Cape Cod, Its Natural and Cultural History*. U.S. National Park Service Handbook, n.d.

Hart, Albert, ed. *Commonwealth History of Massachusetts*. 5 vols. New York: States History Co., 1927–1930. Reprint, 1966.

Hutchinson, Thomas. *The History of the Colony of Massachusetts Bay*. New York: Arno Press, 1972.

Kane, Joseph Nathan. *Famous First Facts*. 4th ed. New York: H.W. Wilson Company, 1981.

Katz, Irving. *August Belmont: A Political Biography*. New York: Columbia University Press, 1968.

Mercy Otis Warren, Conscience of the American Revolution. B&R Samizdat Express. http://www.samizdat.com/warren/.

Morison, Samuel Eliot. *Maritime History of Massachusetts 1783–1860*. Boston: Houghton Mifflin, 1979.

The Newport Mercury Almanac. Newport: Mercury Publishing Company, 1917.

O'Brien, Greg, ed. *A Guide to Nature on Cape Cod and the Islands*. New York: Viking Penguin, 1990.

Oldale, R.N. *Cape Cod and the Islands, The Geologic Story*. East Orleans, MA: Parnassus Imprints, 1992.

"Otis Papers." Collection of Massachusetts Historical Society. Boston, 1897.

Prince, Thomas. *A Chronological History of New England in the Form of Annals*. N.p.: Cummings, Hilliard and Co., 1826.

Quinn, William P. *The Saltworks of Historic Cape Cod: A Record of the Nineteenth Century Economic Boom in Barnstable County*. Orleans, MA: Parnassus Imprints, 1993.

Reid, William James. *The Building of the Cape Cod Canal*. N.p.: Privately printed, 1961. Based on a dissertation for the Boston University Graduate School.

Simmons, William. *Spirit of the New England Tribes: Indian History and Folklore, 1620–1984*. Hanover, NH: University Press of New England, 1986.

Strahler, A.N. *A Geologist's View of Cape Cod*. Orleans, MA: Parnassus Imprints, 1988.

Thomas, J. *Cranberry Harvest: A History of Cranberry Growing in Massachusetts*. New Bedford, MA: Spinner Publications, 1990.

United States Congress, House Committee on Interstate and Foreign Commerce. "Purchase of the Cape Cod Canal." Washington, DC: Government Print Office, 1922.

Wilkie, Richard, and Jack Tager. *Historical Atlas of Massachusetts*. Amherst: University of Massachusetts Press, 1991.

Winslow, Edward. *Glorious Progress of the Gospel Among the Indians of New England*. London, Printed for H. Allen, 1649.

Winslow, Edward, and William Bradford. *Mourt's Relation*. London: Printed for John Bellamie, 1622.

Younger, Barbara. *Purple Mountain Majesties: The Story of Katharine Lee Bates and "America the Beautiful."* New York: Dutton Children's Books, 1998.

The author, J. North Conway, is pictured with his yellow lab Molly at his farm in Assonet, Massachusetts. *Courtesy of Julia Conway.*

About the Author

J ack Conway is the author of a dozen books. An accomplished poet and former
newspaper editor, he teaches English at Bristol Community College in Fall River,
Massachusetts, and at the University of Massachusetts in Dartmouth.

Visit us at
www.historypress.net